Praise for *Abandoned: Chronicling the Journeys of Once-Forsaken Dogs*

"In *Abandoned*, Carver describes, with words and beautiful photographs, the plight of abandoned dogs and how a caring home can transform a frightened cowering being into a confident and happy companion who will give unconditional love. For me, a life without a dog is a life only half lived. A must read."—**Jane Goodall**, Ph.D., DBE; Founder of The Jane Goodall Institute and United Nations Messenger of Peace

"*Abandoned* is a testament to the nobility of dogs, their willingness to forgive, and the great love they offer their humans. Carver has caught all this and more in her moving portraits of these long-suffering animals whose faces will remain in your mind long after you finish this book. The stories are heartbreaking as well as affirming—and a tribute to the hard-working and dedicated people who protect and care for our best friends."—**Sally Mann**, photographer and *New York Times* bestselling author of *Sally Mann: A Thousand Crossings* and *Hold Sill: A Memoir with Photographs*

"This is a gorgeous, emotional tribute to the resilience of dogs and our special connection and responsibility to them. By telling the stories of these abandoned dogs and photographing them so exquisitely, Carver ennobles them and rescues them for all of us."—**Susan Orlean**, *New York Times* bestselling author of *On Animals* and *The Library Book*

"The luminous photographs, and the stories behind them, will break your heart but also fill it with wonderment and joy. This extraordinary book reminds us that for every forsaken creature, for every cruelty and abandoned promise, a happy forever can await, if only we humans step up and say, 'Come home with me, won't you?'"—**John Grogan**, #1 *New York Times* bestselling author of *Marley & Me: Life and Love with the World's Worst Dog*

"This book will break your heart—and then heal it all over again. In words and photographs, Carver has captured both the callous cruelty that led to these dogs' abandonment, and the transformative power of love for both the dogs and their forever humans. Though all dogs deserve a home, not all will find theirs. May these compelling photographs and stories help change that picture, and bring together the people and animals who will love one another until death do they part."—**Sy Montgomery**, *New York Times* bestselling author of *Of Time and Turtles: Mending the World, Shell by Shattered Shell*

"Carver's gorgeous photographs show the individuality of each abandoned dog. Both dog lovers and people who admire black and white photography will love this book."—**Temple Grandin**, *New York Times* bestselling author of *Visual Thinking: The Hidden Gifts of People Who Think in Pictures, Patterns, and Abstractions*

"The word 'abandoned' is just a category, giving us a sense of devaluation, perhaps even of lost hope. But this book, *Abandoned*, gives us just the opposite. Exquisite views of individual creatures, the hope for whom is never lost."—**Carl Safina**, *New York Times* bestselling author of *Beyond Words: What Animals Think and Feel* and *Alfie and Me: What Owls Know, What Humans Believe*

"The best way to peruse Carver's gorgeous book is sitting alongside your own rescued dogs, as I am with Quiddity and Tilde. Both are mixed-breed dogs whose journeys began in the way many dogs' journeys in Carver's book did: the 'precise date and circumstances leading to the arrival at the shelter are unknown.' Each of the individual dogs profiled by Carver is given such dignity by the attention and care taken in her photographs of them. Their personalities, their emotions, their anticipation are all on full display. I felt relief at each adoption story and heartbreak at each loss. Carver's photographs remind us that every dog is a wonderful dog, and it is only up to us to open our hearts to find one."—**Alexandra Horowitz**, #1 *New York Times* bestselling author of *Inside of a Dog: What Dogs See, Smell, and Know* and *The Year of the Puppy: How Dogs Become Themselves*

"I love this book! It tugs at the heartstrings! I think it is a wonderful book and will undoubtedly be cherished by all dog lovers, especially those who have had the heart to adopt a dog from a shelter. One thing I learned from this book: Do NOT buy a dog, there are too many wonderful dogs desperate for a home. Get your dog exclusively from a shelter or rescue organization."—**Jeffrey Moussaieff Masson**, *New York Times* bestselling author of *When Elephants Weep: The Emotional Lives of Animals* and *Dogs Never Lie About Love: Reflections on the Emotional World of Dogs*

"From sad, wary, tired, disheartened, to bright-eyed and joyful, Carver's elegant portraits capture more succinctly than words can ever manage, the glory of finding a home, and the miracle of love. For anyone who has suffered from loneliness or disappointment in their lives, *Abandoned* is a masterful inspiration: get closer to animals. Their emotions are deep, complete, and visible, and they are waiting to wrap you in love."—**Erika Abrams**, President, Animal Aid Unlimited

"*Abandoned* is as hopeful as it is heartbreaking. Full of beautifully written stories and mesmerizing photographs, this is a book that will stay with you long after you've put it down."—**Jennifer Arnold**, *New York Times* bestselling author of *Through a Dog's Eyes: Understanding Our Dogs By Understanding How They See the World*

"Carver's beautiful book, *Abandoned*, is filled with hope, joy, resilience, and proves what dog lovers have always suspected: there is nothing more endlessly satisfying than a rescue dog's unconditional love. May this book inspire you to consider adopting a dog in need."—**Debbie Millman**, host of the *Design Matters* podcast and author of *Why Design Matters: Conversations with the World's Most Creative People*

"If you care about dogs, Carver's book, *Abandoned*, will please you enormously. Dogs are fascinating, remarkable animals, often understanding us humans better than we understand them or even ourselves. Many of us love and respect dogs and want to keep them in our lives. But some of us treat dogs like we treat unwanted objects—with no respect and no understanding. Carver illustrates in her book, *Abandoned*, through her salient photographs and words, the marvel of how the rescue of these intelligent, interesting animals is not only very positive and transformational for the rescued dogs, but it is also simultaneously very beneficial and positively life-changing for their human companions. Animal lovers will love this book. A must read."—**Elizabeth Marshall Thomas**, *New York Times* bestselling author of *The Hidden Life of Dogs*

"With luminous portraiture and sparse text, Carver chronicles the lives and experiences, the despondency and joys, that dogs endure when we love them and when we leave them. Through Carver's skillful vision, the stories contained in *Abandoned* are simultaneously heart-wrenching and hopeful. Humans are not always kind to man's best friend, and *Abandoned* is an intriguing way for us to visually see and learn this lesson to help create a kinder world."—**Jo-Anne McArthur**, Founder of We Animals Media, photojournalist, and author of *We Animals*

"In Carver's heart-wrenching and hope-inspiring book, she deftly documents the journeys of 59 individual companion dogs who have been abandoned by humans and find themselves in the shelter and rescue system. Carver's stunning black and white photographs help us see each dog as an individual being, with a life story, not just as an anonymous 'rescue dog.' Juxtaposed against the photographs are the sparse narratives recording how each dog came to be in the untenable position of abandonment. The individual dogs whose lives we encounter in this book have, without exception, suffered at the hands of human beings. But that isn't the end of the story. Nearly all of the dogs went on to live full and happy lives with their adopted families because of dog rescue. Everyone who cares about dogs should spend some time with *Abandoned*. The dogs within these pages ask us to do better and work harder to give each and every dog the moral consideration they deserve."—**Jessica Pierce**, author of *Who's a Good Dog?: And How To Be a Better Human*

"Carver has assembled a beautiful book of amazing photographs that tell an important story about the dogs' transformations, rebirth, and hope. A true gem."—**Steven Kotler**, Executive Director of the Flow Research Collective and *New York Times* bestselling author of *A Small Furry Prayer: Dog Rescue and the Meaning of Life*

"*Abandoned*, Carver's wonderful, heartfelt project documenting abandoned dogs, contains exquisite black and white photographs, which are lovingly detailed, while simultaneously, admirably unsentimental. The directness and simplicity of the photographs and stories give the dogs their own individual dignity, which makes the words and photographs all the more powerful. The stories are poignant and touching. Although not every dog has a happy ending, this is a book of hope, full of loving stories of compassionate people, who have given these abandoned dogs another chance."—**Sally Muir**, painter and author of *Rescue Dogs* and *A Dog A Day*

"*Abandoned* is a work of great beauty, compassion and, in the end, wonder, which will change the way you see all dogs. This book comprises short narratives, which fill in the stories of each dog, but the power of the book lies in the gorgeous black and white photographs, each a searing portrait of a dog before adoption, then roughly one year later. The transformation is stunning. What results is a powerful glimpse into the emotional lives of dogs and the redemptive power of love to heal. Those who love animals will savor this uplifting and big-hearted exploration of what anyone who has loved a canine knows—dogs simply make us better humans."—**Leila Philip**, *New York Times* bestselling author of *Beaverland: How One Weird Rodent Made America*

"Carver's photography is stunning. If you love great art as much as you love dogs, you'll want this book." —**Patricia McConnell**, author of *The Other End of the Leash: Why We Do What We Do Around Dogs*

"Through beautiful photographs and well-documented shelter and adoption statistics, *Abandoned* is a thoughtfully crafted, timeless tribute to all dogs who, for whatever reason, find themselves homeless in America's shelter and rescue system. The combination of poignant photographs and successful adoption stories reminds us that not only is our work in animal welfare urgent and life-saving, but there is also much hope and community in the work we do on behalf of animals in need. *Abandoned* encourages us to continue rewriting the futures for all dogs in need, remembering that every animal is worth our best efforts and, for most, these efforts can transform their lives."—**Theresa Strader**, Founder and Executive Director, National Mill Dog Rescue

"What better subjects for a talented artist than these extraordinary souls who refused to give up, no matter the odds? Carver's stunning photographs will move you profoundly—a reminder that regardless of how far you have fallen, your life may still be transformed, and that even in the darkest of times, there is always room for hope."—**Brian Hare** and **Vanessa Woods**, *New York Times* bestselling authors of *The Genius of Dogs: How Dogs Are Smarter Than You Think*

"This book is a must-read for anyone who believes in the power of dog rescue and the enduring bond between dogs and their human companions. Carver, through her lens, artfully captures the poignant journeys of shelter and rescue dogs. This heartwarming book beautifully illustrates the resilience and the second chances given to these remarkable dogs, proving that hope exists for these dogs, regardless of their circumstances. Each page bridges the divide between the dogs' lives during their shelter or rescue stay, and their profound transformation after adoption. Friends of Homeless Animals, located in Aldie, Virginia, is a beacon of hope with a mission: 'Home with us until they're home with you.' We proudly endorse *Abandoned*, which resonates deeply with our work to find a home for each animal no matter how long it takes."—**Alison Maurhoff**, Executive Director, Friends of Homeless Animals

"Carver's book contains heartfelt photographs and accompanying stories, illustrating her dedication and devotion, honoring each abandoned dog, acknowledging they existed. Carver exhibits an unwavering persistence to provide each dog's history and story, even when the outcome is not what one hopes for. It's the good stories, and the dogs' transformations shown in the photographs, that will make you smile and turn the page for another story."—**Robin Schwartz**, photographer and author of *Amelia & the Animals*

"Through the power of her photographs, Carver has captured the transformative power of human kindness and love to dogs once abandoned."—**Gregory Berns**, *New York Times* bestselling author of *How Dogs Love Us: A Neuroscientist and His Adopted Dog Decode the Canine Brain*

"With heartwarming stories and stunning photographs, Carver illuminates the world of dog rescue. By following the lives of dogs from abandonment to adoption, Carver allows readers to experience a dog's transformational journey. She brilliantly captures the joy of opening up your heart and home to a dog in need. These touching stories serve as a testament as to why Sochi Dogs rescues and rehabilitates homeless dogs around the globe. They will also delight animal lovers. And, *Abandoned*, may even propel you on your own rescue journey."—**Anna Umansky**, Executive Director, Sochi Dogs

"Abandoned dogs need all the love they can get, and Carver should be lauded for her work on behalf of these amazing sentient beings. Her stories and photographs will surely move readers and clearly show that when we step out of our own shoes into the paws, heads, and hearts of dogs in need, we can give them a second or third chance to live lives spilling over with safety, trust, respect, dignity, and compassion. One important take-home message, among others, is that what is good for the dogs also is good for us—a win-win for all—and I can't think of anything more rewarding than having the emotions that are shared between dogs and humans work as the social glue to bind them together, and have the dogs unconditionally enjoy the forever home they so desperately want, need, and fully deserve."—**Marc Bekoff**, author of *The Emotional Lives of Animals: A Leading Scientist Explores Animal Joy, Sorrow, and Empathy—and Why They Matter*

"Prepare to be moved and inspired by the indomitable spirit of these abandoned dogs as they try to find their way back into the loving embrace of a forever home in Carver's extraordinary book, *Abandoned*. Carver's book resonates with the mission of the SPCA International, making it a must-read for all animal lovers. With an unyielding commitment over the past decade, Carver's lens shines a light on the extraordinary resilience and hope that arises when dogs are given a second chance. Carver highlights the urgent issue of overcrowded shelters and the countless dogs in need through interviews with dedicated heroes—rescue and shelter personnel, foster families, and adopters. *Abandoned* is not just a visual journey, but a tribute to the power of dog rescue, which enriches both the lives of dogs and their human companions; a testament to the enduring bond between dogs and their human companions."—**Emma Kronish**, Executive Committee, SPCA International

ABANDONED

CHRONICLING THE JOURNEYS OF ONCE-FORSAKEN DOGS

KATHERINE CARVER

Lantern Publishing & Media ● Woodstock & Brooklyn, NY

2024
Lantern Publishing & Media
PO Box 1350
Woodstock, NY 12498
www.lanternpm.org

Photographs and writing by Katherine Carver
Foreword by Francis Battista
Afterword by Deborah Samuel
Copyediting by Pauline Lafosse
Design and typesetting by Pauline Lafosse and Emily Lavieri-Scull

Front Cover Photograph: Sheila. For more information on this dog, see pages 2-4.

Printed in the United States of America

Library of Congress Cataloging-in-Publication Data

Names: Carver, Katherine, author.
Title: Abandoned : chronicling the journeys of once forsaken dogs / Katherine Carver.
Description: Woodstock, NY : Lantern Publishing & Media, 2024.
Identifiers: LCCN 2023053326 (print) | LCCN 2023053327 (ebook) | ISBN 9781590567302 (hardcover) | ISBN 9781590567319 (epub)
Subjects: LCSH: Dog rescue. | Animal shelters. | Animal welfare.
Classification: LCC HV4746 .C37 2024 (print) | LCC HV4746 (ebook) | DDC 636.7/0832—dc23/ eng/20240416
LC record available at https://lccn.loc.gov/2023053326
LC ebook record available at https://lccn.loc.gov/2023053327

This book is for Biscuit, my first rescue dog. He filled my heart with love and changed my life forever.

And for my husband, Doug, for his kindness and intelligence and his great and generous heart; for my daughter, Alex; and my beloved rescue Shetland Sheepdog, Victory.

Biscuit, Peggy's Cove, Nova Scotia, 2011
Photograph by Katherine Carver

A portion of the author's royalties, earned from the sales of this book, will be donated to dog rescue and animal welfare causes.

"BECAUSE OF THE DOG'S JOYFULNESS, OUR OWN IS INCREASED. IT IS NO SMALL GIFT."
—MARY OLIVER

CONTENTS

FOREWORD

Francis Battista

There is an almost cosmic sense of satisfaction in adopting a dog from a shelter or rescue organization and making them a member of your family. A lot more goes into it than simply bringing a dog home. That is just the beginning of the journey. There is the moment your new friend understands that they are home; that their place and your acceptance of them is not conditional; and that you are trying as hard as they are to establish communication. When a dog realizes that you have picked up on what they are trying to tell you, it is an experience that opens your heart to an understanding that there is a lot more going on with the animals we share the planet with than we previously knew.

The primary title of this book, "Abandoned," is a harsh word. It implies deliberation and intent, and in the context of Katherine Carver's loving portrayal of dogs, it raises the question of how could any reasonable person abandon a creature as dependent and trusting as a dog?

I have been involved in the rescue and rehoming of thousands of dogs over the course of my forty year career in animal welfare with the Best Friends Animal Society. To be sure, there are some people whose actions are thoughtless, uncaring, and cruel, warranting the description of abandonment. I have also encountered numerous people in dire personal or financial circumstances; one of the hardest lessons to learn has been not to judge people harshly for surrendering a family pet to a shelter or rescue organization. They know nothing about the shelter system or animal welfare, and they take the term "animal shelter" at face value. In their mind, they are handing their pet off to a trusted official and are oblivious to the realities of life in a shelter. Then, of course, there are strays who have been picked up by well-meaning strangers and taken to the local shelter so that their owner can reunite with them.

Be that as it may, regardless of human intent, even the best of shelters is a frightening place for a dog. The noise, the smell of stress, and too often the smell of death is terrifying. But even with that, I do not believe a dog can conceive of being abandoned, because it is simply a foreign concept to them. Dogs do not abandon their people or their pack. It is not part of the dog equation, and it is not something that they would understand. Abandonment is something that people do.

While we can empathize—and empathy is at the core of *Abandoned: Chronicling the Journeys of Once-Forsaken Dogs*—we really cannot comprehend the trauma that a dog experiences when it finds itself separated from its family and imprisoned in a shelter. The fear, the confusion—strangers coming and going, dogs barking, dogs crying, dogs waiting for their person to come for them. No context, no explanation, no cause and effect. Just alone, confused and no point of reference. It is impossible to comprehend.

And yet, many would-be adopters expect a shelter or rescue dog to fit right in and be a happy camper right out of the box—and while some dogs do all that and then some, most need time to build a relationship and learn to trust. That is the most rewarding part of the journey.

Carver's book is photographic proof that this journey is immensely rewarding to both the dogs and their human adopters. Regardless of the circumstances leading to each dog's placement in the shelter and rescue system, Carver's work teaches us that with time, empathy, and love, these previously abandoned dogs can be rehomed and given a second chance at the life they were denied. And with any luck, their human companions' lives will be as equally enriched as the life of the dog they rescued.

—Francis Battista, Co-founder of the Best Friends Animal Society

INTRODUCTION

Approximately three million dogs are abandoned and displaced by people each year in the United States. They find themselves abandoned and terrified, losing, in most cases, the only home they ever knew. Regrettably, people frequently abandon dogs for trivial reasons, without considering how it will negatively and *permanently* impact the dog's life. This betrayal is made worse because the dogs are powerless and depend on their human companions to act in their best interest.

My life changed forever when Biscuit, a rescue Shetland Sheepdog, entered my life in early 2011. A Good Samaritan discovered Biscuit wandering along back roads, terrified and malnourished. Biscuit was taken to a Shetland Sheepdog rescue where he received veterinary treatment and care. When I first met him, he was hopelessly shy, wary of people, and untrusting. He cowered behind tables and chairs, avoiding interaction with humans and other dogs. Biscuit had several missing teeth and he was drastically underweight, his fur coat was heavily matted and virtually nonexistent, and his rear legs were permanently deformed—most likely as a result of spending countless hours cooped up in a small, wire crate. Within a few short months of living with us, I witnessed his transformation into a truly loyal companion whose impact on my life can only be described as extraordinary. He slowly emerged from his shell, and a trusting friendship began to form between us. Gone was the shy, apprehensive creature that hid while living at the rescue. In its place was a confident, friendly, and beautiful dog with a gorgeous fur coat, with a zest for living and a sparkle in his eye—a true companion, a best friend.

Dog rescue provided Biscuit with a second chance at life, and he lived that life to the fullest. I will never forget Biscuit's stretch before a walk, his shake after waking up from a nap, the way he fell over effortlessly for a belly rub, the way he raised his paw and pressed it against my leg when he wanted more treats, and, most of all, his smile. I am immensely grateful to have been a part of Biscuit's life, which was truly a gift to my husband and me. Biscuit's life, unfortunately, ended far too soon from a rare cancer. He passed away peacefully in my arms on July 7, 2013, at home with my husband by our side, during the creation of this body of work. Although it was short, I would never trade my time with Biscuit for anything.

My curiosity and my experience with Biscuit inspired me to learn more about the plight of dogs like him who were abandoned and left to die. In early 2013, I began documenting the fate of approximately sixty abandoned dogs of various breeds living in the Mid-Atlantic region. I wanted to know how these dogs came to live in shelters and rescue organizations, to figure out what actually happens to these forsaken dogs, and to document and raise awareness of the vital role dog rescue serves in saving and positively reshaping abandoned dogs' lives.

I first photographed these abandoned dogs while they resided in shelters and rescue organizations. I then photographed the same dogs again, approximately a year after each adoption. My objective was to chronicle the changes which had occurred in their lives as a result of dog rescue. A narrative accompanies each dog's image and explains, to the extent possible, how and why each dog was abandoned. The narratives also explore the significant impact these dogs have had on their human companions' lives after being adopted into permanent homes. Sadly, not all of the dogs I photographed were fortunate enough to be adopted. A few of them were euthanized without ever finding their home, a fact that embodies the grim reality shelter dogs routinely face. For these dogs, these images are all that remain of their existence.

Yet, through this exploration, I feel a tremendous sense of hope. In many cases, I witnessed abandoned dogs transform into integral family members, similar to Biscuit's story. Dog rescue provided them with an entirely new life. This body of work speaks for these dogs and chronicles their journeys from abandoned dogs to rescued dogs. The rescued dogs now live wonderful lives, and their human companions' lives are equally enriched.

The idea for this project would not have occurred to me if it were not for Biscuit entering my life. He truly, permanently changed my life, and I am profoundly thankful to him for being the inspiration for this body of work. I also believe Biscuit sent us Victory, another rescue Shetland Sheepdog, who came into our lives in the autumn of 2013. Victory was discovered living in a hoarding house, frightened and emaciated. Like Biscuit before her, Victory has transformed into an integral family member and ardent companion who has impacted my life in immeasurable ways. I am sincerely grateful for this journey.

ABANDONED DOGS' PHOTOGRAPHS AND THEIR STORIES

SHEILA
I.D. # A19452904, HOUND-TERRIER MIX, FEMALE, 1 YEAR, 2013

In Spring 2013, Sheila arrived at a local shelter in Maryland. She was adopted soon thereafter, but returned four months later. The shelter reported that the adopter could no longer afford to take care of her. At the time of her return, shelter personnel estimated Sheila to be approximately one year old. Their veterinary team reported no health or behavior problems. According to the shelter, "Sheila is sweet, crate trained, knows basic commands, is good with kids, and is tolerant of cats."

During her initial photo shoot, Sheila was very sweet, calm, well-behaved, and even-tempered.

Sheila was transferred from the shelter to a local Maryland rescue in August 2013.

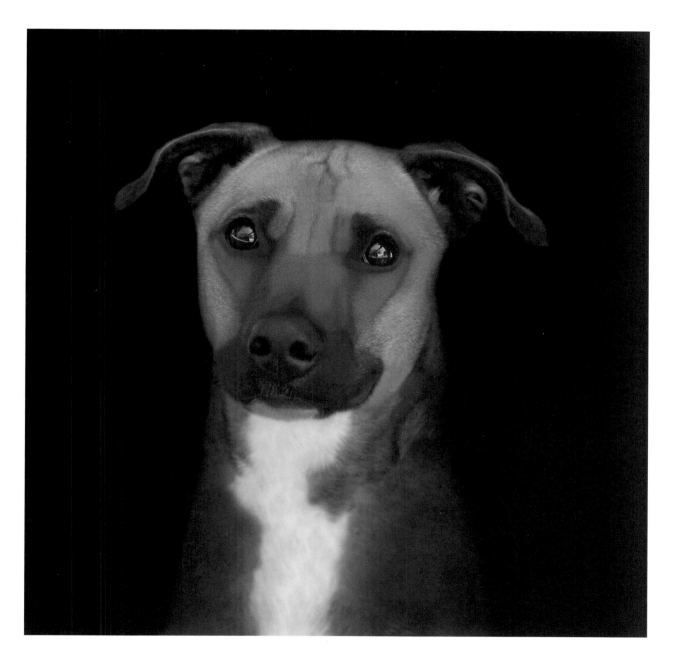

SHEILA
HOUND-TERRIER MIX, FEMALE
UNABLE TO LOCATE TO PHOTOGRAPH A SECOND TIME

Although Sheila was transferred from the shelter to a local Maryland rescue during the summer of 2013, the shelter was unable to provide the name and contact information of the rescue organization due to a confidentiality agreement. As a result, Sheila could not be photographed a second time.

ROBO
I.D. # PGAMD-13-440-NM, BELGIAN TERVUREN MIX, MALE, 1.5 YEARS, 2013
ADOPTED—564 DAYS IN THE RESCUE

In Autumn 2013, Robo was transferred from a shelter to a local Maryland rescue after two failed adoptions. The precise date and circumstances leading to his (at least) third surrender are unknown. At the time, rescue personnel estimated him to be about one and a half years old. Their veterinary team reported no health problems; however, they noted that he suffered from severe separation anxiety. His medical file explained that "Robo is very anxious and shy, and he needs to be in a home with another dog due to his separation anxiety." The rescue also noted that "Robo loves belly rubs, he does well on a leash, and he knows basic commands."

During his initial photo shoot, Robo displayed nervous energy and I struggled to interest him in being photographed.

After spending over a year and a half in foster homes and the rescue's boarding facility, Robo was adopted on May 18, 2015. He was renamed "Washburne" by his adopter and now responds to the nickname "Wash."

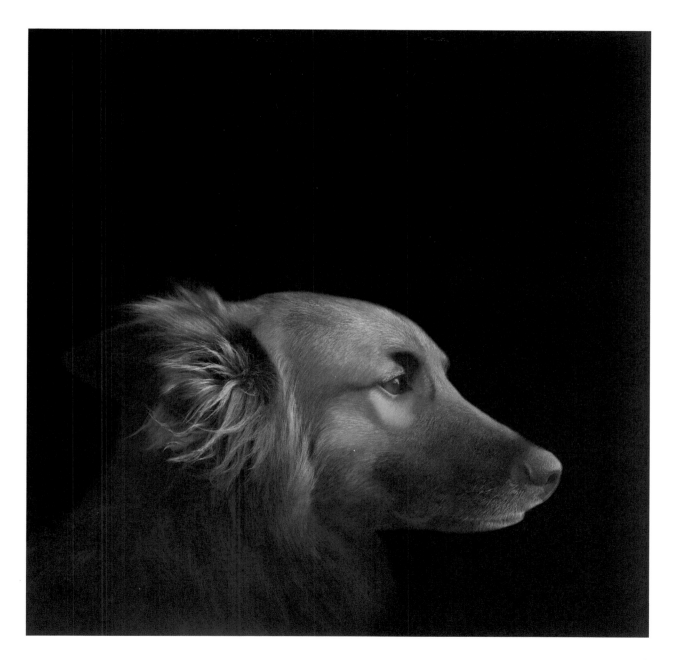

WASHBURNE
BELGIAN TERVUREN MIX, MALE, 2.5 YEARS, 2015

"My wife and I already had a dog for a couple of years, a Belgian Tervuren, which we adopted as a puppy. We have fallen in love with the breed, and always wanted a second dog, but figured it would be years off. However, when we saw Washburne ('Wash') on a rescue's website, we had to reach out and see if he was available. We fell in love with the photos of him and his description; and from the moment we met him, we knew he was coming home with us."

According to Wash's adopter, he continues to thrive in his new home. Since his adoption in 2015, Wash has become a "big brother." He loves playing with his sister, who is also a Belgian Tervuren, and chasing her around the yard.

"Wash has been a great addition to our family. Wash is a loving and cuddly little guy that is always up for sitting with us and keeping us company. And, with the two dogs, they both need a ton of exercise, which has forced my wife and I to both be more involved in their care and to get our own walks in!"

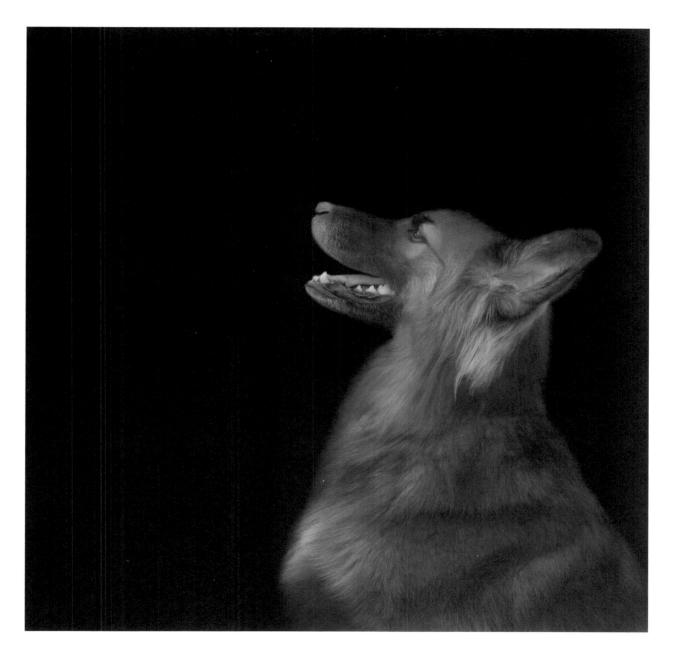

SKYLAR
WHIPPET MIX, FEMALE, 1 YEAR, 2014
ADOPTED—2 DAYS IN THE RESCUE

In Summer 2014, Skylar was transferred to a local Maryland rescue after Animal Control seized her. The precise date and circumstances leading to Skylar living in a shelter are unknown. At the time, rescue personnel estimated Skylar to be one year old. Their veterinary team reported no health or behavioral issues. The rescue noted that "Skylar is very sweet, a bit shy, but she warms up quickly, as she wants to be around humans and enjoys playing with other dogs."

During her initial photo shoot, Skylar seemed shy; however, she really enjoyed having her photograph taken.

After spending only two days at the shelter, Skylar was adopted on June 29, 2014. Skylar was renamed "Lucy" by her adopter.

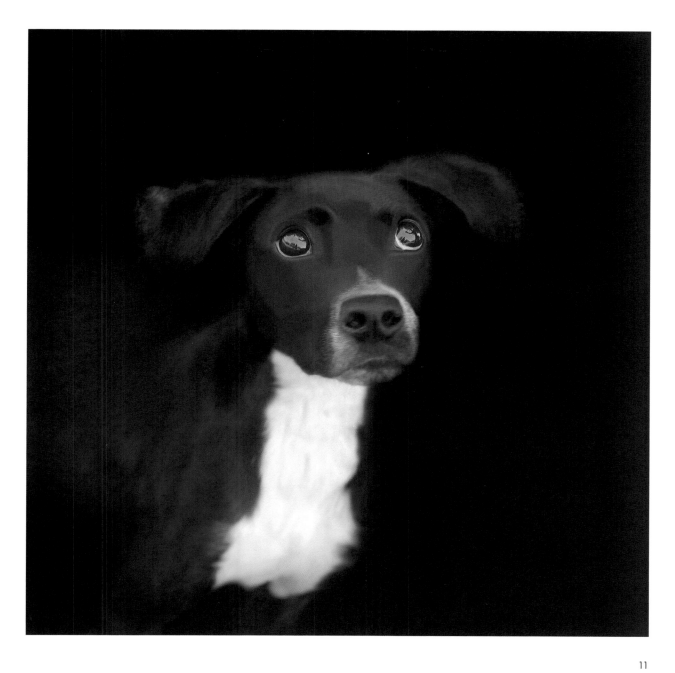

LUCY
WHIPPET MIX, FEMALE, 2 YEARS, 2015

"We wanted a whippet and a friend saw Lucy on the rescue's website; we went to see Lucy, and our boys fell in love."

"She greets us enthusiastically at the door each time we come home, and she snuggles with us every chance she gets."

"Our boys adore Lucy and take good care of her. They make sure she never leaves our gated yard so that she is safe from traffic on our busy street. The boys also enjoy taking her for walks and playing ball with her."

According to Lucy's adopter, Lucy has adjusted very well to her permanent home. She is sweet, and full of love and energy. "She has added fun and excitement to our family. She's a great dog and we are so fortunate to have found and adopted her."

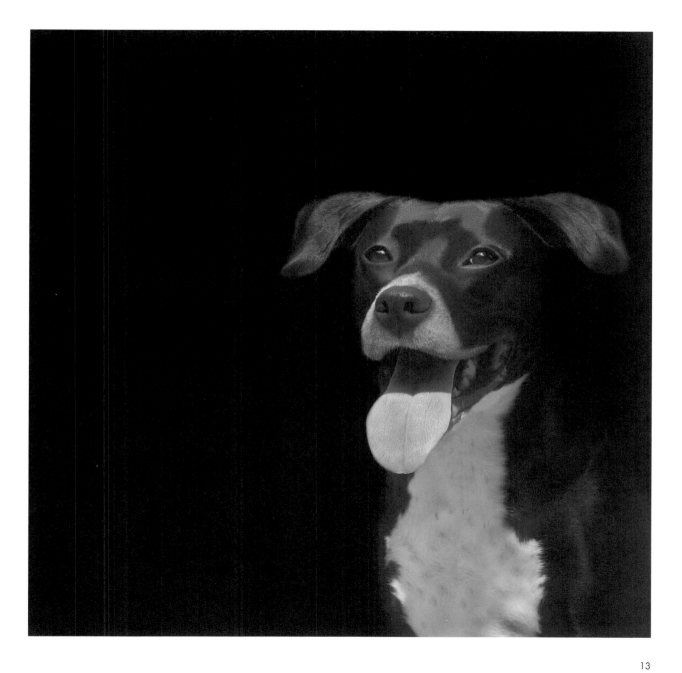

Mario
I.D. # HUNWV-14-102-MP, Hound Mix, Male, 2.5 months, 2014
Adopted—90 days in the Rescue

In Winter 2014, Mario and his sister, Princess Peach, were transferred from a shelter in West Virginia to a local Maryland rescue. The exact date and circumstances leading to his placement in a shelter are unknown. At the time, rescue personnel estimated him to be approximately two and a half months old. Their veterinary team did not report any health or behavioral issues.

During his initial photo shoot, Mario posed very well for the camera and did not appear shy.

After spending three months in the rescue, Mario was adopted on May 31, 2014. His adopter renamed him "Teddy."

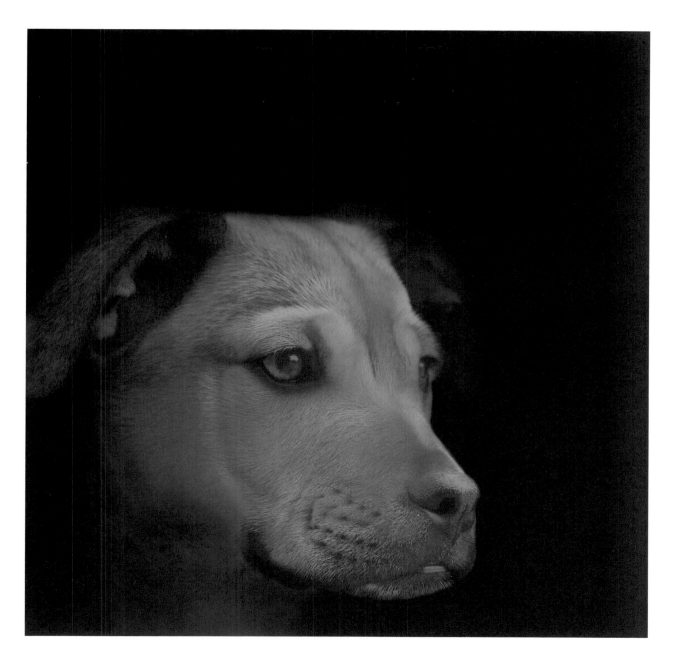

TEDDY
HOUND MIX, MALE, 1.5 YEARS, 2015

"He looks like my childhood dog, and he was the age we were looking for. Once we met Teddy, we liked that he was in a foster home with a little girl and a cat, like we have."

"My daughters have taken a very active role in teaching and taking care of Teddy. Teddy has also made the kids learn how to act calmly and respectfully towards animals. It has been really good for the girls."

"Teddy is very cuddly and loveable, and very gentle with kids and animals alike." Importantly, according to Teddy's adopter, "Teddy has been a super companion, and he is part of the family."

According to Teddy's adopter, he is doing very well in his new home and fits right in with his new family. "We were amazed with how smart Teddy is. He learned all the rules of our house very quickly. It was a brand-new environment, with new guidelines, and Teddy adapted very quickly."

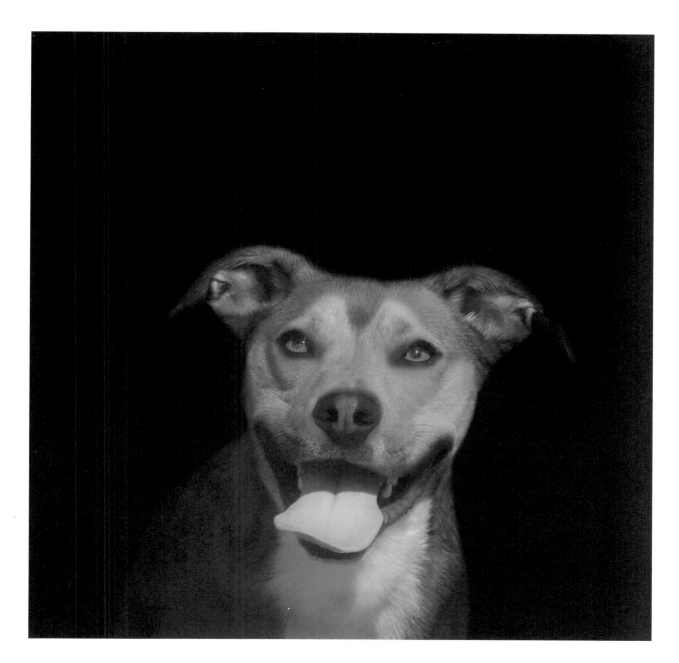

PRINCESS PEACH
I.D. # HUNWV-14-103-FP, HOUND MIX, FEMALE, 2.5 MONTHS, 2014
ADOPTED—67 DAYS IN THE RESCUE

In Winter 2014, Princess Peach, along with her brother, Mario, was transferred from a shelter in West Virginia to a local Maryland rescue. The precise date and circumstances leading to her surrender to the shelter are unknown. At the time, rescue personnel estimated her to be approximately two and a half months old. Their veterinary team reported no health or behavioral issues.

During her initial photo shoot, Princess Peach posed very well for the camera and seemed at ease.

After spending two months in the rescue, Princess Peach was adopted on May 8, 2014. She was renamed "Willow" by her adopter.

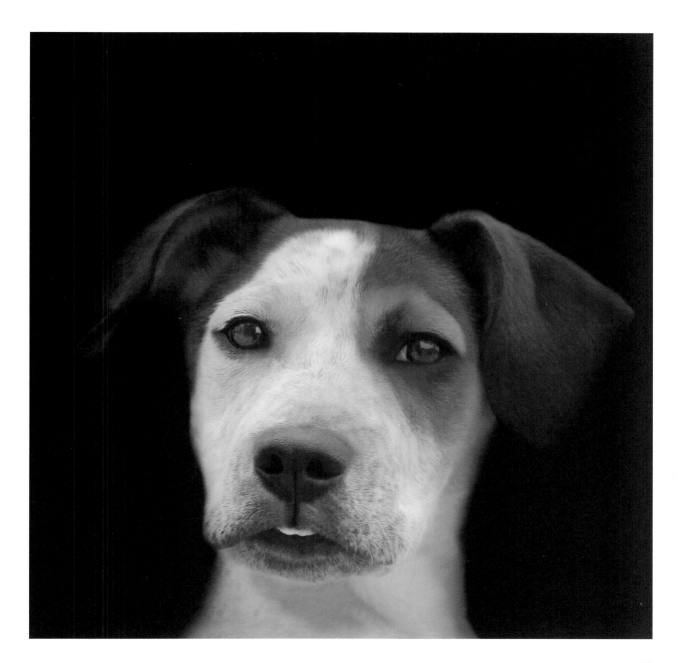

WILLOW
HOUND MIX, FEMALE, 1 YEAR, 2015

Willow's adopters discovered her through an internet search and fell in love with her photographs. "We fell in love with her. We really wanted to adopt a dog, and Willow was the first one we visited. She was very happy, sweet, and cuddly."

"Willow makes me happy every time I walk in the door!"

"Willow has positively impacted every aspect of our lives! We try to take her everywhere possible. She sleeps with us, and she follows us everywhere we go! We couldn't be happier to share our home with her, and she is part of our family now."

Willow's adopters report that she has done very well adjusting to her permanent home; however, she does experience separation anxiety at times.

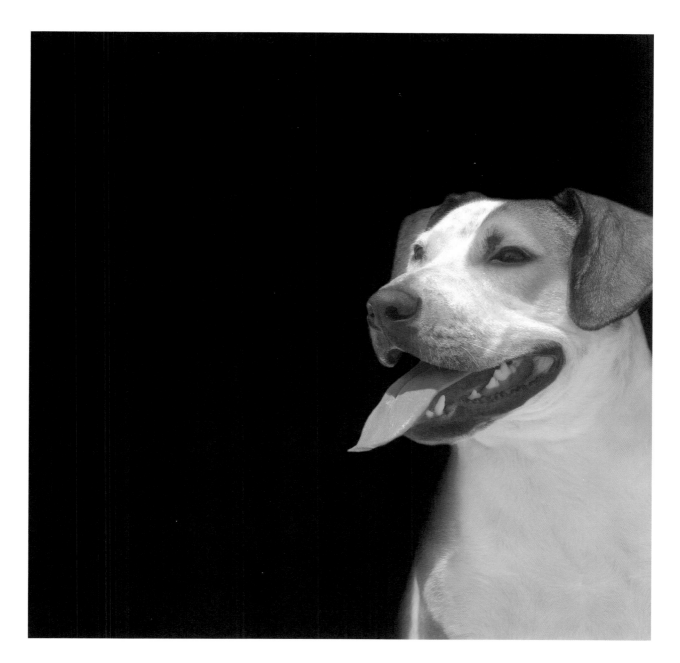

FIONA
WEST HIGHLAND WHITE TERRIER MIX, FEMALE, 8 YEARS, 2014
ADOPTED—74 DAYS IN THE RESCUE

In Spring 2014, Fiona was transferred from a shelter to a local Maryland rescue. The exact date and circumstances leading to her arrival at the shelter are unknown. At the time, rescue personnel estimated Fiona to be eight years old and reported no behavioral issues. In fact, the rescue noted that "Fiona loves people and attention!" However, their veterinary team noted that Fiona had a very bad skin condition. A flea infestation was left untreated and caused her to lose her hair. According to the rescue, "Over half of Fiona's skin was blood-red, and she spent eleven days at the emergency vet."

During her initial photo shoot, Fiona seemed happy and enjoyed being photographed.

After spending nearly three months in the rescue, Fiona was adopted on August 23, 2014. She was renamed "Bella" by her adopter.

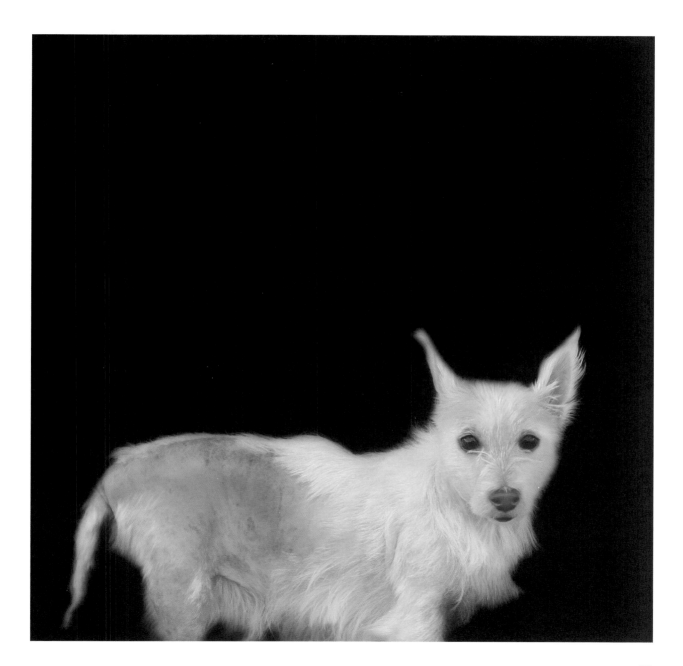

BELLA
WEST HIGHLAND WHITE TERRIER MIX, FEMALE, 9 YEARS, 2015

"Adopting a dog was the last thing my husband and I ever thought about doing. Both of us are in our seventies, and we thought having a dog would be too much responsibility. But now, we can't imagine our lives without Bella."

"We set out to rescue an older Bichon, but when we saw Bella at the dog rescue, she captured our attention."

"She has made remarkable progress and all of her fur has grown in; she looks like a totally different dog."

"Besides being a great companion dog, Bella makes us laugh all the time. We truly enjoy having her around and taking care of her."

According to Bella's adopter, she is prospering in her permanent home. Bella was anxious at first, but her adopter indicated she has adjusted very well to her new surroundings. Bella's adopter noted that she is very smart, loves attention, and has even gained a bit of weight since being adopted.

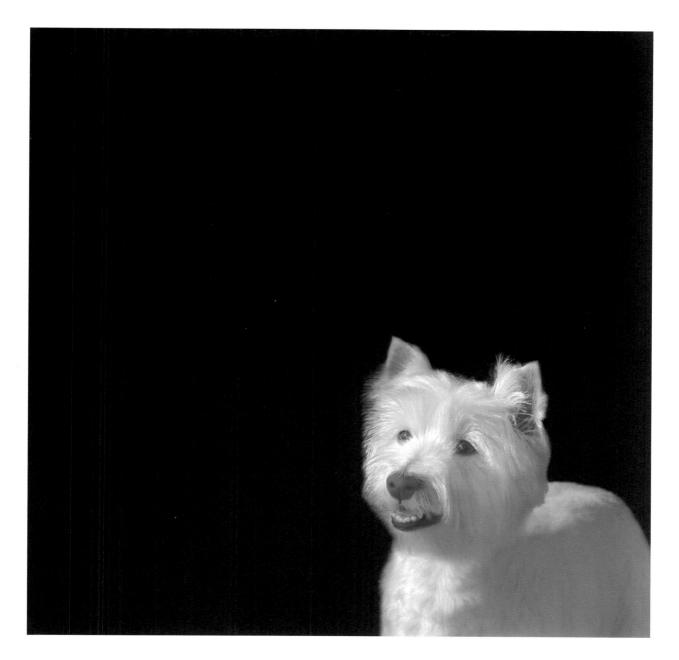

TRUCKER
I.D. # HUNWV-14-038-NM, SHEPHERD-HUSKY MIX, MALE, 1.5 YEARS, 2014
ADOPTED—63 DAYS IN THE RESCUE

In Winter 2014, Trucker was transferred from a shelter in West Virginia to a rescue in Maryland. The precise date and circumstances which led to him being placed in a shelter are unknown. At the time, rescue personnel estimated him to be approximately one and a half years old. Their veterinary team reported no health or behavior problems. The rescue noted that "Trucker is very sweet, and he loves to run and play. He is good with other dogs, cats, and kids, and he especially loves belly rubs."

During his initial photo shoot, Trucker was extremely easy to photograph as he gazed straight into the camera.

After spending approximately two months in the rescue, Trucker was adopted on April 5, 2014. Trucker's adopter renamed him "Townes."

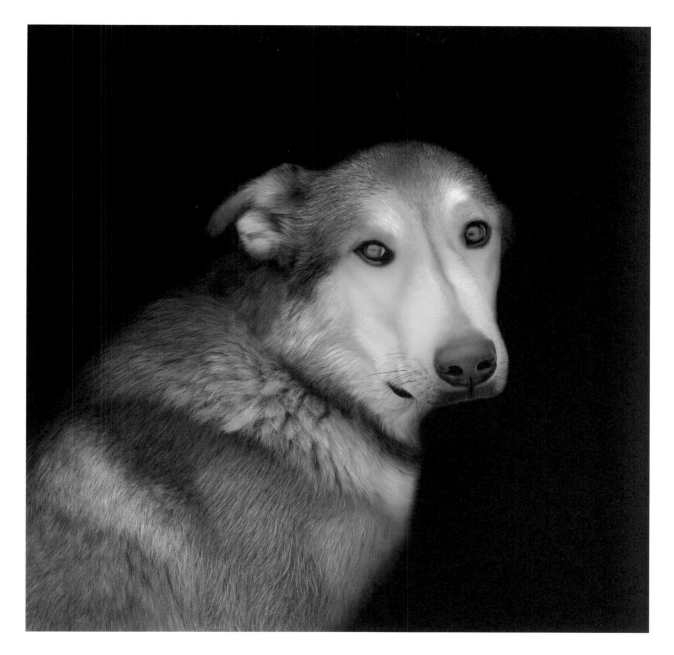

TOWNES
SHEPHERD-HUSKY MIX, MALE, 2 YEARS, 2014

"I feel a duty to rescue dogs and I have always had a good experience rescuing dogs in the past."

Townes' adopter decided to adopt him after losing a beloved dog to cancer. The family likes to have at least two rescue dogs at a time, and they wanted to find a new companion for their resident dog, Iko.

"When we met Townes, we could tell that he was a very kind dog, and he was also very handsome."

According to Townes' adopter, he is doing very well and is happy in his permanent home. "Townes is a funny guy who is a jokester. He loves jumping around the house and playing. He also gets along well with our ten-month-old daughter. I feel that I am doing my part by rescuing dogs. However, it is the dogs that are really doing us a favor." Most importantly, Townes' adopter reported, "I cannot imagine our life without dogs."

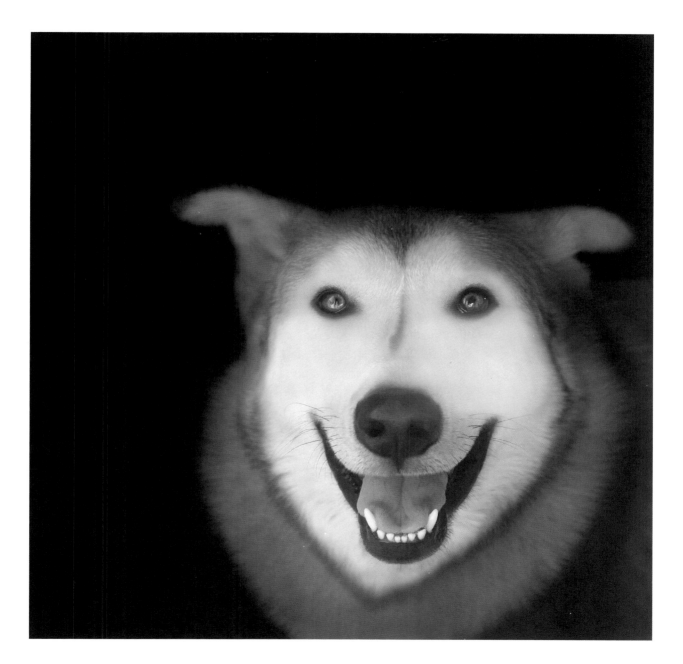

TOBY
I.D. # OSMD-11-223-NM, HOUND-SHEPHERD MIX, MALE, 8 YEARS, 2013
ADOPTED—1,216 DAYS IN THE RESCUE

In Summer 2011, Toby's owner surrendered him to a local Maryland rescue. The precise date and circumstances leading to his surrender this time are unknown. The rescue noted that Toby was previously adopted on two occasions for brief periods and was returned both times due to separation anxiety. At the time, rescue personnel estimated him to be approximately eight years old. Their veterinary team reported no health problems, but did note that Toby experienced anxiety. He was prescribed 40 mg. of Prozac per day for anxiety. Toby's medical file explained that his separation anxiety improved while taking the Prozac, but noted that Toby is a senior dog and does not always get along well with other dogs.

During his initial photo shoot, Toby was cooperative, calm, and very food-motivated!

Toby was adopted into his permanent home on February 24, 2015, after spending over a thousand days at the rescue. Toby's extended stay in the rescue is one of the longest waiting periods for a permanent home recorded in this project.

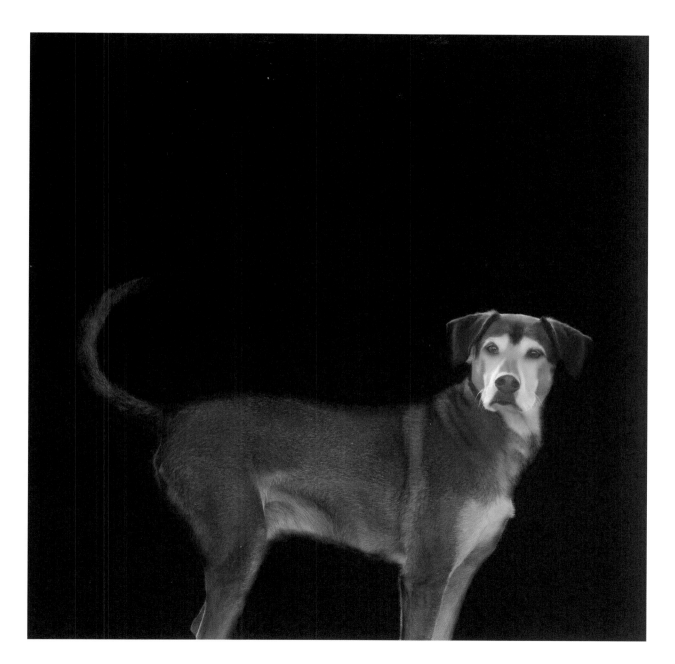

TOBY
HOUND-SHEPHERD MIX, MALE, 9 YEARS, 2015

"When Toby was living in foster care with his foster mom, Lindsey, I couldn't stop thinking about him for the two years after we adopted Camo, our other rescue dog. Camo was also a foster with Toby and Lindsey at the rescue. Even though we knew Toby required a bit more attention, because of his separation anxiety, we just felt pulled to him."

"He is so sweet, so precious, and such a joy. I couldn't bear the thought of him going another day without a home of his own. He has brought me so much happiness. I am sure Toby never had a doting stage mother, but he has got one now!"

"He's always excited and happy and he reminds me to appreciate everything, even the tiny things. I feel honored to be his Mommy and I'm so happy he's done so well since joining our pack!"

Importantly, according to Toby's adopter, "I feel so grateful that he is ours. I told Lindsey, Toby's foster mom, perhaps the reason that he wasn't adopted is because he was waiting on me! I love him."

According to Toby's adopter, he did very well in his permanent home. Toby was happy, spunky, obedient, sweet, affectionate, and loved to please. "We were told that Toby was anxious and may have separation issues, but we are not having any issues with that. We are home a lot, so he does not spend a lot of time alone."

Sadly, Toby passed away peacefully in a little garden during the summer of 2020, with birds chirping all around him on a beautiful, cool, Sunday morning.

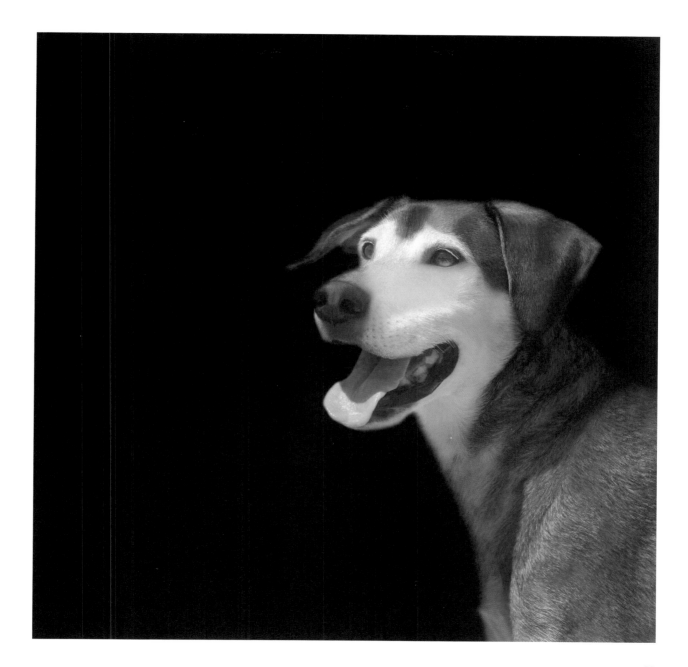

BENTLEY
I.D. # BACMD-13-445-MP, TERRIER-BOXER MIX, MALE, 2 MONTHS, 2013
ADOPTED—65 DAYS IN THE RESCUE

In Autumn 2013, Bentley and his sister, Lulu, arrived at a local Maryland rescue after being seized by Animal Control in the basement of an apartment building. Animal Control reported that it was unable to locate their mother or any other puppies where Bentley and Lulu were found. At the time, rescue personnel estimated Bentley and Lulu were approximately two months old. Their veterinary team reported no health or behavior problems. The rescue noted that both Bentley and Lulu required bottle-feeding and intensive care to survive. According to the rescue, "Bentley is a big teddy bear that grunts when he is picked up and hugs you and loves to snuggle. When you sit on the floor with Bentley, he immediately climbs into your lap for some loving. He also loves to play with his sister, Lulu."

During his initial photo shoot, Bentley was constantly on the move, rolling all around—a ball of energy!

After spending approximately two months in the rescue, Bentley was adopted on January 7, 2014.

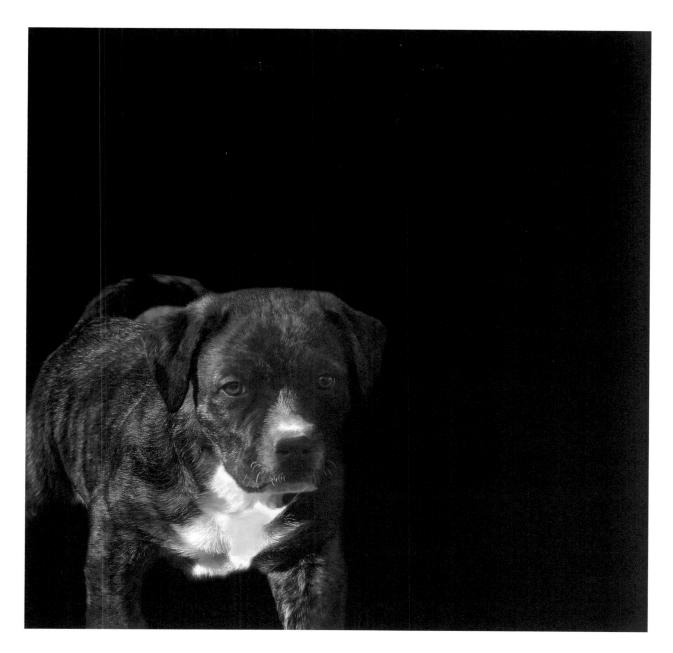

BENTLEY
TERRIER-BOXER MIX, MALE, 1 YEAR, 2014

"I wanted a large dog, and I saw Bentley's photographs, and liked his possible breed."

"Bentley is a great companion and a protector of my wife and I and our property." Importantly, according to Bentley's adopter, "Bentley has brought many laughs and smiles watching his antics and seeing him grow into the young dog he has become."

According to Bentley's adopter, he has transitioned well into his permanent home. Bentley listens well in the house to signs and voice commands. Additionally, Bentley is very playful and full of energy, an excellent guard dog, yet shows no signs of aggression. "However, outside, he has realized he can get away, and he decides what games to play!"

LULU
I.D. # BACMD-13-444-FP, TERRIER-BOXER MIX, FEMALE, 2 MONTHS, 2013
ADOPTED—63 DAYS IN THE RESCUE

In Autumn 2013, Lulu and her brother, Bentley, arrived at a local Maryland rescue after being seized by Animal Control in the basement of an apartment building. Animal Control reported that it was unable to locate their mother or any other puppies near where Lulu and Bentley were found. At the time, rescue personnel estimated Lulu and Bentley to be approximately two months old. Their veterinary team reported no health or behavior problems. The rescue noted that both Lulu and Bentley required bottle-feeding and intensive care to survive. According to the rescue, "Lulu loves to wag her tail and kiss you relentlessly. When she is in your arms, she wiggles her way up to your head and neck and kisses you repeatedly!" The rescue also noted that Lulu is very smart, and she is doing well with her house training. "As soon as she steps on the grass outside, she goes potty, and then chases her brother, Bentley!"

During her initial photo shoot, Lulu was constantly on the move and full of energy!

After spending approximately two months in the rescue, Lulu was adopted on January 5, 2014. Lulu's adopter renamed her "Hurley."

HURLEY
TERRIER-BOXER MIX, FEMALE, 1 YEAR, 2014

"We were interested immediately after reading Hurley's and her brother, Bentley's, story, and we couldn't wait to give Hurley a loving home and a great life."

Additionally, Hurley's adopter indicated that Hurley is very friendly, sweet, loving, protective, and she also knows many tricks, which she is proud to show off! "Rightfully so, she is completely spoiled, and we wouldn't have it any other way!"

"When my husband's mother became ill with cancer, Hurley would put her paw up on her bed, 'asking' if it was okay to jump up on the bed with my mother-in-law. After being given permission, she would gently lay down with my husband's mom and give her cuddles and kisses for hours. Hurley was therapeutic to my mother-in-law and the rest of our family during the difficult times."

"Hurley is such a huge part of our family! We all love her so much and couldn't imagine life without Hurley! She is a perfect fit!"

According to Hurley's adopter, she is doing fantastic in her new home and loves to cuddle. "She immediately fit right in with us. She seemed to have skipped over the 'puppy phase' and went right into being an excellent, trustworthy girl! She is so sweet and loving, and no matter where we take Hurley on our adventures, she has always gotten along great with everyone, including other dogs."

TREASURE
CHIHUAHUA-CHI MIX, FEMALE, 4 YEARS, 2014
ADOPTED—171 DAYS IN THE RESCUE

In Spring 2014, Treasure arrived at a local Maryland rescue after she was seized from a puppy mill in Pennsylvania. At the time, rescue personnel estimated her to be approximately four years old. Their veterinary team reported no health or behavioral issues. "Treasure is very untrusting of people at first, especially of men. Treasure would be a great companion for a single person who would love to dote on her," said the rescue.

During her initial photo shoot, Treasure was very gentle and shy.

After spending nearly six months in the rescue, Treasure was adopted on October 19, 2014. Treasure's adopter renamed her "Chessie."

CHESSIE
CHIHUAHUA-CHI MIX, FEMALE, 5 YEARS, 2015

"I saw Chessie on Facebook through the *Lutherville Patch*, and I knew I had to have her. We had never rescued a dog before. After seeing her on Facebook and seeing how many dogs needed a forever home, I knew that Chessie had to become ours."

Chessie's adopter reported that she is still wary of men. "In her past, men must have treated her badly. It was reported to us that she was rescued from a puppy mill and Chessie was used for breeding."

"She is a good friend to our two Chihuahuas and four cats. She has become part of the 'gang.'" Most importantly, "No words can express the sweetness of Chessie. She is playful and loving. Chessie is a joy!"

Overall, according to Chessie's adopter, she is doing very well in her permanent home. Chessie has slowly begun to become acquainted with her new Daddy. "It is funny how while in bed, she will sleep between the pillows between my husband and myself, and she will let my husband pet her without any fear. Yet, when my husband stands up, Chessie backs away."

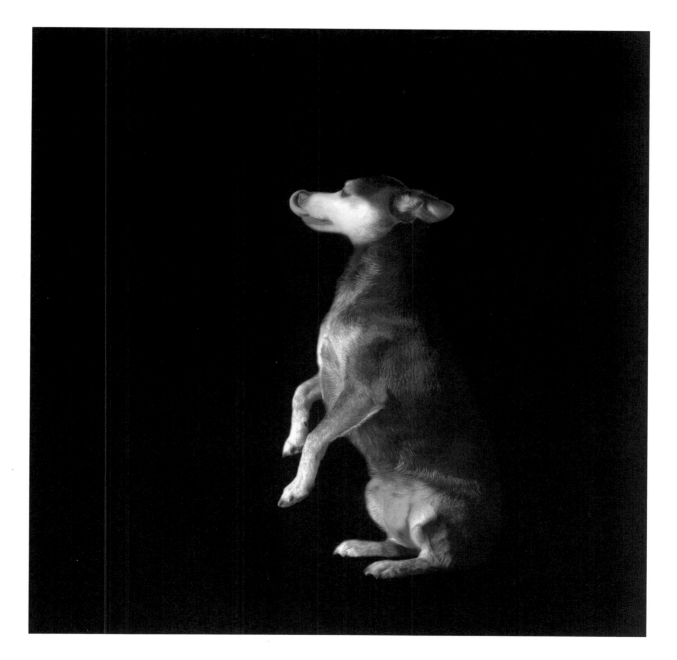

MAGGIE
CHOW-SHETLAND SHEEPDOG MIX, FEMALE, 15 YEARS, 2013
EUTHANIZED—1,298 DAYS IN THE RESCUE

In Winter 2010, Maggie was transferred from a shelter to a local Maryland rescue. The precise date and circumstances leading to her placement in a shelter are unknown. According to the rescue, a concerned citizen saw Maggie on the shelter's website and promptly informed a breed-specific rescue that Maggie was living at the shelter. At the time, rescue personnel estimated her to be fifteen years old. Their veterinary team reported that Maggie was severely malnourished and that her fur coat was very matted. It was later discovered, during subsequent veterinary visits, that Maggie had arthritis, which the rescue treated, and she was also blind. No behavioral issues were reported. According to the rescue, "Maggie has a wonderful temperament, and we fed her one heaping cup of food three times a day until we had put the weight, a healthy weight, back on her."

The rescue indicated that "Maggie is very gentle, and she loves people, dogs, and cats." According to the rescue, Maggie was an 'escape artist,' and escaped from the rescue on three occasions. According to the rescue, during one of Maggie's escapes, she was gone for nine consecutive days until she was found and returned. The rescue noted that Maggie stopped eloping as her mind slowly deteriorated.

"Maggie presently eats, but it takes her most of the day and night to finish her bowl of food. She no longer likes to be touched because it hurts her."

The rescue noted that Maggie, unfortunately, did not receive any adoption applications while she lived at the rescue for over three consecutive years. Maggie waited for a permanent home for nearly thirteen hundred days. Only one other dog in this project waited longer for a permanent home.

During her initial photo shoot, Maggie was very calm and smiled, but appeared very fragile. Maggie was euthanized on August 30, 2013.

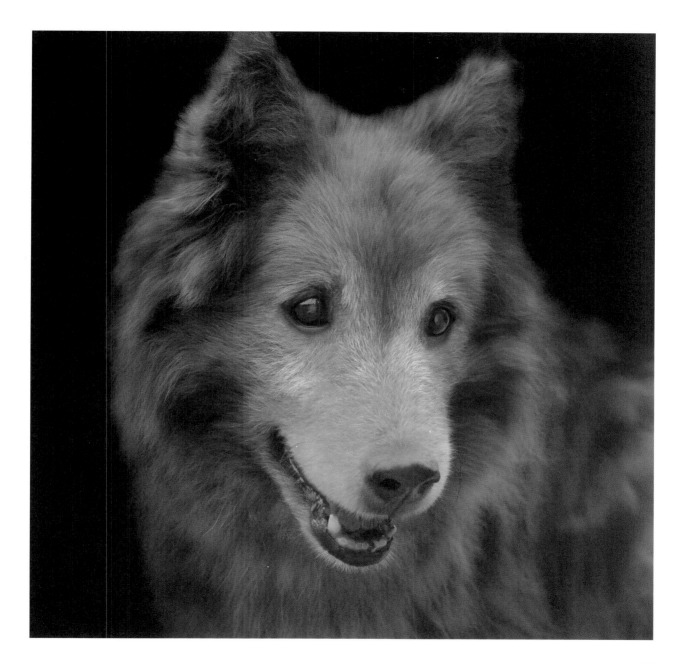

MAGGIE
CHOW-SHETLAND SHEEPDOG MIX, FEMALE, 15 YEARS
EUTHANIZED, AUGUST 30, 2013

Sadly, Maggie was euthanized on August 30, 2013. The primary reason the rescue provided for Maggie's euthanization was that "Maggie got confused and she was very uncomfortable after a veterinarian evaluation. At that time, it was determined that Maggie's quality of life was deteriorating rapidly, and it was determined that Maggie no longer had a good quality of life."

According to the rescue, "Maggie, at the end, was disoriented; she continually walked in circles, and she had arthritis throughout her entire body, causing her pain."

Dagwood
I.D. # APLIN-13-031-NM, Golden Retriever-Labrador Mix, Male, 2 years, 2013
Adopted—725 days in the Rescue

In Winter 2012, Dagwood arrived at a local Maryland rescue after he and his sister were found locked in an abandoned house in Indiana with no food or water. The precise date Dagwood arrived at the shelter in Indiana is unknown. The rescue speculated that "The owners likely moved away and just left them to die." At the time, rescue personnel estimated him to be approximately nine months old. Their veterinary team reported no health problems; however, the rescue noted Dagwood had separation anxiety. The rescue stated that Dagwood had been adopted once previously, but was returned due to his separation anxiety. The rescue noted that "Outside of Dagwood's anxiety, he is sweet with dogs, people, kids, and cats. He has some basic manners and walks well on a leash, and he loves to cuddle and be near people."

During his initial photo shoot, Dagwood was very calm, well-behaved, and was very easy to photograph.

After spending two years in the rescue, a nursing home in Maryland adopted Dagwood on January 6, 2014.

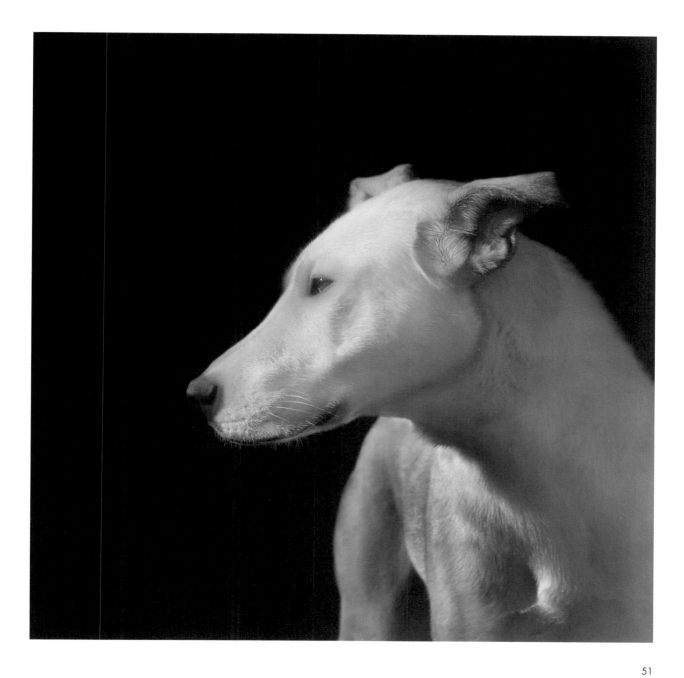

DAGWOOD
GOLDEN RETRIEVER-YELLOW LABRADOR MIX, MALE, 3 YEARS, 2014

"After a volunteer from the rescue brought Dagwood out for a visit, a special needs dog due to his fear and anxiety, we all let Dagwood run around outside and the manager, on behalf of the nursing home, decided to give it a try and see how the placement would go." After the trial period was completed, the nursing home adopted Dagwood without hesitation. According to a nursing home representative, Dagwood's rescue was the only rescue organization to entertain the idea of a business adopting a dog.

"Dagwood has come a long way over the past months, and he is happy and comfortable in his new home surrounded by his many 'grandparents!'"

"Dagwood still has some anxiety and takes a low dose of Prozac, which, unfortunately, lessens his food drive. Dagwood is not food, treat, or toy-motivated, so praise over time has been the best training technique employed with him."

"Everyone loves Dagwood at the nursing home. He is kind and loving to the residents, and he has his favorites that he likes to spend time with during the day. Dagwood is a constant friend and support for the residents, especially for those who do not have many friends or family that come to visit. Dagwood lights up the residents' day just by being himself!"

According to the nursing home representative, Dagwood is doing well as the "Resident House Dog" at the nursing home. Dagwood lives there full-time and has adjusted well to his surroundings—staff reported that Dagwood even sleeps near the front concierge desk each night!

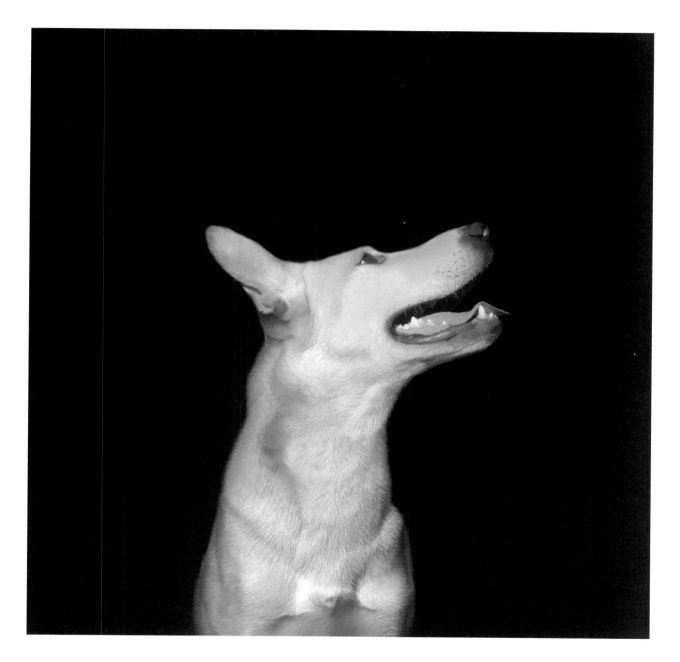

ABEL
I.D. # HUNW-14-081-NM, Golden Shepherd Mix, Male, 1 year, 2014
Adopted—22 days in the Rescue

In Winter 2014, Abel was transferred from a shelter in West Virginia to a local Maryland rescue. The precise date and circumstances leading to his placement in a shelter are unknown. At the time, rescue personnel estimated him to be approximately one year old. Their veterinary team reported no behavioral issues; however, Abel's medical file noted that he had a health condition: a double cryptorchid or "undescended testicles." Abel also had a portion of his ear bitten off by another dog, the result of an accident which occurred at the shelter in West Virginia. The rescue successfully treated both medical conditions and Abel made a full recovery.

During his initial photo shoot, Abel was very sweet, calm, and always looked directly into the camera.

After spending close to a month in the rescue, Abel was adopted on March 16, 2014. Abel was renamed "Cal" by his adopter.

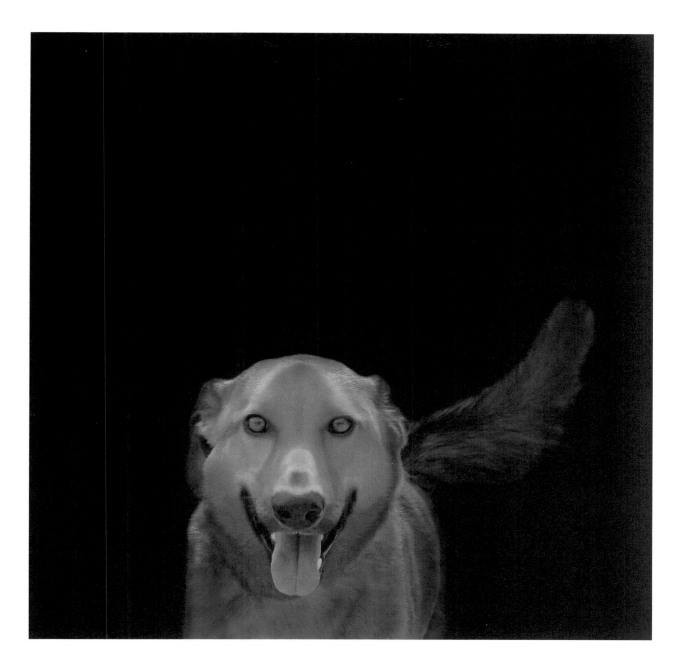

CAL
GOLDEN SHEPHERD MIX, MALE, 2 YEARS, 2015

"When I met Cal, he jumped right up on his hind legs and started licking me, so I knew he was the perfect fit, and he came home with me that day."

According to Cal's adopter, he is doing terrific in his permanent home. He is very relaxed and sleepy during the day, while his adopter is at work. "However, Cal perks up and shakes his butt with excitement, when he sees his human family members—an indication Cal knows it's time to play, go for a walk, and hang out."

His adopter also stated, "Cal has been such a great addition to our family. He has made us greatly appreciate the family time we spend together. Having him be so excited to see us, makes even the worst days so much better and he never ceases to make me smile or laugh with his goofy antics!"

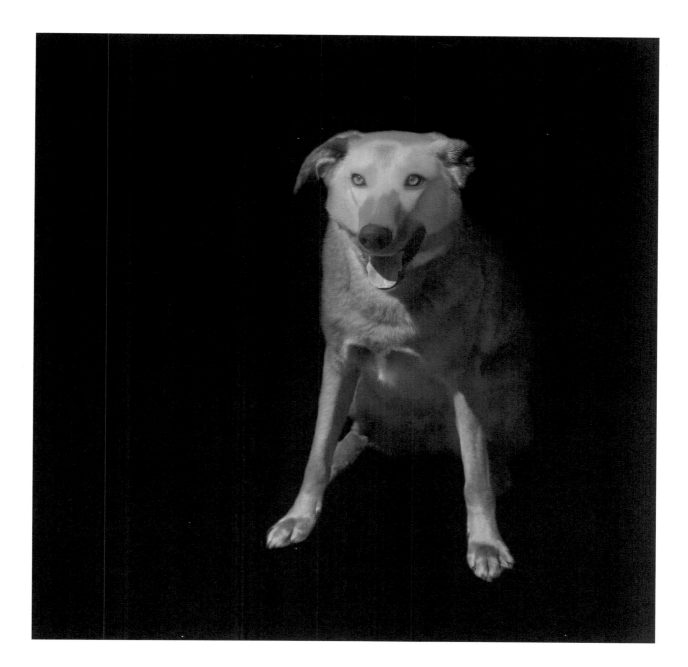

TEDDY RUXPIN
SHIH TZU-BRUSSELS MIX, MALE, 4.5 YEARS, 2014
ADOPTED—54 DAYS IN THE RESCUE

In Spring 2014, Teddy Ruxpin was transferred from a shelter in southern Virginia to a local Maryland rescue. The precise date and circumstances leading to his placement in a shelter are unknown. At the time, rescue personnel estimated him to be approximately four and a half years old. Their veterinary team did not report any health or behavioral issues. The rescue indicated that "Teddy Ruxpin is very sweet and high energy."

During his initial photo shoot, Teddy Ruxpin was challenging to photograph as he was constantly on the move!

After spending close to two months in the rescue, Teddy Ruxpin was adopted on June 15, 2014. Teddy Ruxpin was renamed "Teddy" by his adopter.

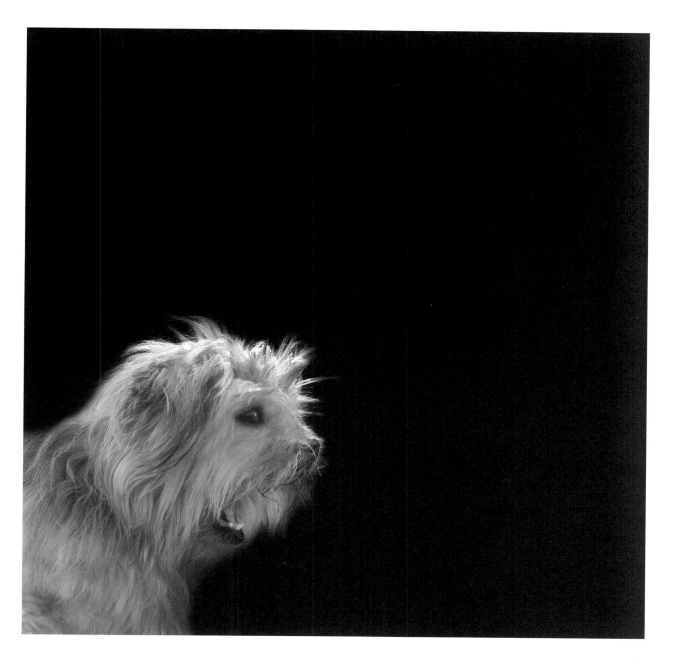

TEDDY
SHIH TZU-BRUSSELS MIX, MALE, 5.5 YEARS, 2015

"We found Teddy on the rescue's website, and I knew he was my dog. There was something so loving and wanting in his eyes, and I just knew we could give him exactly what he needed." Most of all, "I know I have a friend for life—it sounds really silly, but I get him! Although, this is not my first rescue dog, this is the first time I really understand the saying about who rescued whom."

According to Teddy's adopter, he is doing very well in his permanent home. Teddy is very loving and playful. "He follows me around the house, and he gets so excited to see me when I come home that he jumps from the ground right into my arms." However, since arriving at his new home, Teddy has bitten a few times, and his adopter is working with a private trainer to help alleviate the stress and anxiety Teddy clearly feels when new people are present. "It's not that he is a nasty or unfriendly dog, he has just been through a lot," according to Teddy's adopter. "Simply being around people who don't hurt him and being in a consistent environment has done wonders to calm him down."

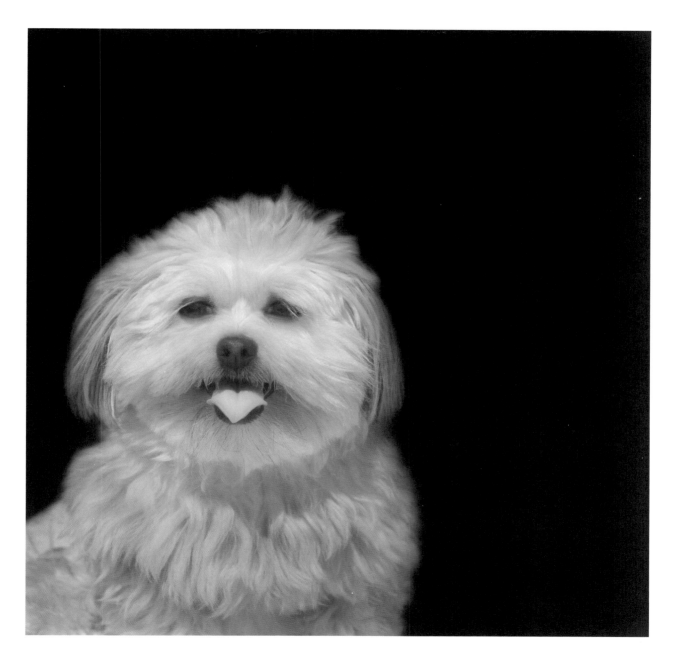

DENNISON
I.D. # HWHMO-14-052-NM, SHEPHERD MIX, MALE, 6 MONTHS, 2014
ADOPTED—138 DAYS IN THE RESCUE

In Winter 2014, Dennison was transferred from a shelter in West Virginia to a local Maryland rescue. The exact date and circumstances leading to his arrival in the shelter are unknown. At the time, rescue personnel estimated him to be approximately six months old. Their veterinary team reported no behavioral issues; however, Dennison's medical file indicated he had roundworm and whipworm, which were successfully treated. The rescue indicated that "Dennison needs another dog in the home; needs basic training for confidence and rehabilitation for shyness and fear, as he is stressed by loud noises and fast movements."

During his initial photo shoot, Dennison was very calm, kind, cooperative, and easy to photograph.

After approximately five months in the rescue, Dennison was adopted on July 4, 2014. Dennison was renamed "Denny" by his adopter.

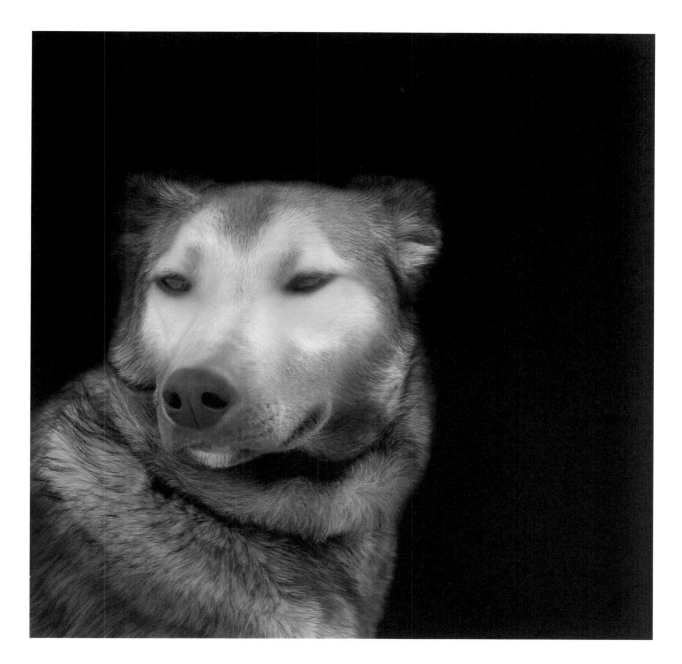

DENNY
SHEPHERD MIX, MALE, 1.5 YEARS, 2015

Denny's adopter lost their family dog several years ago and spent a long time looking for the "right" dog to adopt. Denny's adopter, who lives on a farm, fell in love with his photo on the rescue's website, and decided to go meet and adopt him. "The impact is more on the farm and the people that come to the farm daily. Everyone is enjoying him. He is a very entertaining dog. It is uncanny how he has fit right in and has some of the same habits as our old farm dog, including the places he likes to sleep and hang out in."

According to Denny's adopter, he has settled into his new home and family very well. Denny's family adores him, and he has had a tremendous impact on his adopters' lives. "Denny is the greeter when people arrive, and he will sometimes stand in the middle of the driveway and not let them by. Our former dog that passed away, Max, did the same thing. Everyone is happy to have a farm dog again. It has been four years, and I knew the right one would come along and somehow find us. He also gets along great with our Basset dogs and does a good job of keeping the young ones exercised!"

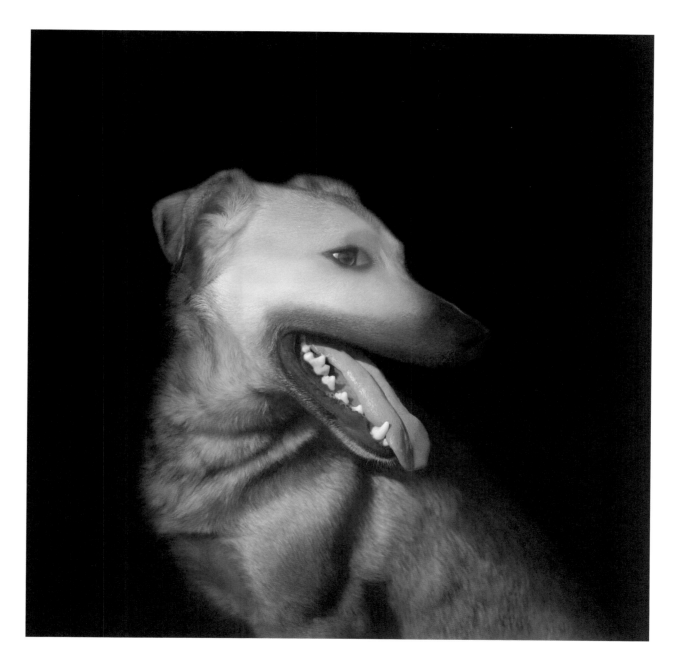

Darjeerling
I.D. # SEMO-13-437-SF, Saint Bernard, Female, 5.5 years, 2014
Adopted—210 days in the Rescue

In Autumn 2013, Darjeerling was transferred from a shelter in Missouri to a local Maryland rescue. According to the rescue, a man served jail time after abandoning six Saint Bernard dogs in the care of his frail, elderly parents, who were unequipped to care for these large dogs. The six dogs were forced to live in outside pens, which were muddy and filled with feces. The rescue also noted that all six dogs were bred at some point. Darjeerling was one of these forsaken dogs. Rescue personnel estimated Darjeerling to be approximately five and a half years old. Their veterinary team reported that she was heartworm positive, had orthopedic issues, a matted fur coat, and was not spayed. The rescue successfully treated Darjeerling for heartworm and orthopedic issues. The rescue indicated that "Darjeerling has a sweet disposition and needs an experienced owner with no other pets."

During her initial photo shoot, Darjeerling moved around constantly and tried to stay very close to her foster mom's side.

After seven months in the rescue, Darjeerling was adopted on May 25, 2014. Darjeerling was renamed "Honey" by her adopter.

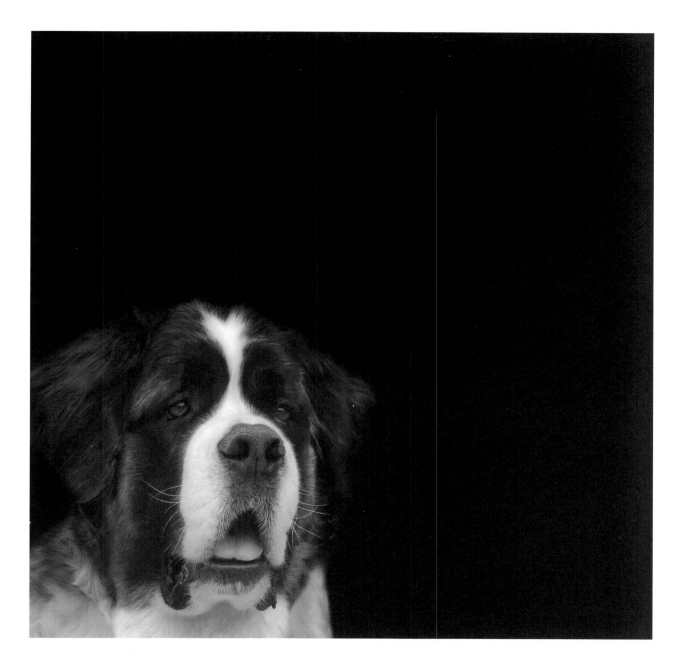

HONEY
SAINT BERNARD, FEMALE, 6.5 YEARS, 2015

"Honey is my greatest and most faithful companion who was by my side during my cancer treatments, from which I have made a full recovery."

"When neighbors or people drive by, and see Honey outside or on a walk, most people stop and tell me that she looks just like Beethoven from the film, *Beethoven!* People generally do not see too many Saint Bernards out and about, therefore making Honey stand out."

According to Honey's adopter, "Honey always wants to be by my side. She provides me with wonderful loyal companionship, love, and support."

Honey's adopter stated that she is doing well in her new home, which she guards with loud barks whenever she hears someone approaching the house. Honey initially had some health concerns, which her adopter successfully treated. Honey's adopter also reported that she goes to the spa each month for a bath along with manicure and pedicure treatments!

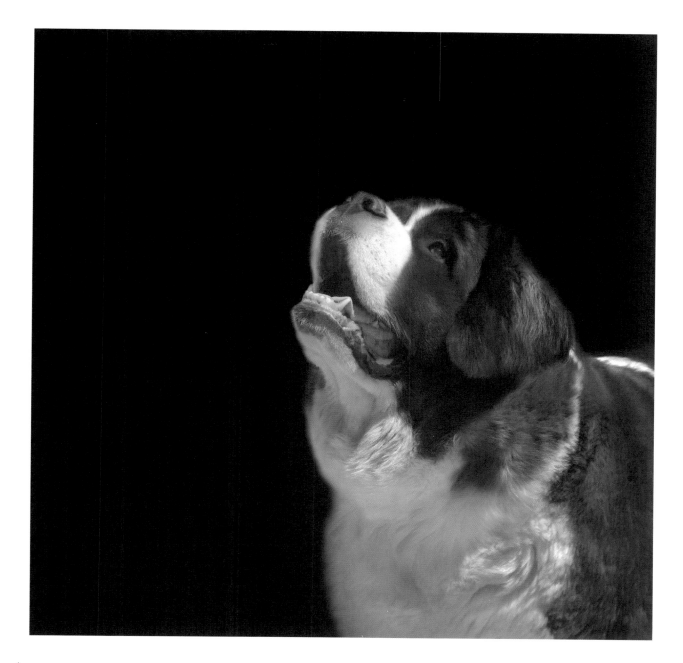

MERLOTTE'S TARA
I.D. # DHSLA-14-116-FP, GERMAN SHEPHERD MIX, FEMALE, 2.5 MONTHS, 2014
ADOPTED—51 DAYS IN THE RESCUE

In Winter 2014, Merlotte's Tara and her brother, Merlotte's Alcide, were transferred from a shelter in Louisiana to a local Maryland rescue. Merlotte's Tara's mother gave birth to her and her brother in a Louisiana shelter, which had been contaminated with distemper on various occasions. Consequently, both puppies were at high risk of dying in the shelter. At the time, rescue personnel estimated that Merlotte's Tara was a few months old. Their veterinary team reported no health or behavioral issues.

During her initial photo shoot, Merlotte's Tara posed extremely well for the camera.

After spending nearly two months in the rescue, Merlotte's Tara was adopted on April 28, 2014. She was renamed "Tara" by her adopter.

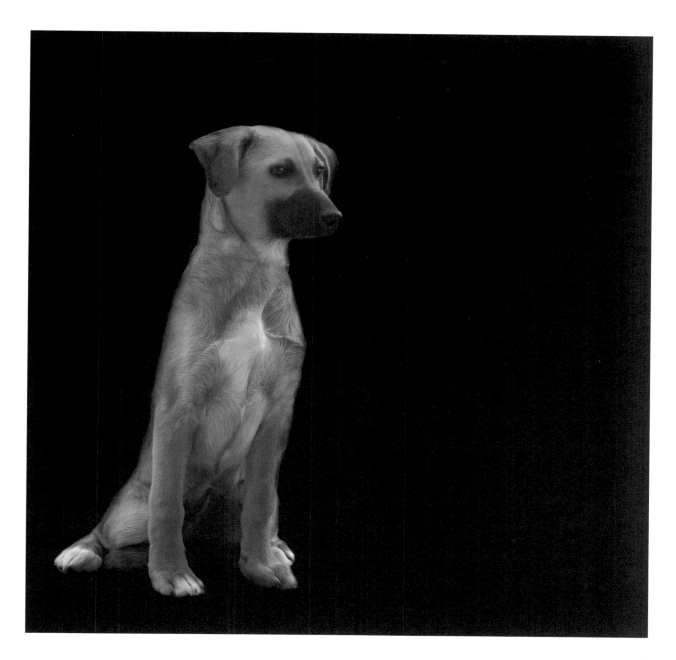

TARA
GERMAN SHEPHERD MIX, FEMALE, 1 YEAR, 2015

"I first learned of and saw Tara at her foster mom's house. Tara needed a home, and my other dog needed a playmate, so I decided to adopt her."

"Tara loves to speed race around the large backyard with her stuffed toys in her mouth, and she especially loves to throw her toys up in the air and catch them!" Tara's adopter also indicated, "Tara loves to dig holes in the backyard, as she often smells the voles and moles."

According to Tara's adopter, she is doing really well in her new home. "She is still a bit shy of strangers, but she loves other dogs, animals, and children."

Tara loves her adopter and the other animals that she shares a home with! Most of all, "She's a good dog, a good watch dog with her hearty bark, and she is wonderful company for me and my other dog."

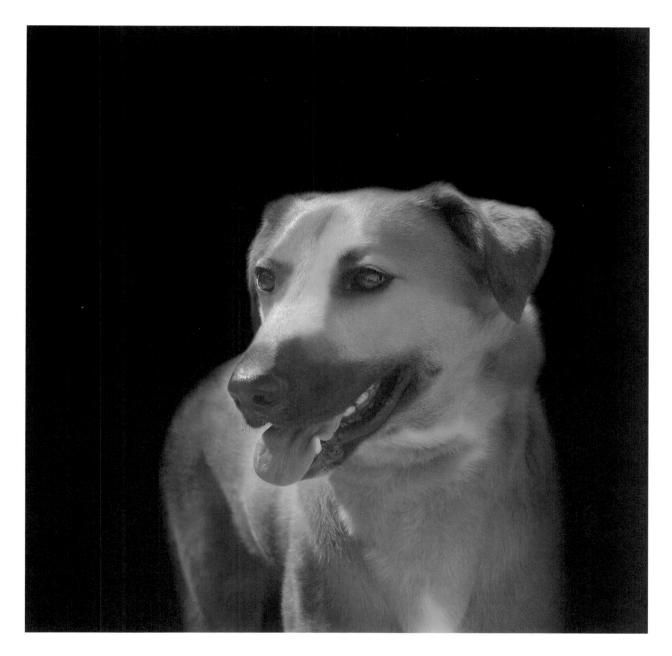

Merlotte's Alcide
I.D. # DHSLA-14-111-MP, German Shepherd Mix, Male, 2.5 months, 2014
Adopted—51 days in the Rescue

In Winter 2014, Merlotte's Alcide and his sister, Merlotte's Tara, were transferred from a shelter in Louisiana to a local Maryland rescue. Merlotte's Alcide's mother gave birth to him and his sister in a Louisiana shelter, which had been contaminated with distemper on various occasions. Consequently, both puppies were at high risk of dying in the shelter. At the time, rescue personnel estimated that Merlotte's Alcide was a few months old. Their veterinary team reported no health or behavioral issues. The rescue noted, "Merlotte's Alcide is shy and needs another dog in the home, as well as a patient adopter who is willing to socialize him."

During his initial photo shoot, Merlotte's Alcide posed extremely well for the camera.

After spending nearly two months in the rescue, Merlotte's Alcide was adopted on April 28, 2014. He was renamed "Alcide" by his adopter.

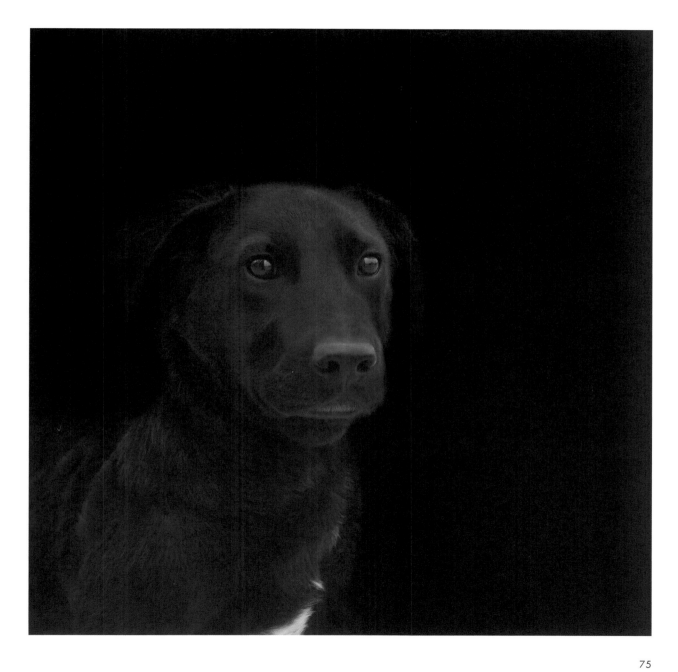

ALCIDE
GERMAN SHEPHERD MIX, MALE, 1 YEAR, 2015

"My husband saw Alcide's photo, and it was love at first sight."

"Once we adopted Alcide, I have had so much more responsibility, and it is amazing. There is always something for me to be doing for him."

"Also, it may sound kind of strange, but Alcide is someone I can talk to during the day. Alcide may be a boy, but he is like one of my girlfriends, and I don't feel alone when my husband is at work. Alcide is great company!"

According to Alcide's adopter, he has settled into his new home quite well. Alcide still has some anxiety around strangers, but he loves other dogs. Alcide is still quite young, and has a lot of energy. He loves to run and play off leash at a nearby field with the other neighborhood dogs. However, some days, according to his adopter, Alcide just wants to sleep all day!

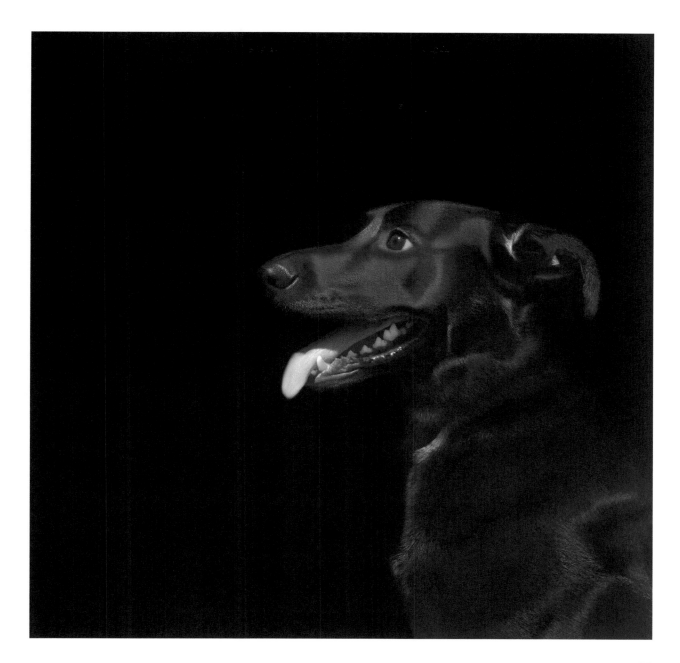

LAYNE
CHI-JACK RUSSELL-TERRIER MIX, MALE, 4 MONTHS, 2014
ADOPTED—46 DAYS IN THE RESCUE

In Spring 2014, Layne and his sister, Louis, were transferred from a shelter in Virginia to a local Maryland rescue. According to the rescue, the siblings were dumped at a gas station in southern Virginia, where an Animal Control officer picked them up and took them to a shelter. The shelter contacted the Maryland rescue and asked to transfer custody of these two young puppies because they were terrified while living in the shelter. At the time, rescue personnel estimated Layne to be approximately four months old. Their veterinary team did not report any health or behavioral issues. According to the rescue, "Layne is very sweet."

During his initial photo shoot, Layne was very cooperative and loved having his photo taken!

After nearly two months in the rescue on June 22, 2014, the same adopter gave Layne and his sister, Louis, a permanent home.

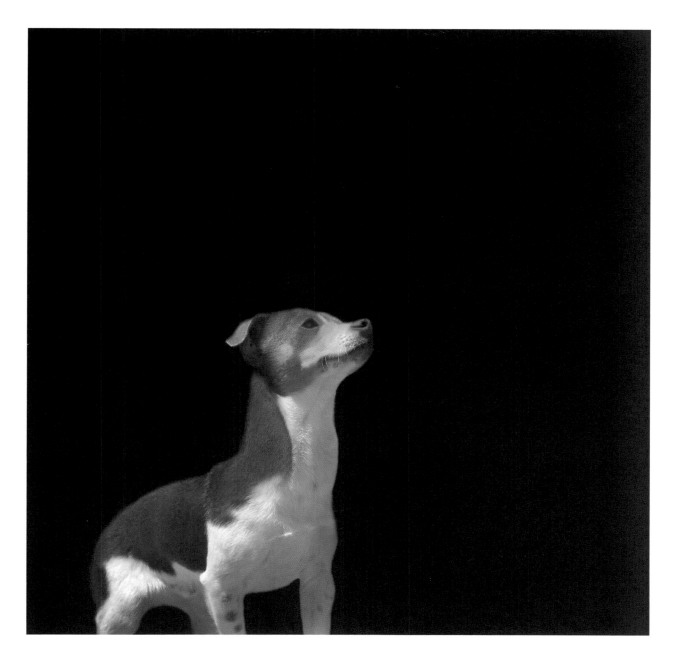

LAYNE
CHI-JACK RUSSELL-TERRIER MIX, MALE, 1 YEAR, 2015

"We had a dog that died suddenly of a brain tumor after being with us for six years. It was very hard on our family, and a friend told us to consider adopting another dog. At the beginning, we were not sure; however, we started looking at the dog adoption websites anyway. We saw the photographs of Layne and Lucy (nee Louis), and we just fell in love with them. We went to visit them, and we just loved them so much that we took them home."

The adopter indicated the rescue required Layne and Lucy be adopted together, which worked quite well for them. "Layne takes care of Lucy while we are gone during the day."

"They have definitely helped our family through the loss of our Chihuahua; they do not replace him, but they have brought us a lot of happiness, and we really love and enjoy them. They are part of the family."

According to his adopter, Layne and his sister have transitioned well into their permanent home. "He easily goes to new people, and he loves to be pampered!"

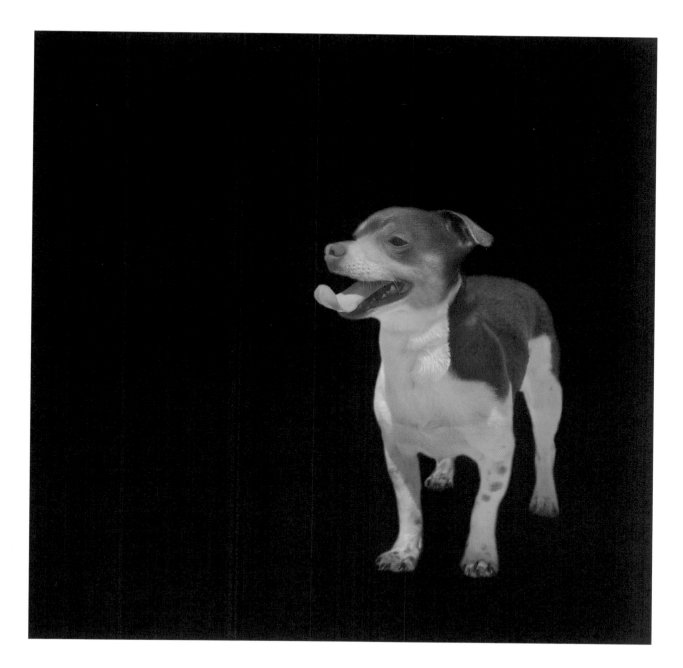

LOUIS
CHI-JACK RUSSELL-TERRIER MIX, FEMALE, 4 MONTHS, 2014
ADOPTED—46 DAYS IN THE RESCUE

In Spring 2014, Louis and her brother, Layne, were transferred from a shelter in Virginia to a local Maryland rescue. According to the rescue, the siblings were dumped at a gas station in southern Virginia, where an Animal Control officer picked them up and took them to a shelter. The shelter contacted the Maryland rescue and asked to transfer custody of these two young puppies because they were terrified while living in the shelter. At the time, rescue personnel estimated Louis to be approximately four months old. Their veterinary team did not report any health or behavioral issues. According to the rescue, "Louis is very sweet."

During her initial photo shoot, Louis was very cooperative and loved having her photo taken!

After nearly two months in the rescue on June 22, 2014, the same adopter gave Louis and her brother, Layne, a permanent home. Louis was renamed "Lucy" by her adopter.

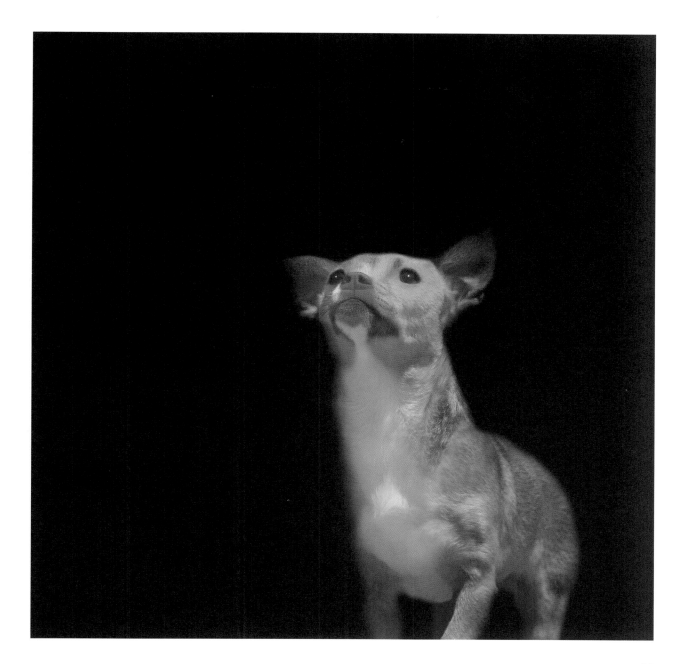

LUCY
CHI-JACK RUSSELL-TERRIER MIX, FEMALE, 1 YEAR, 2015

"We had a dog that died suddenly of a brain tumor after being with us for six years. It was very hard on our family, and a friend told us to consider adopting another dog. At the beginning, we were not sure; however, we started looking at the dog adoption websites anyway. We saw the photographs of Lucy and Layne, and we just fell in love with them. We went to visit them, and we just loved them so much that we took them home."

The adopter indicated that the rescue required Lucy and Layne be adopted together, which worked out quite well for them. "Lucy takes care of Layne while we are gone during the day."

"They have definitely helped our family through the loss of our Chihuahua; they do not replace him, but they have brought us a lot of happiness and we really love and enjoy them. They are part of the family."

According to her adopter, Lucy and her brother have transitioned well into their permanent home. Lucy's adopter indicated that "She appears to be the more mature of the two dogs!"

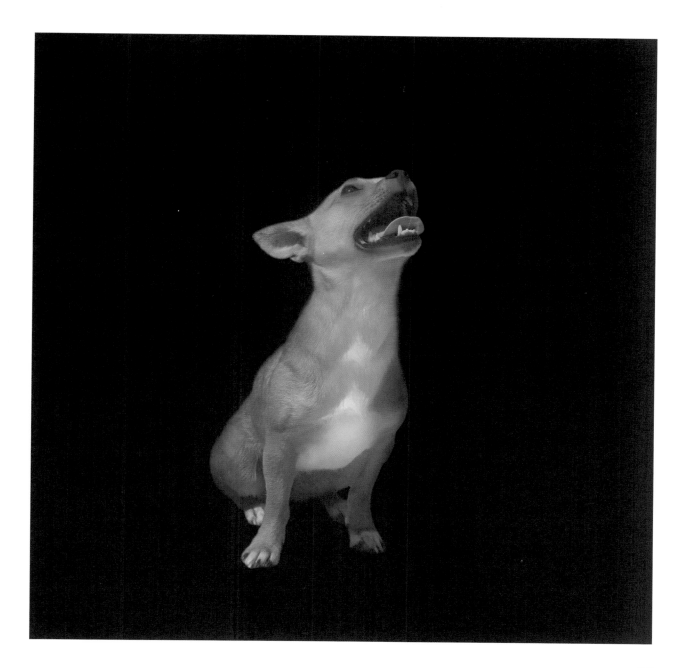

MILLIE
I.D. # A19841793, Terrier-Pit Bull Mix, Female, 7 years, 2013
Euthanized—44 days in the Shelter

In Spring 2013, Animal Control seized Millie from an undisclosed property in Maryland and placed her in a local shelter. At the time, shelter personnel estimated her to be about seven years old. Their veterinary team reported no behavioral issues. However, Millie's medical file noted that she came to the shelter with burn marks on her body and had discharge oozing out of both eyes, likely from an infection.

During her initial photo shoot, Millie was very shy and timid, but kind. It was apparent that she did not feel comfortable being out of her cage at the shelter.

Millie spent a month and a half at the shelter, where she was euthanized on June 20, 2013.

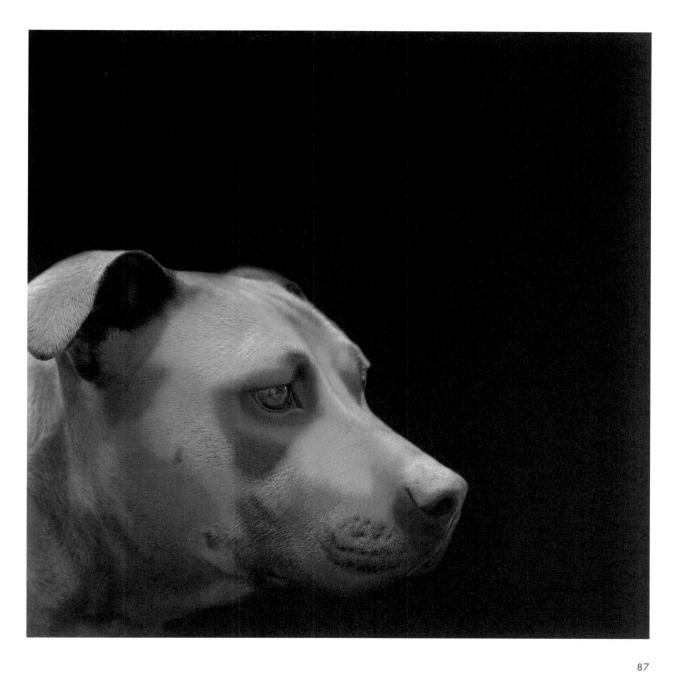

MILLIE
I.D. # A19841793, TERRIER-PIT BULL MIX, FEMALE, 7 YEARS
EUTHANIZED, JUNE 20, 2013

Sadly, Millie was euthanized at the shelter on June 20, 2013. The need for more space at the shelter was the primary reason shelter staff provided for Millie's euthanasia. The second reason provided by the shelter was that "Millie had been withdrawn and aloof in her cage, and she later growled at the veterinarian."

TRIXIE
I.D. # HUNWV-14-141-SF, AUST. SHEPHERD-WIREHAIRED MIX, FEMALE, 2 YEARS, 2014
ADOPTED—30 DAYS IN THE RESCUE

In Winter 2014, Trixie was transferred from a shelter in West Virginia to a local Maryland rescue. The precise date and circumstances leading to Trixie's arrival at the shelter are unknown. According to the shelter, Trixie was kept outside with another dog, neglected, and not fed by her owner throughout the cold and snowy winter of 2014. A neighbor helped these dogs by placing food outside their kennels. Reports indicate local police were called about the owner's treatment of Trixie and the other dog she lived with; however, the police never took any action. Rescue personnel estimated Trixie to be approximately two years old. Their veterinary team did not report any health issues. However, the rescue noted, "Trixie has mild separation anxiety and barks when left alone. Trixie prefers to be with people, and she does not like dogs to be too close to her face."

During her initial photo shoot, Trixie posed well for the camera; however, she was quite shy and wanted to remain close to her foster mom.

After spending a month in the rescue, Trixie was adopted on April 14, 2014. She was renamed "Iris" by her adopter.

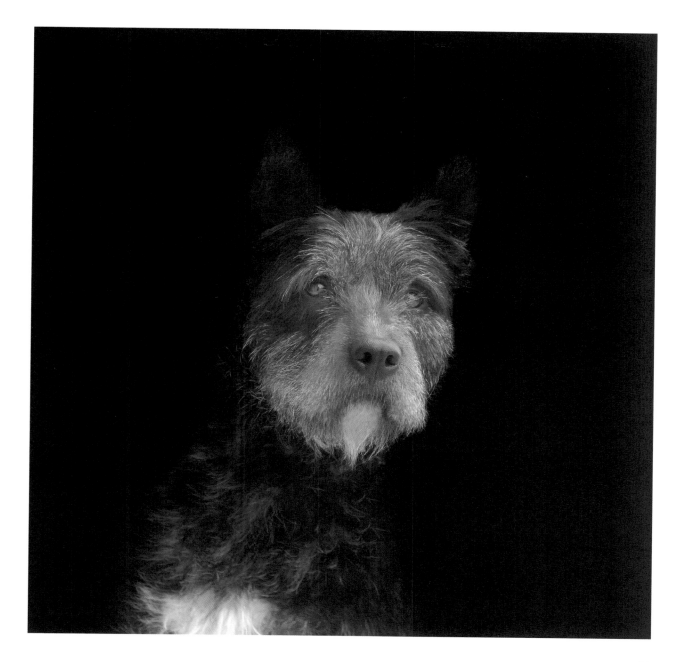

Iris
Australian Shepherd-Wirehaired Mix, Female, 3 years, 2015

"My wife was taken with her just from her photographs, showing her shaggy Schnauzer look and her sad brown eyes."

Iris' adopters indicated that they really love dogs. They had lost their longtime canine companion the previous year, and were searching for a dog to welcome into their home. "We knew we wanted a big dog for our family."

According to Iris' adopter, she is making great strides and fits right into her permanent home. "She was so shy and cautious at the start, and she took a while to open up and play. But now, she spends her days running and playing around our farm, taking her lunches with the farm crew, and cuddling with us at the end of the day."

Iris' adopter later learned she suffers from a low-grade heart murmur, which has not appeared to slow Iris down at all. Iris' adopter noted that "She is the bounce in our family's step. She is exuberant, motivating, and very loving. It's been such a pleasure to watch Iris' confidence grow and to be part of her crew. She looks great!"

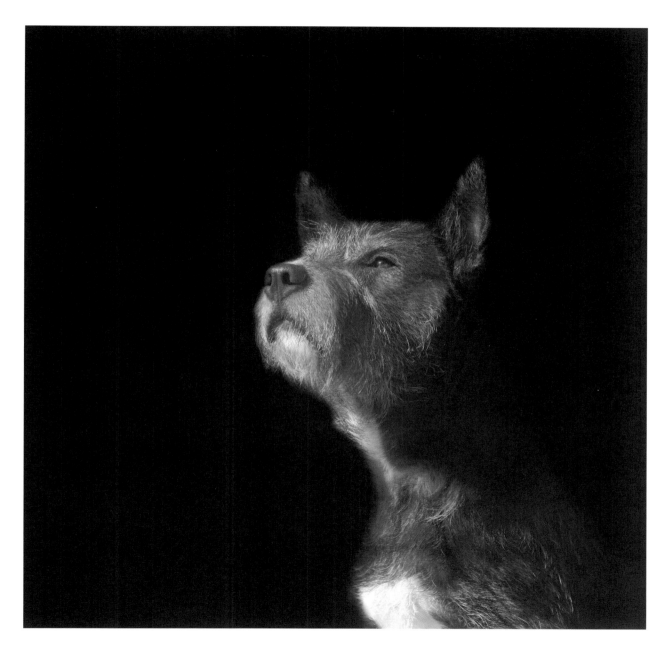

CLOONEY
PUG, MALE, 1.5 YEARS, 2014
ADOPTED—77 DAYS IN THE RESCUE

In Summer 2014, Clooney was transferred from a shelter in West Virginia to a local Maryland rescue. The exact date and circumstances leading to his arrival in the shelter are unknown. At the time, rescue personnel estimated him to be about one and a half years old. Their veterinary team did not report any health or behavioral issues. According to the rescue, "Clooney is very sweet and loving and his tongue is always hanging out!"

During Clooney's initial photo shoot, he was very easy to photograph. He was adorable with his tongue constantly hanging out of his mouth!

After spending approximately two and a half months in the rescue, Clooney was adopted on October 30, 2014.

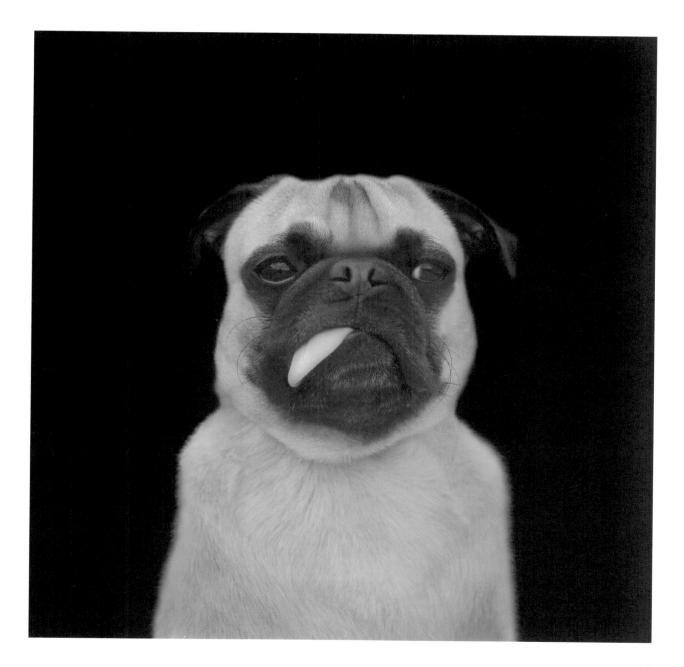

CLOONEY
PUG, MALE, 2.5 YEARS, 2015

"We have young kids, and we wanted a young, energetic dog to keep up with our family. We needed a dog that liked kids, and we wanted a younger dog with few health problems—we didn't want our children to have to experience the death of another dog anytime soon."

"Clooney has brought our family great joy. My son, age two, won't go to sleep at night until he has given Clooney a good night hug. Our entire family is smitten. Nothing seems bad when you look at that goof ball's face with the tongue hanging out. He's always happy and either wants to play or snuggle in someone's lap. He's a great addition to our family."

According to Clooney's adopter, he has adjusted very well to his permanent home. "Clooney is happy, excited, calm, and not anxious."

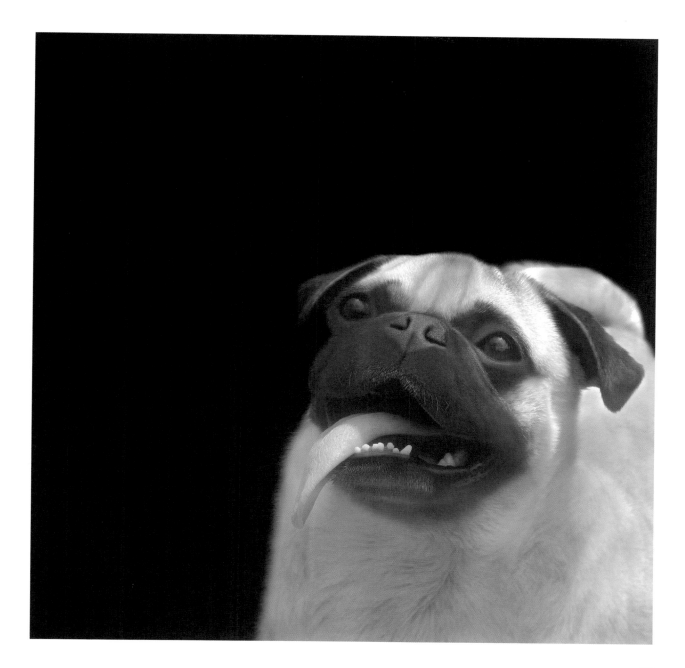

BEANS
BOSTON TERRIER, MALE, 6 YEARS, 2014
ADOPTED—70 DAYS IN THE RESCUE

In Spring 2014, Beans was transferred from Missouri to a local Maryland rescue. The rescue reported that Beans, along with several other dogs, was seized from an Amish puppy mill. The rescue reported that Beans spent the early years of his life in a cage in an environment devoid of human kindness. At the time, rescue personnel estimated Beans to be approximately six years old. Their veterinary team did not report any health or behavioral issues. According to the rescue, "Beans is a very shy and timid little guy that is afraid of people. He is getting a little better; however, he still needs a lot of patience so he can continue to become the dog he was meant to be."

During his initial photo shoot, Beans was quite shy; it was evident that he had a gentle soul.

After spending approximately two months in the rescue, Beans was adopted on June 11, 2014.

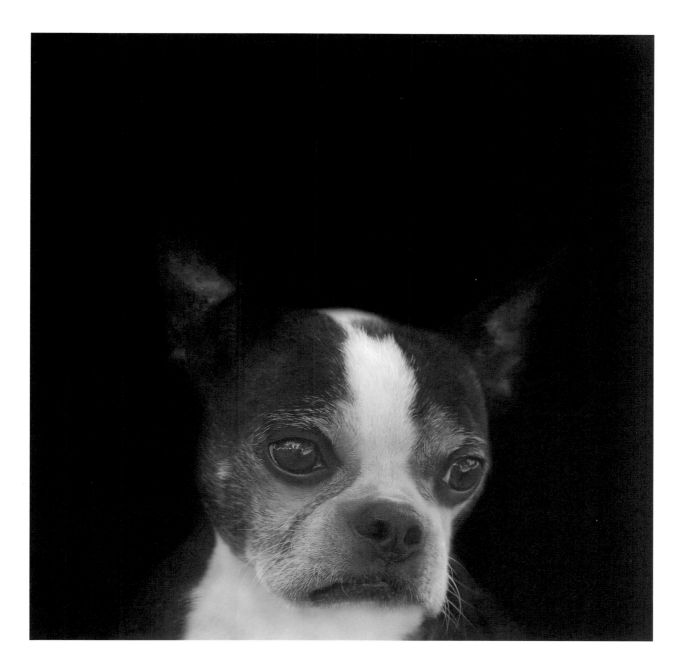

BEANS
BOSTON TERRIER, MALE, 7 YEARS, 2015

"Beans needed a good home, and I am very glad that we were the family he came to. He really needed a lot of love and special care, but we have been able to give him that, and I think he's much happier now than when we first got him."

"Beans has integrated nicely into our family—and I think he welcomes the opportunity to be part of a real family and to have people around him who love him."

According to Beans' adopter, he has adjusted very well to his permanent home. Beans is a very loving little dog who wants to be included in family activities. Beans continues to recover from fear issues after the trauma of a puppy mill experience. His adopter reported that Beans has become more involved in playful and affectionate activities. "He has come out of his shell quite a bit since adopting him and he is able to frequently interact with people without the awful fear reactions Beans previously experienced; and he is progressing nicely and seems to be a much happier little guy in general than he was when he first came to us."

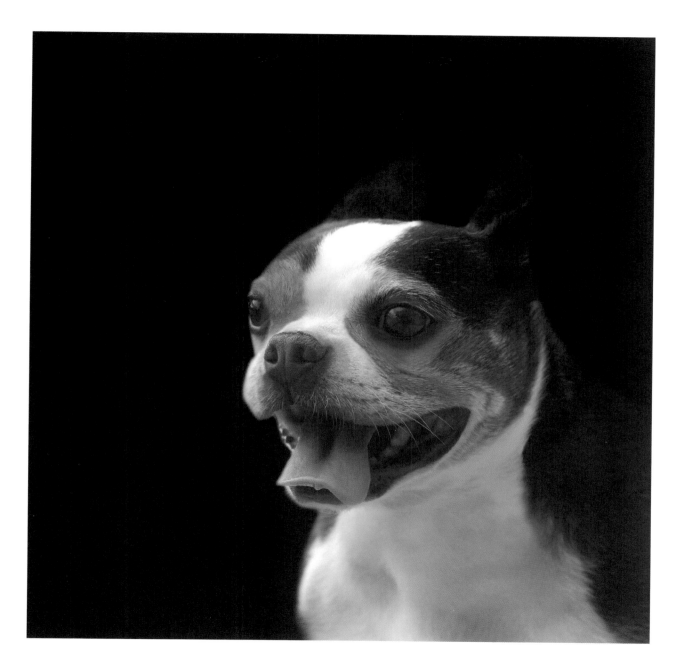

MINERVA
I.D. # HUNWV-13-272-SF,
GREAT DANE-BLACK LABRADOR MIX, FEMALE, 1.5 YEARS, 2014
ADOPTED—256 DAYS IN THE RESCUE

In Summer 2013, Minerva was transferred from a shelter in West Virginia to a local Maryland rescue. The precise date and circumstances leading to her placement in a shelter are unknown. At the time, rescue personnel estimated her to be approximately one and a half years old. Their veterinary team did not report any behavioral issues; however, Minerva's medical file noted that she came to the rescue heartworm positive, which the rescue successfully treated. The rescue noted that Minerva was previously adopted, but was returned for unknown reasons prior to her adoption being finalized. The rescue noted, "Minerva is high energy and loves people."

During Minerva's initial photo shoot, she exhibited very high energy levels and really enjoyed being in front of the camera.

After nearly a year in the rescue, Minerva was adopted on March 2, 2014. Minerva was renamed "Murphy" by her adopter.

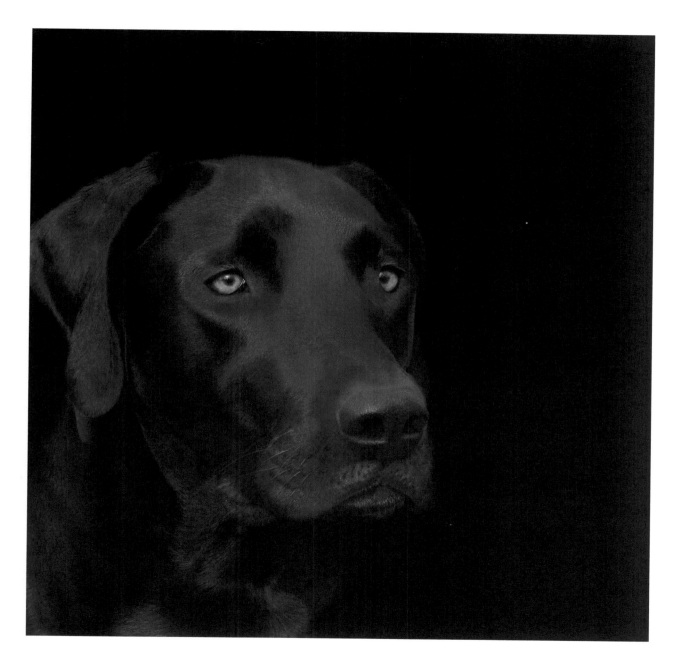

MURPHY
GREAT DANE-BLACK LABRADOR MIX, FEMALE, 2.5 YEARS, 2015

Murphy's adopter searched online for a dog to rescue after losing a beloved family pet, and was smitten after seeing her photograph online: "Murphy's face looked like a black version of a yellow lab we had just lost, and we were drawn to her."

"Murphy is very good, happy, loves her KONG toy filled with peanut butter, loves to lay in the sun and watch family members, and enjoys long walks with her dad."

"Murphy has provided more exercise for us. She is big enough for everyone to love, and it feels like we have had her forever!"

"By adopting Murphy, we have the satisfaction of saving an unwanted dog, thereby creating a positive impact for our entire family."

According to Murphy's adopter, Murphy is doing well in her permanent home. Murphy's adopter also said she is the best security system one could have, and that she is strong as an ox. "Murphy is a wonderful dog, and she moved right in and made herself comfortable. She has taken to sleeping in the bed, which is like having a third person in bed, and she hogs the blankets!"

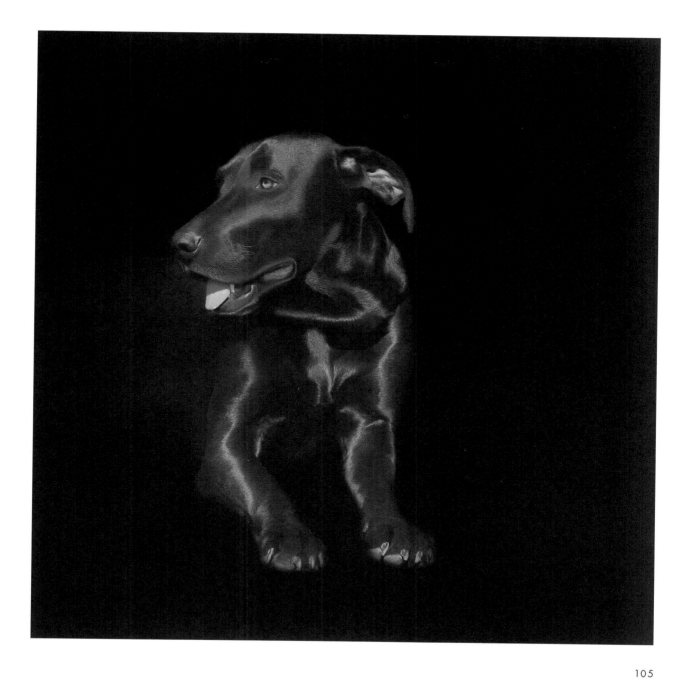

EDMONT
I.D. # HUNWV-13-431-NM, YELLOW LABRADOR MIX, MALE, 1 YEARS, 2014
ADOPTED—134 DAYS IN THE RESCUE

In the Autumn of 2013, Edmont was transferred from a shelter in West Virginia to a local Maryland rescue. The precise date and circumstances leading to his arrival in a shelter are unknown. At the time, rescue personnel estimated him to be approximately one year old. Their veterinary personnel noted that Edmont was successfully treated for hookworm, whipworm, and allergies. Additionally, due to Edmont's high energy levels, the rescue recommended that he be placed in a home with children older than five years of age. The rescue also indicated that Edmont was adopted previously, but was returned when his adopter lost his job and was no longer able to care for him.

During the initial photo shoot, Edmont's high energy levels made him challenging to photograph.

After about five months in the rescue, Edmont was adopted on March 23, 2014. Edmont was renamed "Eddie" by his adopter.

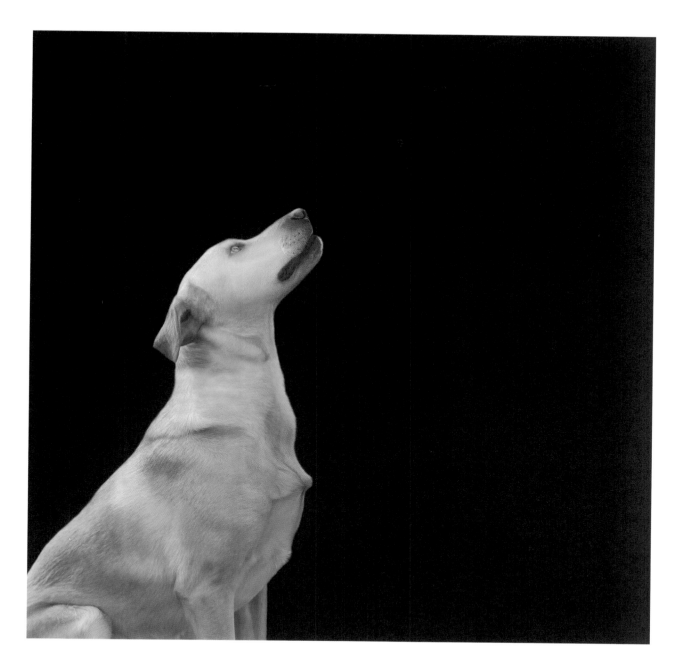

EDDIE
YELLOW LABRADOR MIX, MALE, 2 YEARS, 2015

"We wanted an energetic dog to play with our resident dog, and Eddie fit the bill!"

"Eddie's hallmark is that he wags his tail from the collar back, in a front to back motion!"

"Eddie is exceedingly friendly and playful, and very energetic with other dogs. When we have company, children included, Eddie accepts them and licks them! We love him dearly; he is an important part of our family."

According to Eddie's adopter, he is doing very well in his permanent home. "Eddie and our other dog constantly play together in their large fenced-in backyard! And Eddie appears to be the dominant one of the two dogs!"

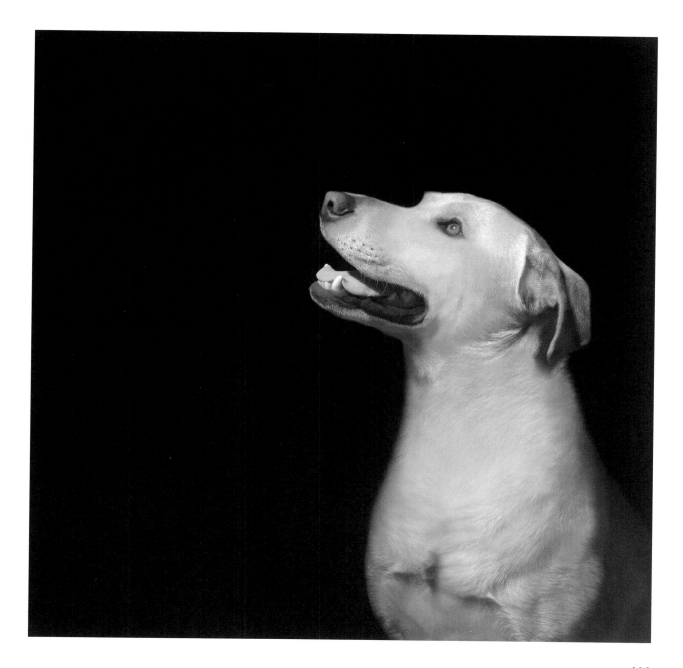

REY
I.D. # HUNWV-14-094-NM, ROTTWEILER MIX, MALE, 6 MONTHS, 2014
ADOPTED—40 DAYS IN THE RESCUE

In Winter 2014, Rey was transferred from a shelter in West Virginia to a local Maryland rescue. The precise date and circumstances leading to Rey's arrival in a shelter are unknown. At the time, rescue personnel estimated he was approximately six months old. Their veterinary team indicated Rey was successfully treated for roundworm and reported no behavioral issues.

During his initial photo shoot, Rey was very cooperative and posed very nicely for the camera.

After a little over a month in the rescue, Rey was adopted on April 11, 2014. Rey was renamed "Rocky" by his adopter.

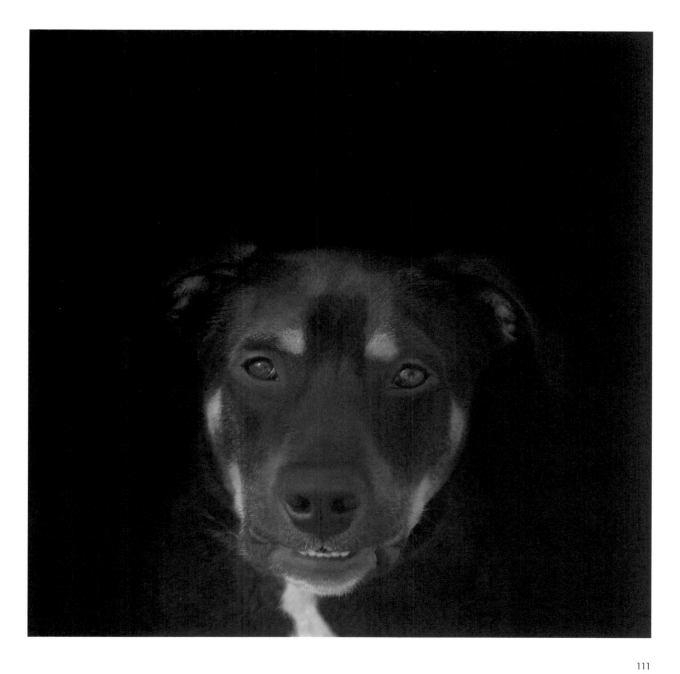

ROCKY
ROTTWEILER MIX, MALE, 1.5 YEARS, 2015

"On Sunday, April 5, 2014, my husband and I went to a dog rescue event at a car dealership located in Glen Burnie, Maryland. I just happened to see the event listed online that morning and we decided to go and see what it was all about. When we saw Rocky, my husband and I were so taken with how friendly he was. When I bent down to pet Rocky, his immediate response was to lick my face. It was such a loving response, and we knew he was the one."

"He is extremely loving and affectionate to our family and he is very, very friendly to strangers as well."

Most importantly, "Rocky wants to be with us all the time and he shows us nothing but love."

According to Rocky's adopter, he has a wonderful disposition and is thriving in his new home. Rocky's adopter indicated that he is the most expressive dog they have ever seen, along with being extremely intelligent. "When he sees my husband put on his baseball cap, Rocky recognizes this as a signal that he is going for a walk. He then begins to whine, and it sounds like he is talking, and he goes to the closet where his leash is kept."

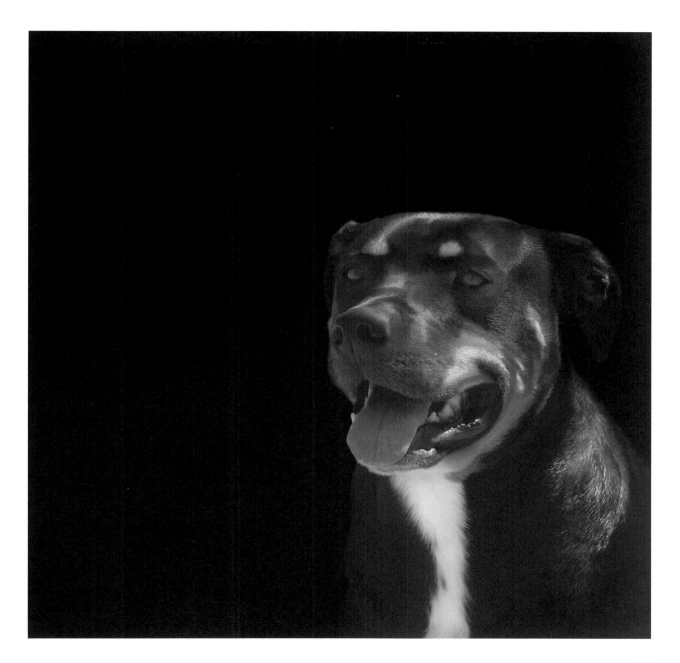

MELLO
CORGI MIX, MALE, 4 YEARS, 2014
ADOPTED—125 DAYS IN THE RESCUE

In Summer 2013, Mello was transferred from a shelter in Maryland to a local Maryland rescue. The exact date and circumstances leading to Mello's placement in the shelter are unknown. At the time, rescue personnel estimated he was approximately four years old. Their veterinary team did not report any health or behavioral issues. The rescue noted that Mello was originally adopted during the winter of 2013, but he was returned to the rescue approximately six months later. Mello was adopted, again, during the summer of 2014. However, the rescue rescinded the adoption agreement during the spring of 2015, when it discovered Mello was forced to live in the basement of his adopter's home and was receiving poor care and little attention. According to the rescue, "Mello is friendly, sweet, and probably a bit traumatized from living in a neglectful home."

During his initial photo shoot, Mello was happy, cooperative, and enjoyed having his photograph taken.

After several unsuccessful adoptions, and a total of nearly four months in the rescue, Mello was officially adopted on June 21, 2015.

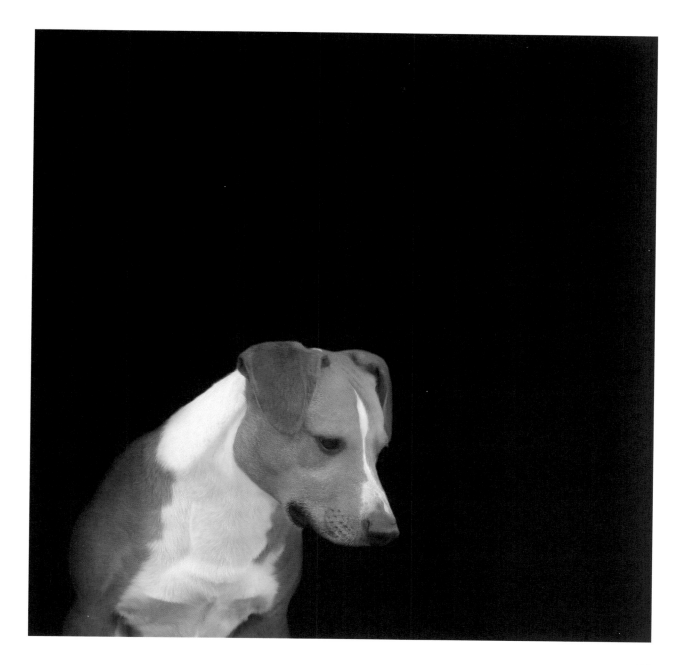

MELLO
CORGI MIX, MALE, 5 YEARS, 2015

"I fell in love with Mello since I had first seen his photograph on the rescue's website. I read about his background, and I had an opportunity to meet Mello, and it just seemed to be the perfect match for me and my family."

"I am very grateful for Mello; he has brought joy, laughter, love, and happiness to our family. He has brought me such happiness with just the loving dog that he is. He has also brought our other dog, Jackson, out of his shell and he plays and listens a lot more thanks to Mello. Mello has only been with us a short time, and he has already brought so much joy; and I cannot wait to have many more years with my Mello."

According to Mello's adopter, Mello is acclimating well to his permanent home. His adopter also stated that Mello is very laid back and very loving. "Mello has only added more happiness into our lives. I love coming home from a long day at work to see my little handsome, brown-eyed boy wagging his tail when I walk through the door."

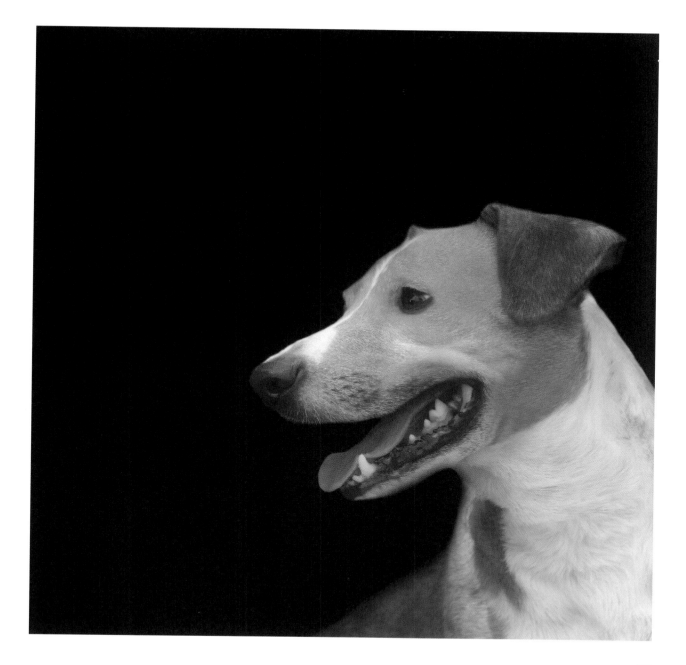

ARGYLE
I.D. # A19812251, TERRIER-PIT BULL MIX, MALE, 3 YEARS, 2013
ADOPTED—141 DAYS IN THE SHELTER

In Spring 2013, a Maryland Animal Control department seized Argyle when they discovered him tied to a tree in the backyard of a vacant house. He was brought to a local Maryland shelter and was then transferred to a foster home in June 2013. At the time, shelter personnel estimated him to be approximately three years old. Their veterinary team did not note any health or behavioral issues. The shelter reported that "Argyle came to the shelter a little thin, but he was calm and relaxed."

During his initial photo shoot, Argyle was very calm, gentle, sweet, and well-mannered.

After spending about five months at the shelter and foster home, Argyle was adopted on September 22, 2013.

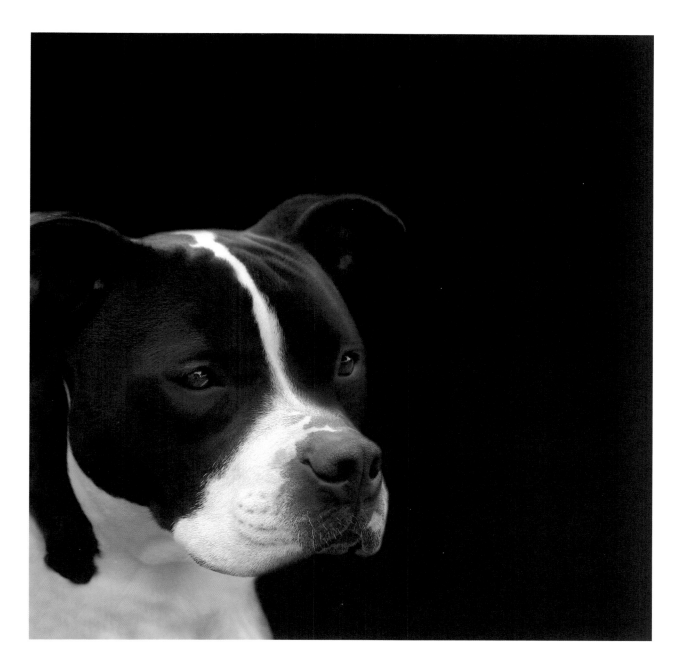

119

ARGYLE
TERRIER-PIT BULL MIX, MALE, 5.5 YEARS, 2015

"Argyle has shown me that, even though he was abandoned, he still has plenty of love to give. I am a believer that everything happens for a reason, and I am glad that Argyle came into my life and home."

According to Argyle's adopter, he had some minor health problems, including worms, which were cleared up with veterinary treatment.

Argyle's adopter reported that he is doing really well in his new environment, and he has become very attached to the other two dogs in his home. "At first, I worried about his size compared to my other two smaller dogs, but Argyle has shown a large heart. He is very protective towards me and the other dogs."

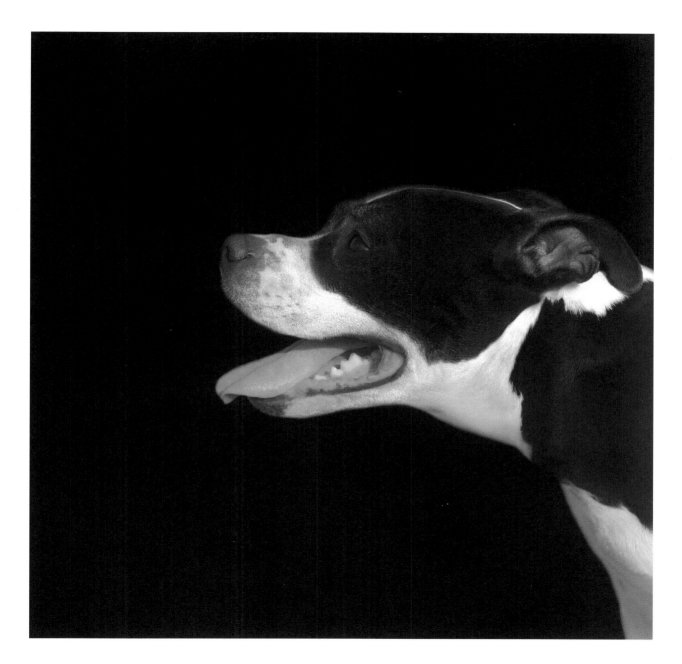

JACKS
ENGLISH BULLDOG, MALE, 5 YEARS, 2014
ADOPTED—31 DAYS IN THE RESCUE

In Autumn 2014, Jacks was surrendered by his owner to a Maryland shelter and transferred to a local Maryland rescue. The precise date he arrived at the shelter is unknown. At the time, rescue personnel estimated Jacks to be five years old. Their veterinary team noted that Jacks was underweight. The rescue stated that "It was clear that Jacks had not been fed regularly." The rescue noted that Jacks did not exhibit any behavioral issues, and reported, "Jacks is sweet and loving."

During Jacks' initial photo shoot, he was very sweet and easy to photograph; he was extremely treat-motivated!

After spending a month in the rescue, Jacks was adopted on December 21, 2014. Jacks was renamed "Taco" by his adopter.

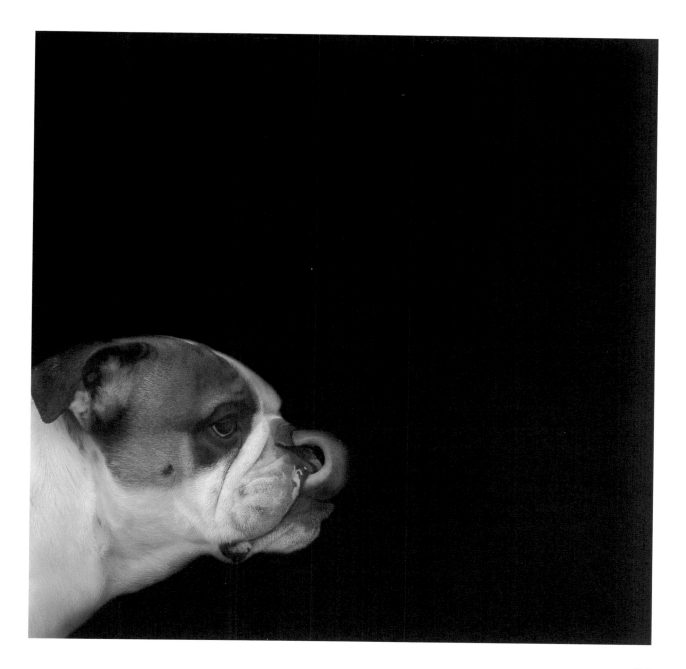

TACO
ENGLISH BULLDOG, MALE, 6 YEARS, 2015

"I was always struck with the English Bulldog breed from a young age. I was planning on buying an English Bulldog from a breeder, but my wife was adamant about adopting, so my search began. I was willing to travel as far as New York, and, luckily, Taco happened to be in the Washington, DC area. During our search, we saw Taco online, and we immediately applied for him through the dog rescue."

"Taco has had a huge impact on our lives. Taco is the definition of love. He loves all people, he loves all dogs, and he loves everything. Everybody in our area knows him, and they make sure to come say 'hello' to him when we are out on walks."

"Taco has changed my perspective. Taco reminds me to get excited about the things that most people consider mundane, like a car ride, or enjoying a frozen yogurt. Taco has reminded me to enjoy the little things in life."

According to Taco's adopter, he is doing well in his permanent home. "Taco is a sweetheart, and a ball of energy wrapped into one. The transitional period into our house from the foster's house took probably less than two hours."

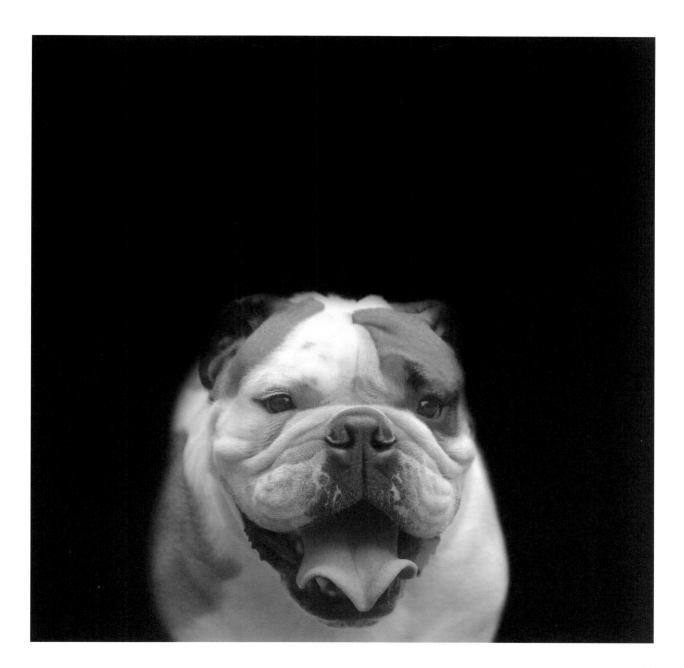

Dreifuss
I.D. # ARCTN-14-088-NM, Orange Labrador Mix, Male, 1.5 years, 2014
Adopted—242 days in the Rescue

In Winter 2014, Dreifuss was transferred from Tennessee to a local Maryland rescue in connection with a cruel dog hoarding case via the Animal Rescue Corps—Operation Mending Hearts. At the time, rescue personnel estimated that Dreifuss was approximately one and a half years old. Their veterinary team noted that Dreifuss has an amputated left front leg and carpal valgus, a condition in which the limb deviates outward from the midline below the knee. Despite Dreifuss' disability, he has learned to compensate, and his mobility is excellent with only three legs. The rescue did not report any behavioral issues. Dreifuss was adopted once previously, but he was returned to the rescue for unknown reasons. The rescue stated, "Dreifuss is noisy during the night and the adopter will need to understand that there will be a transition period."

During his initial photo shoot, Dreifuss displayed a great deal of happiness and was full of energy!

After spending roughly eight months in the rescue, Dreifuss was adopted on October 28, 2014. Dreifuss was renamed "Dreyfuss" by his adopter.

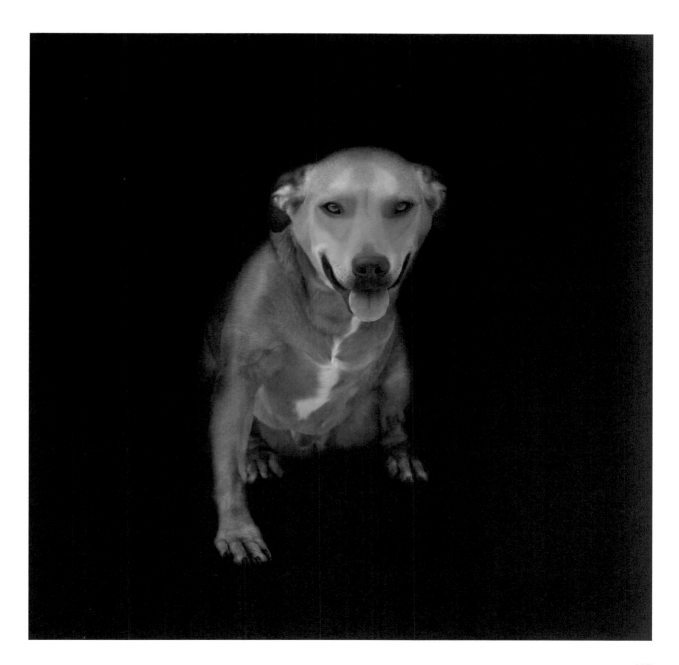

DREYFUSS
ORANGE LABRADOR MIX, MALE, 2.5 YEARS, 2015

"Many people backed out of adopting Dreyfuss because they felt he would be difficult due to being a special needs dog. I felt he deserved a loving home just like any other rescue dog."

Dreyfuss' adopter met him at an adoption event at a local pet store, while waiting for her other rescue dog, Max, to finish a grooming appointment. The adopter spent time with Dreyfuss and his foster mom. And, after the short visit, expressed interest in adopting Dreyfuss.

"Dreyfuss has brought nothing but love to our family. Dreyfuss is not a dog to feel sorry for, but a dog that inspires us every day to push through anything."

According to Dreyfuss' adopter, he is doing well in his permanent home. "Dreyfuss is missing his front left leg, and he doesn't seem to notice it. Other than that, he is completely healthy." Dreyfuss' adopter indicated he is training quickly and has no behavioral issues. Dreyfuss is very energetic and thoroughly loves being outside. His adopter also reported that he is an extremely loving dog to both people and other dogs.

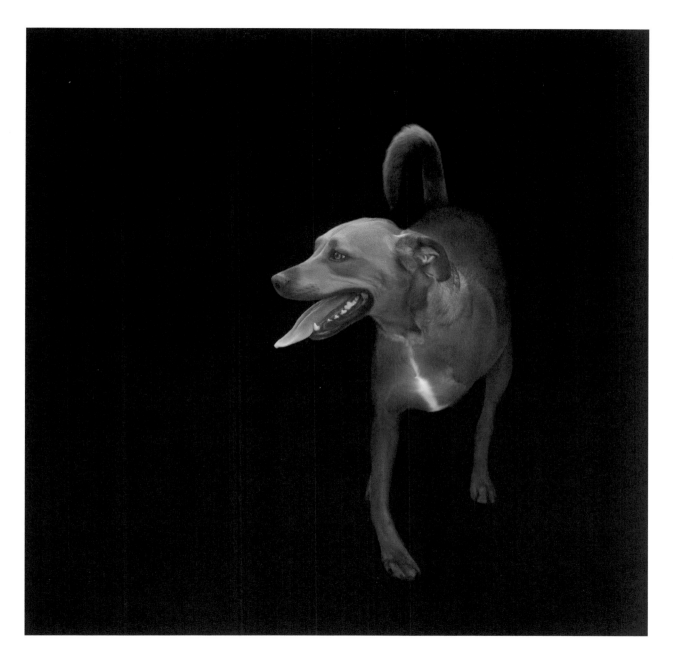

ACER
I.D. # GALOH-12-580-NM,
GOLDEN RETRIEVER-LABRADOR MIX, MALE, 3 YEARS, 2013
ADOPTED—804 DAYS IN THE RESCUE

In Autumn 2012, Acer was transferred from a high-kill shelter in Ohio to a local Maryland rescue. The only thing known for certain about Acer is that his previous owner surrendered him to the high-kill shelter in Ohio. The exact date and circumstances leading to Acer's arrival in the shelter are unknown. At the time, rescue personnel estimated Acer to be approximately three years old. Their veterinary team did not report any health issues; however, the rescue noted that "Acer has fear and separation anxiety."

During his initial photo shoot, Acer was full of energy and seemed quite happy to be in front of the camera.

After spending over two years in the rescue, Acer was adopted by his foster family on January 24, 2015.

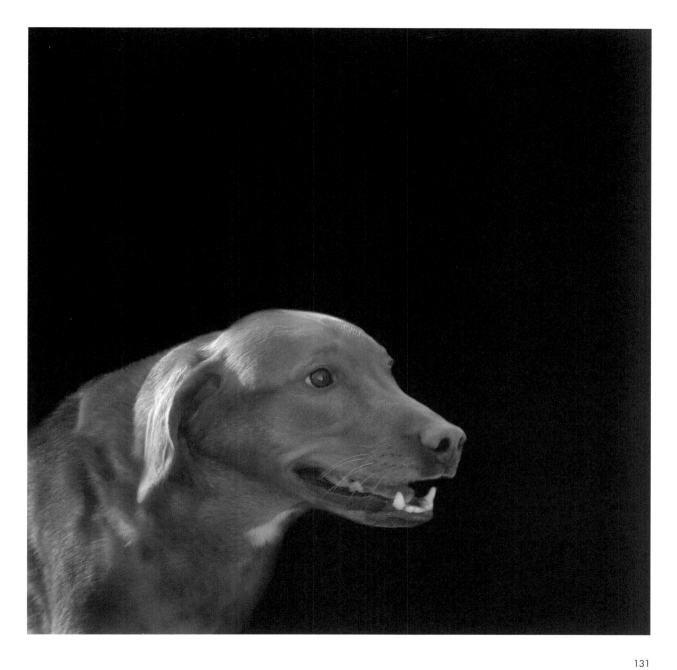

ACER
GOLDEN RETRIEVER-LABRADOR MIX, MALE, 4 YEARS, 2014

According to Acer's adopter, who fostered him for over two years, "The rescue's board of directors decided that the rescue's liability insurance may not cover Acer any longer due to his previous bite history, and we were then given the option to adopt Acer or else he would need to be euthanized."

"Acer is excited to play with dogs off leash, go for walks, and run around the yard. He is a happy dog in our home."

"Acer has taught us patience, trust, happiness, and to give second chances in life. Acer chose our family for a reason and made it clear he did not want to ever leave. I am sure Acer has a special purpose in our lives and we will discover it. He is a great dog that just needs a little fine tuning."

Acer's adopter indicated that his is progressing well in his permanent home. "Acer is calm when he is comfortable with his surroundings; however, he is still very anxious with new people and new places."

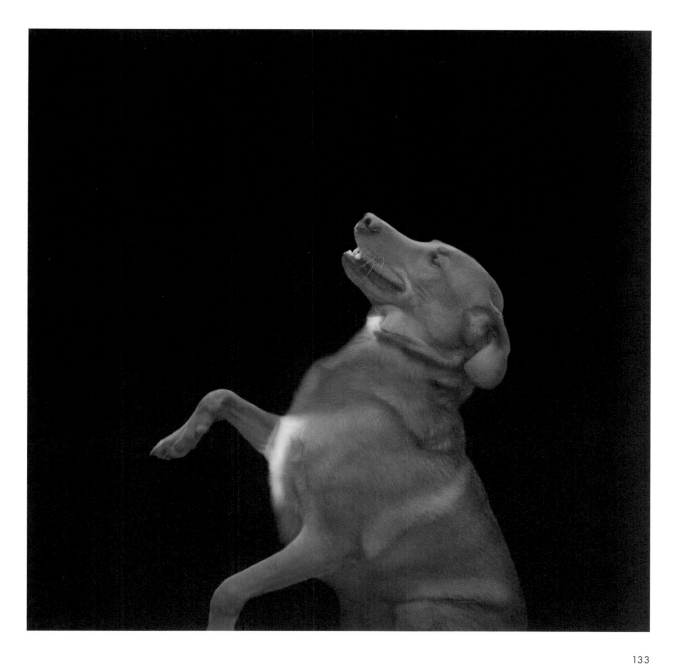

Gamma
I.D. # A19913350, Shepherd Mix, Female, 1.5 years, 2013
Adopted—19 days in the Shelter

In Spring 2013, Gamma was a stray dog brought to a Maryland shelter. The circumstances leading to Gamma living in the shelter are unknown. At the time, rescue personnel estimated her to be one and a half years old. Their veterinary team did not report any health or behavioral issues. The shelter noted that "Gamma is sweet and loves belly rubs!"

During her initial photo shoot, Gamma exhibited very high energy levels and loved moving around!

After spending about three weeks at the shelter, Gamma was adopted on June 4, 2013. Gamma was renamed "Maddie" by her adopter.

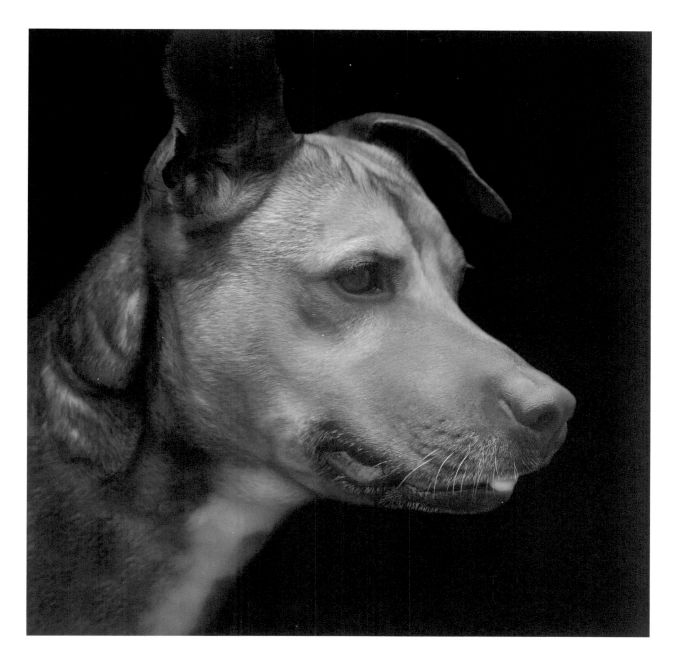

MADDIE
SHEPHERD MIX, FEMALE, 2.5 YEARS, 2014

According to Maddie's adopter, "I picked her out at the shelter, and it was love at first sight!"

Maddie is the adopter's first dog, and the adopter wanted to feel confident in her ability to care for any dog she chose to adopt. According to Maddie's adopter, "Maddie caught my eye because of her size." At their initial meeting, Maddie rested her chin on her adopter's thigh as the adopter knelt down to pet Maddie for the first time. "I was nervous in making the commitment and saying 'yes' to adoption, but I am so glad I did!"

"Adopting Maddie has been one of the best decisions I have ever made. I love her so much, and I love taking care of her. I really want the best for her, and I am willing to take the time to train her and practice so that she is a happy dog."

"I am now more passionate than I was before about adopting and fostering animals and giving them the homes they need. The number of dogs put down is unnecessary and very sad."

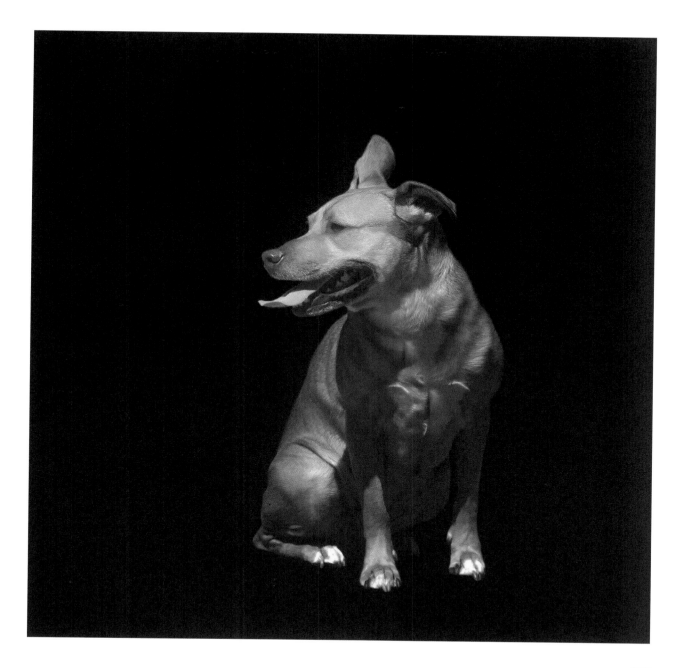

CHARLIE
PIT BULL MIX, MALE, 3.5 MONTHS, 2014
EUTHANIZED—318 DAYS IN THE RESCUE

In Spring 2014, Charlie was transferred from a Maryland shelter to a local Maryland rescue. The precise date and circumstances leading to Charlie's arrival in a shelter are unknown. At the time, rescue personnel estimated him to be approximately six weeks old. Their veterinary team noted that Charlie had a congenital condition, which was successfully treated. According to the rescue, "Charlie is a very happy, very playful, and rambunctious puppy!"

Charlie was adopted on October 19, 2014, but he was returned to the rescue nearly a year later. The rescue reported, "Charlie bit a kid, though not badly. However, the child's mom stated that she wouldn't take action if the adopter 'got rid' of Charlie. Charlie never had done anything like that before, so we [the rescue] are not one hundred percent sure what the issue was." After returning to the rescue, Charlie lived in a boarding facility for several months, and waited for a foster family or permanent home.

During his initial photo shoot, Charlie was very playful and cooperative.

Charlie spent nearly a year in the rescue's care, where he was euthanized on May 6, 2016.

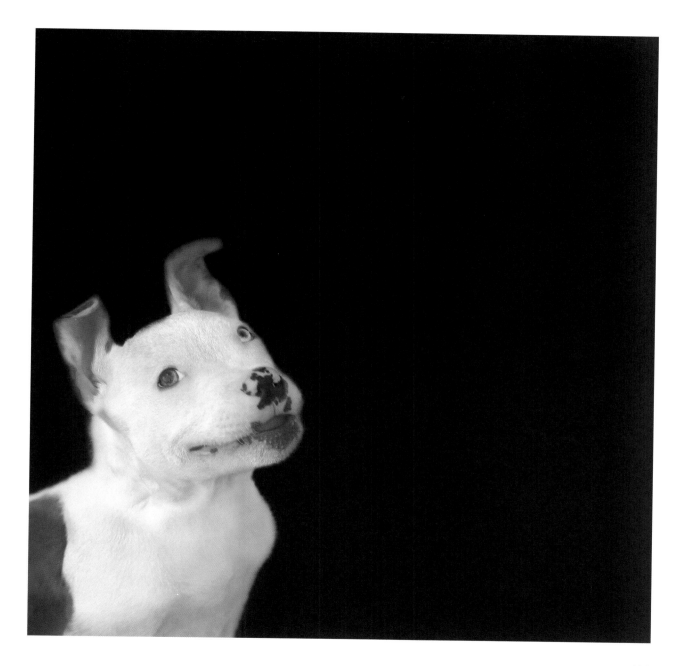

CHARLIE
PIT BULL MIX, MALE, APPROXIMATELY 2 YEARS
EUTHANIZED, MAY 6, 2016

Sadly, Charlie was euthanized on May 6, 2016. According to the rescue, "Unfortunately, we had to make the very difficult decision to euthanize Charlie. He was becoming increasingly aggressive and that became a huge liability to us."

TYSON
GREAT DANE MIX, MALE, 6 MONTHS, 2014
ADOPTED—39 DAYS IN THE RESCUE

In Summer 2014, Tyson was transferred from a high-kill shelter in West Virginia to a local Maryland rescue. The precise date and circumstances leading to Tyson's placement in a shelter are unknown. At the time, rescue personnel estimated him to be approximately six months old. Their veterinary team noted that Tyson was very underweight and malnourished. No behavioral issues were reported. The rescue stated, "Tyson is sweet, loyal, and an active dog."

During Tyson's initial photo shoot, he was very sweet and full of energy!

After spending just over a month in the rescue, Tyson was adopted on October 5, 2014. Tyson was renamed "Cruz" by his adopter.

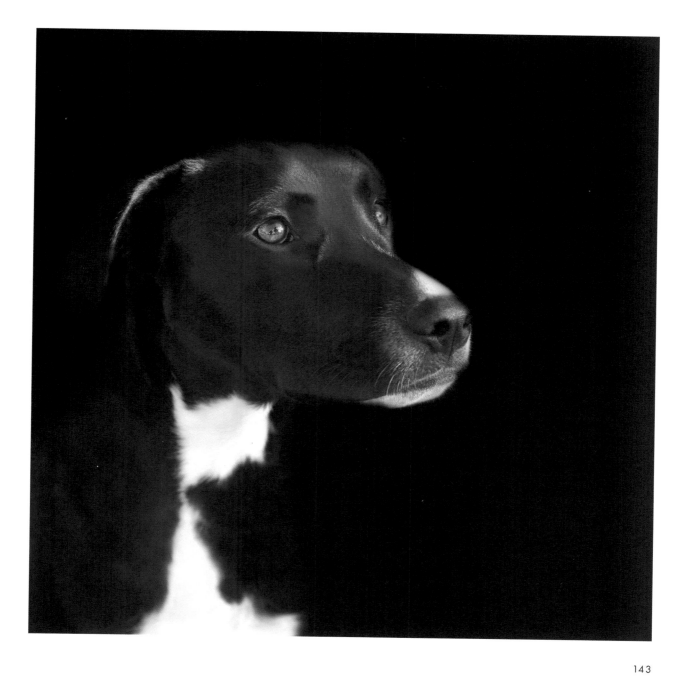

CRUZ
GREAT DANE MIX, MALE, 1 YEAR, 2015

"We were without a dog for the first time in twenty years, and we decided that we wanted to adopt a dog from a rescue."

"We were in search for a larger breed dog, and Cruz sounded like he might be a good fit for our family, as he was described as being great with people, great with animals, and enjoying the water."

According to Cruz's adopter, Cruz is doing very well in his new home.

"Though we still miss our Rebel, our former dog, and no pet will replace Rebel in our hearts, Cruz has helped us through this loss. He has proven to be such an essential part of our family life, which I often think how lucky we are that someone gave him up for adoption, and that there was a network of animal rescue workers who participated in bringing him to us. Your [Katherine Carver] work in sharing the stories of these rescued animals may help bring other pets into the lives of families like ours."

About nine months after adopting Cruz, his adoptive family experienced a tragedy when their daughter was injured in a fall and left paralyzed. According to Cruz's adopter, "As we have gone through this family disaster, Cruz has been a constant source of comfort for us. He knows when we need to sit quietly, nap, play, or just laugh at his crazy antics."

"His puppy energy and loving personality are a delight, and his training and socialization has been a fun project, which we can all take part in together. Sharing his antics from the day provides great entertainment and hours of conversation. He is definitely a positive addition to the family, and I can't help thinking he was somehow meant to be part of our family."

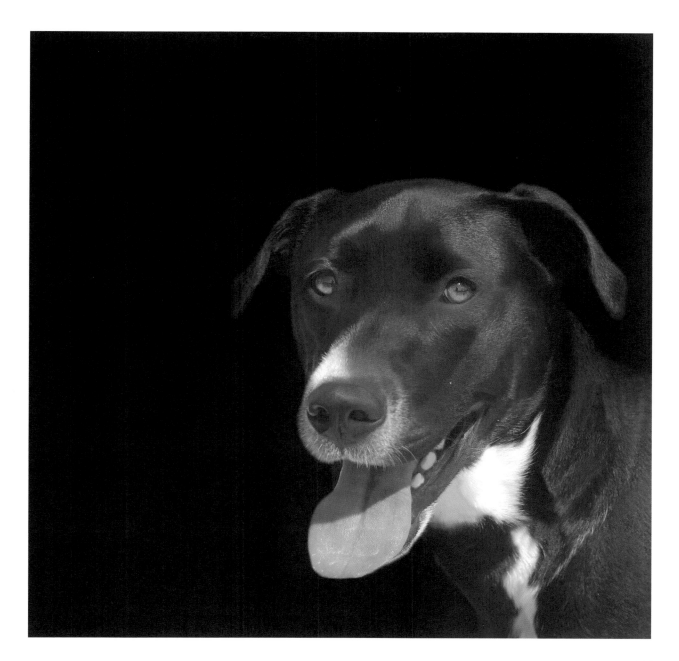

145

CASEY
YORKSHIRE TERRIER MIX, MALE, 2 YEARS, 2014
ADOPTED—208 DAYS IN THE RESCUE

In Summer 2014, Casey was transferred to a local Maryland rescue after 130 dogs were seized during a puppy mill raid in Virginia. At the time, rescue personnel estimated him to be approximately two years old. Their veterinary team indicated that, upon his arrival at the rescue, Casey was covered in feces, malnourished, and experienced intestinal issues. The rescue stated, "Words cannot describe the condition he was in." Additionally, Casey suffered from cryptorchid or "undescended testicles." Fortunately, the rescue's veterinary team successfully treated all of Casey's medical conditions. The rescue noted, "Casey is very fearful of new people, and he still spins in circles due to being in a cage most of his life."

During Casey's initial photo shoot, he was a bit scared and unsure at first, but he quickly warmed up, and was a delight to photograph.

After spending approximately six months in the rescue, Casey was adopted on January 16, 2015.

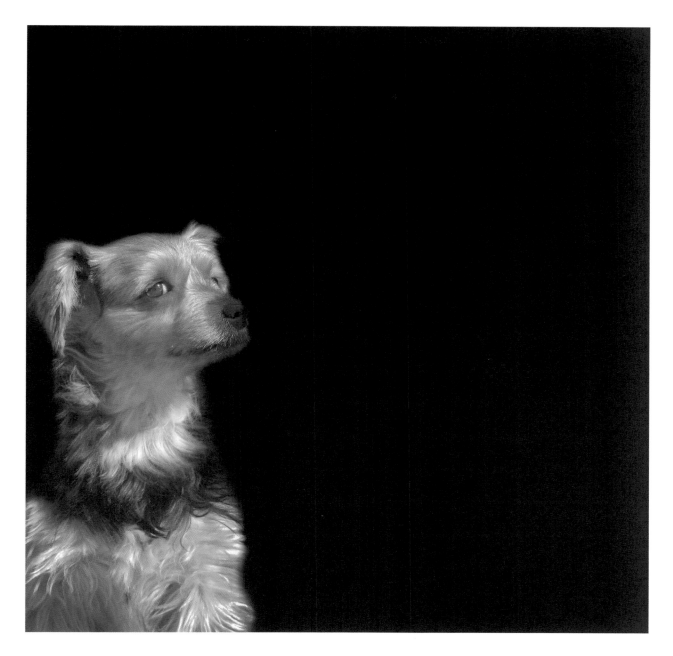

CASEY
YORKSHIRE TERRIER MIX, MALE, 3 YEARS, 2015

"I saw his photograph on the rescue's website and fell in love with his cute face. We actually weren't looking for a third dog; however, something about Casey touched us. I truly believe he was meant to be ours. Once I read about him being a puppy mill survivor, I could not stop thinking about Casey. About a week after I first saw Casey on the rescue's website, I put in an application, which led to his adoption."

"I believe that Casey is happy, feels safe, and feels our love more and more every day."

"Giving Casey a good home, and watching him progress has been one of the most rewarding experiences we have ever had. We love him more and more and more every day. We love our little 'Casey Face,' as we call him. He is a very, very special boy."

According to Casey's adopter, he has transitioned well and is thriving in his permanent home. "Casey has adjusted beautifully. Casey spent the better part of the first two weeks with us in his carrier. Since that time, he enjoys following me everywhere, receiving belly rubs, and getting lots of treats!" Casey's adopter reported that he is learning how to be around new people and visitors to the house. He is also making more contact with his adoptive family each day.

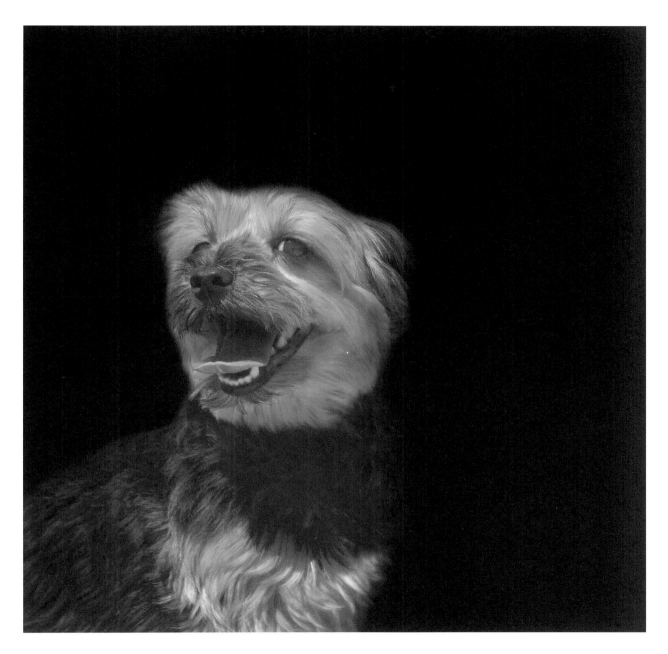

HUMPHREY
I.D. # HUNWV-13-448-NM, FLAT-COATED RETRIEVER MIX, MALE, 8 MONTHS, 2013
ADOPTED—43 DAYS IN THE RESCUE

In Autumn 2013, Humphrey was transferred from a shelter in West Virginia to a local Maryland rescue. According to the rescue, Humphrey and his sister arrived at the shelter as very young puppies riddled with mange, hair loss, and skin irritation issues. The rescue learned that Humphrey and his sister were adopted together from the West Virginia shelter about six months earlier, but were returned for unknown reasons. Upon his arrival in Maryland, he was estimated to be approximately eight months old. Their veterinary team did not report any health or behavioral issues. The rescue noted that Humphrey was adopted from the rescue previously, but he was returned due to reports of excessive barking when left alone. The rescue noted that "Humphrey is low to medium energy and good with kids, both big and small."

During his initial photo shoot, Humphrey was very calm and easy to photograph; he had beautiful and soulful eyes.

After spending just over a month in the rescue, Humphrey was adopted on December 21, 2013. Humphrey's adopter renamed him "Ricky-Bobby."

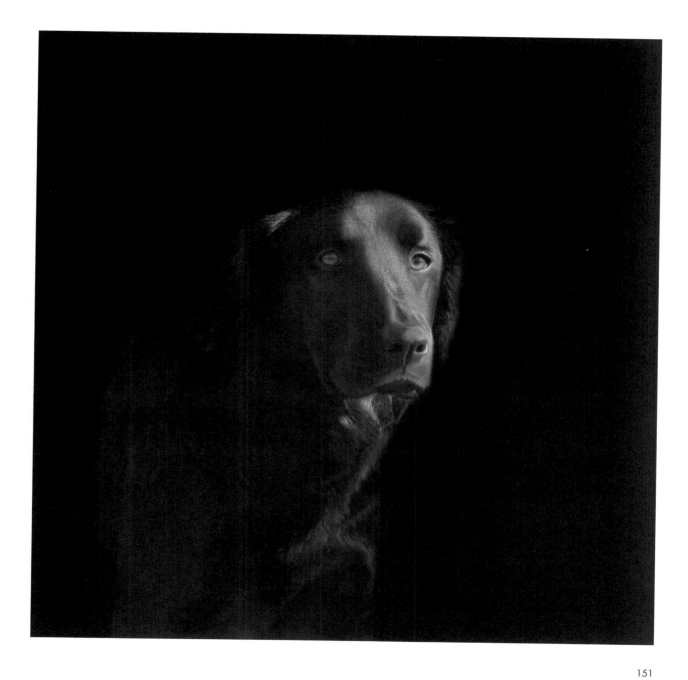

RICKY-BOBBY
FLAT-COATED RETRIEVER MIX, MALE, 1.5 YEARS, 2014

"I rescued Ricky-Bobby for companionship."

"The impact of adopting Ricky-Bobby has been nothing short of happiness and love."

Significantly, Ricky-Bobby has had a positive, meaningful impact on his adopter's life. "No matter how tough of a day I have had, he always greets me at the door with a smile and a playful romp around the house when I get home from work, and it always puts a smile on my face."

According to Ricky-Bobby's adopter, he is thriving, loves his new home, and could not be happier to have a brother, a Rottweiler rescue. "Ricky-Bobby still acts like a puppy! He is full of energy, sometimes too much! Most any toy he gets is torn up within a week! And, though I am not the best trainer, Ricky-Bobby is very smart."

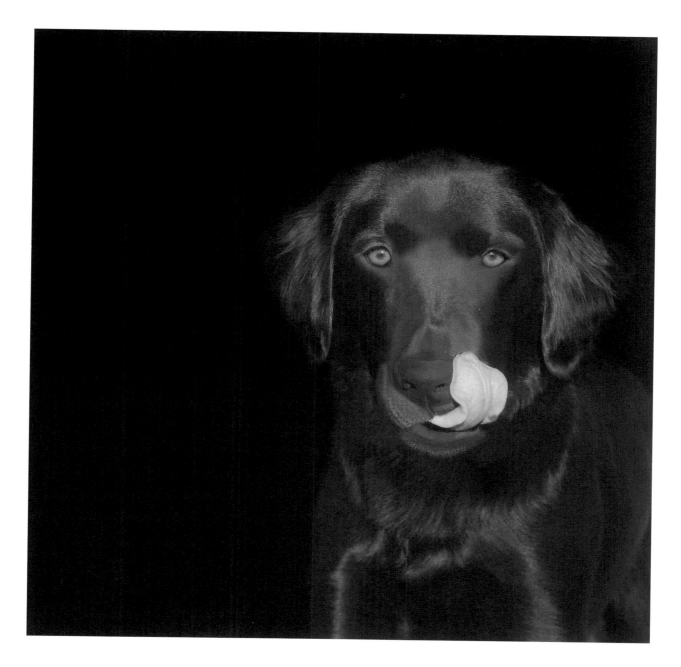

DARLA
I.D. # A19469862, TERRIER-PIT BULL MIX, FEMALE, 3 YEARS, 2013
ADOPTED—126 DAYS IN THE SHELTER

In Spring 2013, Darla arrived at a Maryland shelter as a stray dog. At the time, she was estimated to be three years old. The shelter's veterinary team did not note any health or behavioral issues. The shelter noted, "Darla has a unique, heart-shaped marking on her muzzle."

During her initial photo shoot, Darla was a little shy and very calm.

Darla was transferred from the shelter to a foster home on May 11, 2013, and she was adopted a few months later on July 26, 2013.

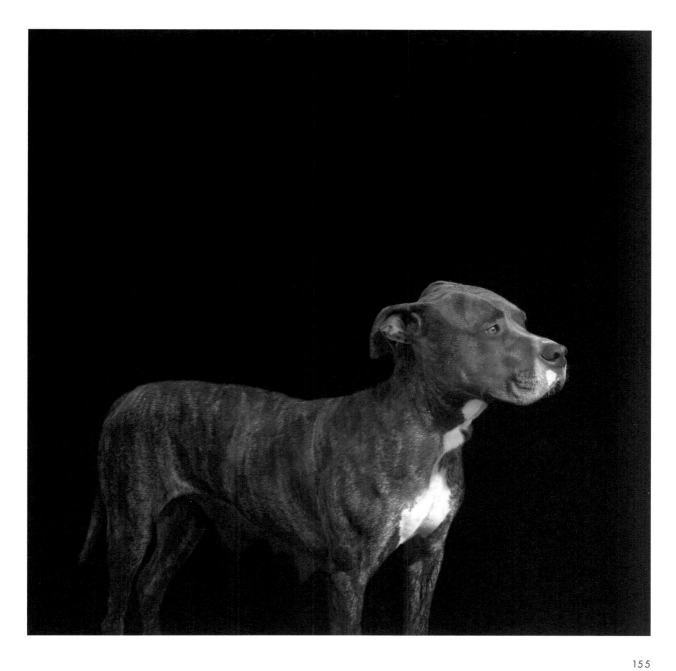

DARLA
TERRIER-PIT BULL MIX, FEMALE, 4 YEARS, 2014

"She is by far the smartest dog we have ever had. She is particularly good at responding to verbal cues. I have to be honest—I never saw us adopting a pit bull mix and we probably wouldn't have if not for the opportunity to get to know Darla first, thanks to our daughter."

Shortly after adopting Darla, one of her adopters experienced a personal tragedy with the diagnosis of early-stage breast cancer. "Darla has been my constant companion and comfort during my treatment and recovery. She is truly a member of the family."

According to Darla's adopter, she is thriving in her permanent home. She gained weight and is now maintaining a healthy weight.

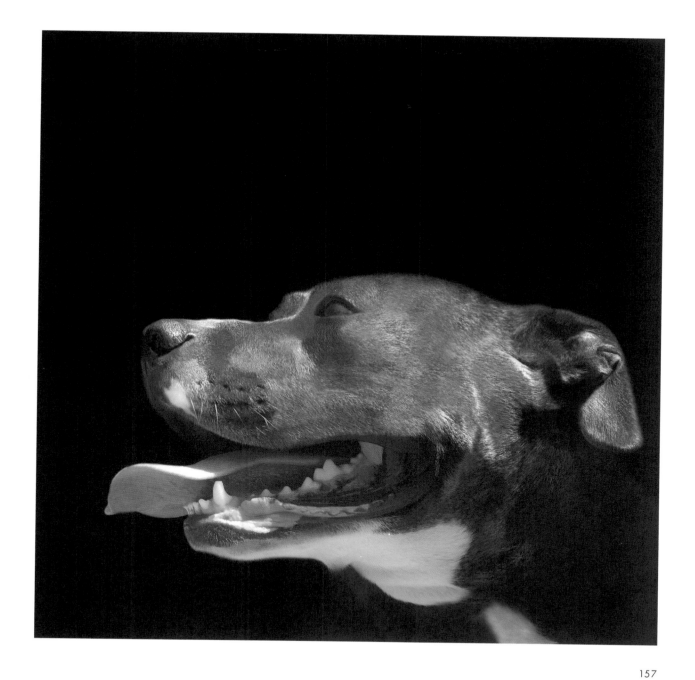

MOUSE
FRENCH BULLDOG, MALE, 3.5 MONTHS, 2014
ADOPTED—160 DAYS IN THE RESCUE

In Summer 2014, Mouse was transferred to a local Maryland rescue after he was seized from a Maryland puppy mill. At the time, rescue personnel estimated him to be approximately three and a half months old. Their veterinary team reported that Mouse was infested with fleas and parasites; he had a dislocated shoulder; and suffered from a severely damaged leg, which had been left untreated for an extended period of time. The rescue successfully treated Mouse for these aforementioned medical conditions. The rescue did not note any behavioral issues.

As Mouse recuperated, the rescue reported that he began to experience seizures. A Magnetic Resonance Imaging (MRI) test revealed that Mouse had a genetic condition called hydrocephalus, which causes excessive buildup of fluid on the brain and results in pain, pressure, headaches, seizures, degraded vision, and instability. The rescue successfully raised money for a neurologist to perform the surgery to remove the fluid on Mouse's brain. Post-surgery, however, his prognosis continued to look grim. The surgery could not cure Mouse's congenital condition and, according to the rescue, he continued to experience daily seizures, despite surgery and medication.

During his initial photoshoot, Mouse was extremely easy to photograph; he was relaxed and playful.

After spending five months in the rescue, on February 27, 2015, Mouse's foster family adopted him. Mouse's adopter renamed him "Mo."

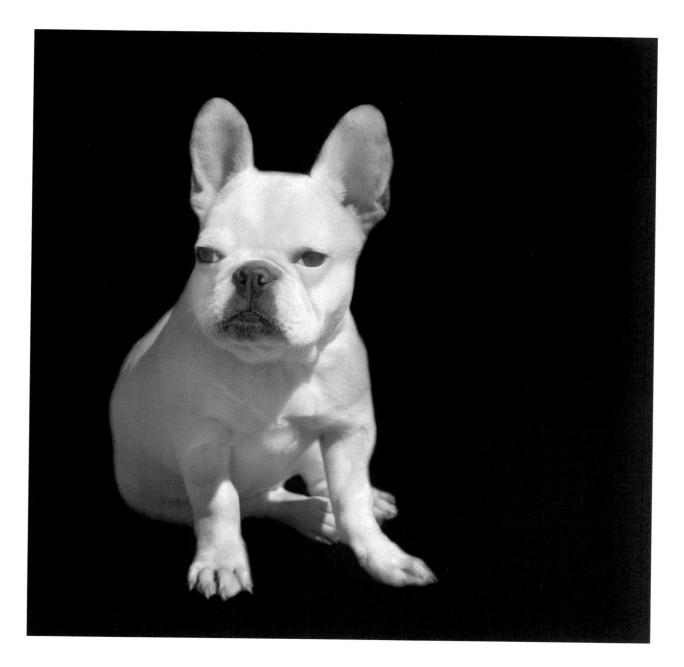

Mo
French Bulldog, Male, 1 year, 2015

"Mo is a special little guy who brings joy and happiness to our lives every single day. Everyone that meets him, loves him."

"Mo was very ill when he came to the rescue. He was my foster, and we adopted him so we could give him the care he needed to address his medical needs. We have rearranged our schedules so that we are home to give him the medicines that he needs during the day."

"Since we adopted Mo, we've seen a complete transformation. What was a sick little puppy with a mangled paw and a brain condition, is now a bouncy, happy, young dog that loves to play, loves his brothers and sisters, loves his family, and loves life. I would encourage everyone to consider adopting a special needs dog. Little Mo gives us so much more than he takes, and we are grateful for every single day that little bundle of energy is in our lives."

According to Mo's adopter, despite his medical issues, Mo has adjusted well to his permanent home. "Mo is super funny, and a sweet guy that everyone loves. Mo is very energetic, playful, sweet, and a good puppy!"

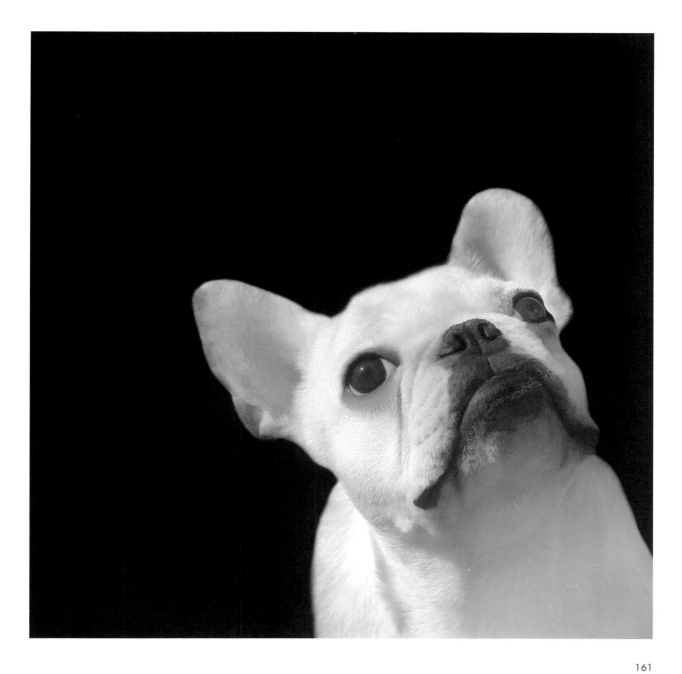

LUCY
POMERANIAN, FEMALE, 7.5 YEARS, 2014
ADOPTED—408 DAYS IN THE RESCUE

In Spring 2013, Lucy was transferred to a local Maryland rescue after she was seized from a puppy mill in Virginia. The owner of the puppy mill contacted the rescue and instructed the rescue to pick-up Lucy within an hour, or she would be killed. The rescue stated, "The backyard breeder no longer had any use for Lucy. She lived in a cage where she was forced to breed over and over again." When she was seized from the puppy mill, rescue personnel estimated Lucy to be approximately seven and a half years old. Their veterinary team did not report any health or behavioral issues. According to the rescue, "It has taken time to get her to come out of her shell, but Lucy is making steady progress. Lucy is still learning how to walk on a leash, and live in a home as a 'normal dog.'"

During Lucy's initial photo shoot, she was happy, smiled, and seemed to enjoy the camera!

After spending over a year in the rescue, Lucy was adopted on July 28, 2014.

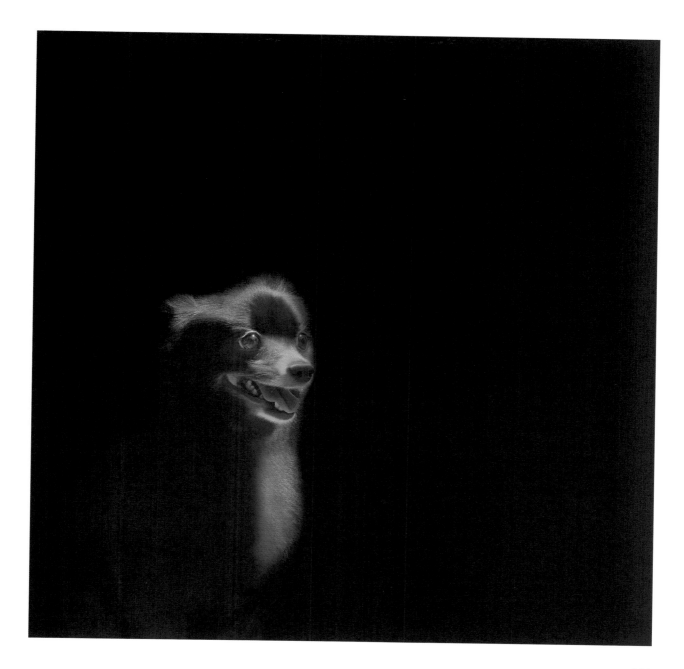

LUCY
POMERANIAN, FEMALE, 8.5 YEARS, 2015

"I had previously rescued another black Pomeranian, when I was recovering from cancer. When I saw Lucy, she looked like my black Pomeranian. I felt bad that Lucy was on the rescue's website for over a year, and we decided to rescue her."

Lucy's adopter wanted to give her a better life, since she was a "working mom" all of her life. "I had found out that she had been a puppy mill mom and, when she was done being useful, she was discarded."

According to Lucy's adopter, despite her mistreatment in the puppy mill, she is thriving in her permanent home. "Lucy came to us as a very shy and timid little lady, but she has a lot of spunk! Lucy is still very timid at times, but she has settled in and is a very smart girl. Lucy has also claimed all of the dog beds in the house as her own, regardless of whether someone is lying in it!"

"Lucy is being pampered and we are having a great time doing so!"

Lucy's adopter indicated that Lucy recently had surgery to remove mammary masses, and happily reported that Lucy is now cancer-free!

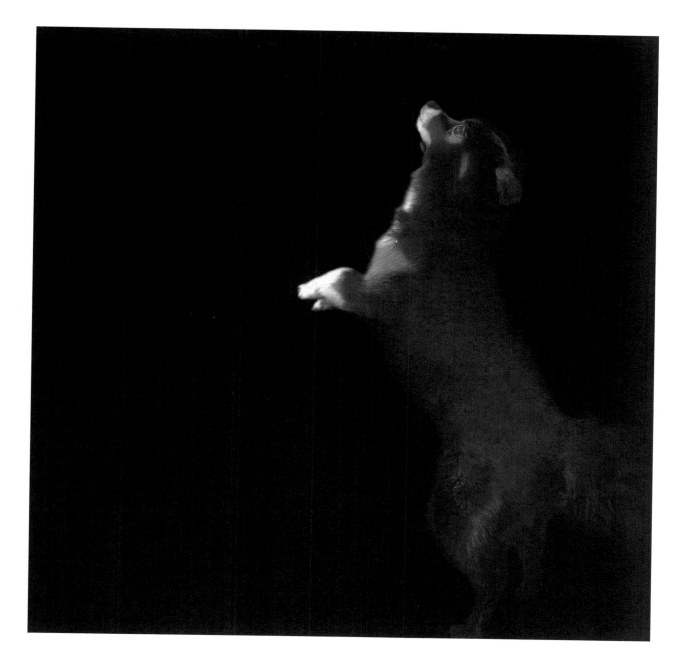

SABRE
I.D. # A20638147, SHEPHERD MIX, MALE, 4 YEARS, 2013
ADOPTED—5 DAYS IN THE SHELTER

During Summer 2013, Sabre was transferred to a Maryland shelter after being seized by Animal Control from a vacant house whose owners had moved and abandoned him. At the time, shelter personnel estimated Sabre to be approximately four years old. Their veterinary team reported no health or behavioral issues.

During his initial photo shoot, Sabre was very well-behaved and gazed directly into the camera.

After only a few days in the shelter, Sabre was adopted on August 7, 2013. Sabre's adopter renamed him "Arfy."

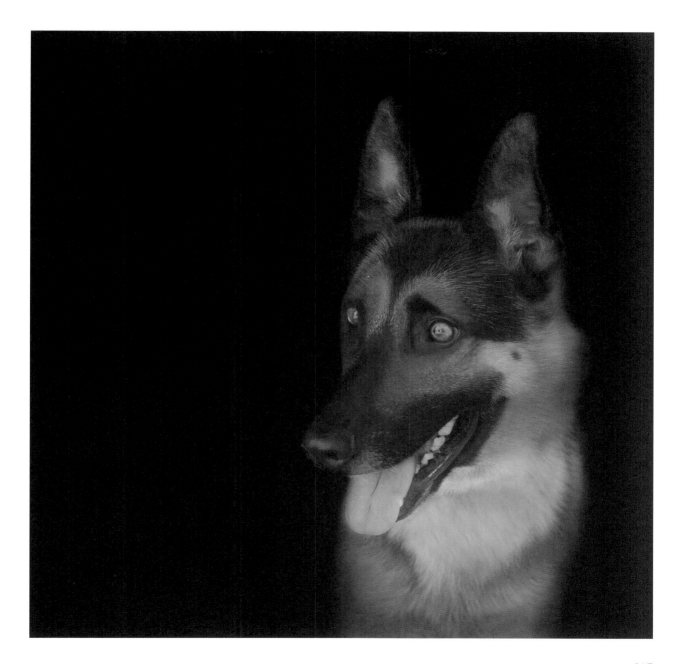

ARFY
SHEPHERD MIX, MALE, 5 YEARS, 2014

"I run early in the morning, usually before the sun is up. After getting nagged by my coworkers about how unsafe it was for me to be out alone, I decided to look for a big dog that would look just scary enough to keep attackers away, while actually not being aggressive or protective. This dog also had to be good with our two small boys and our cat."

"At the end of the day, after visiting numerous shelters that day, we saw Arfy sitting quietly at the front of his kennel, looking sad, and we decided to adopt him on the spot."

"Arfy is a great dog, sweet and energetic. We love him. Arfy gets complimented everywhere he goes, and people are always amazed that we got him from a shelter."

According to Arfy's adopter, he gained weight and is doing really well in his permanent home. "Our boys adore him, and he has been a great motivator in my running, and a great companion."

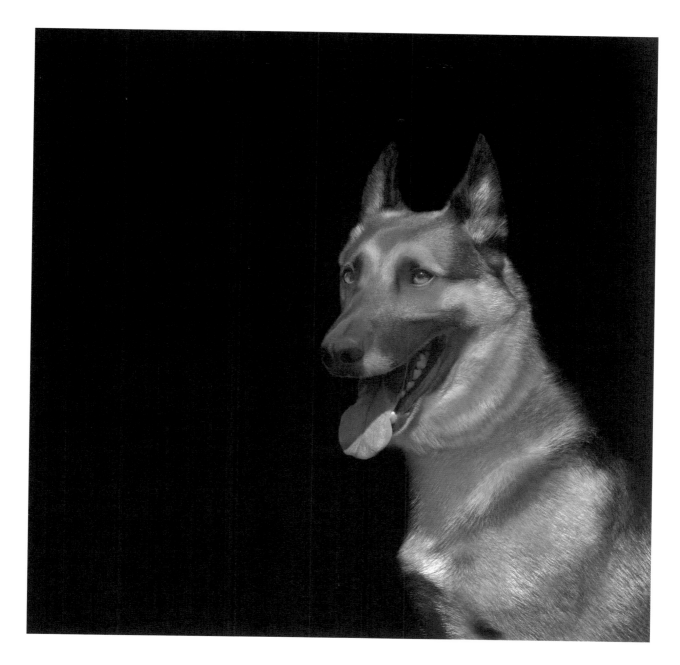

ROSIE
PUG MIX, FEMALE, 4.5 YEARS, 2014
ADOPTED—138 DAYS IN THE RESCUE

In Winter 2014, Rosie's owner surrendered her to a shelter in southern Virginia, which then transferred her to a local Maryland rescue. The rescue indicated, "The previous owner could not deal with Rosie's medical issues." The precise date Rosie arrived at the shelter is unknown. However, the rescue estimated Rosie to be four and a half years old. Their veterinary team noted that Rosie arrived at the rescue with several medical issues, including severely irritated skin characterized by large cysts and erupting follicles all over her body. The rescue took Rosie to several specialists, who successfully treated her skin conditions. No behavioral issues were noted by the rescue. The rescue indicated, "Rosie is very sweet and friendly."

During her initial photo shoot, Rosie was very easy to photograph and in good spirits, despite the many cysts covering her body.

After about four months in the rescue, Rosie was adopted on June 11, 2014.

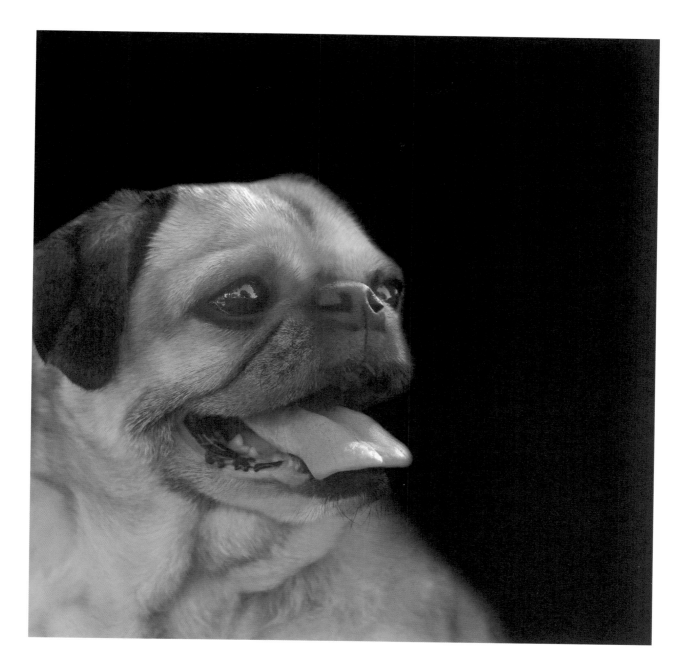

ROSIE
PUG MIX, FEMALE, 5.5 YEARS, 2015

"My daughters have grown up with friends and family members with disabilities, which gives them compassion for dogs that are 'different.'" According to Rosie's adopter, they wanted to adopt a female pug for their resident dog, Oscar, a Chug. Rosie was the only female pug available in the adopter's geographic area.

"We were really touched by the rescue's website, Rosie's sweet disposition, and her struggles with feeling like a 'lumpy pot of potatoes.'"

"Rosie is very sweet and affectionate. She gets along well with everyone. My twin girls adore her, and they appreciate that she sits on their laps and snuggles with them when they get home from school. Rosie also gets along well with our other rescue dog, Oscar."

Most importantly, according to her adopter, "Rosie has brought us a lot of joy, and she is ensconced as a member of our family. Both of my girls are thrilled that they have a lap dog."

Rosie's adopter said she thrived in her new permanent home. Rosie's adopter also reported that their family had been extremely diligent treating Rosie's skin issues, "We have taken Rosie to the dermatologist and also for follow-up appointments, and the veterinarian is pleased with the gradual improvement in Rosie." Fortunately, Rosie responded favorably to antifungal and antibiotic treatments for her skin issues.

Rosie lived the remaining two years of her life with her wonderful adoptive family. Sadly, Rosie passed away during the summer of 2016, after developing recurring antibiotic-resistant infections. According to Rosie's adopter, "We miss her terribly, and feel grateful for the time we had with her. We still have Rosie's friend, Oscar, and we adopted another rescue dog, Pixie."

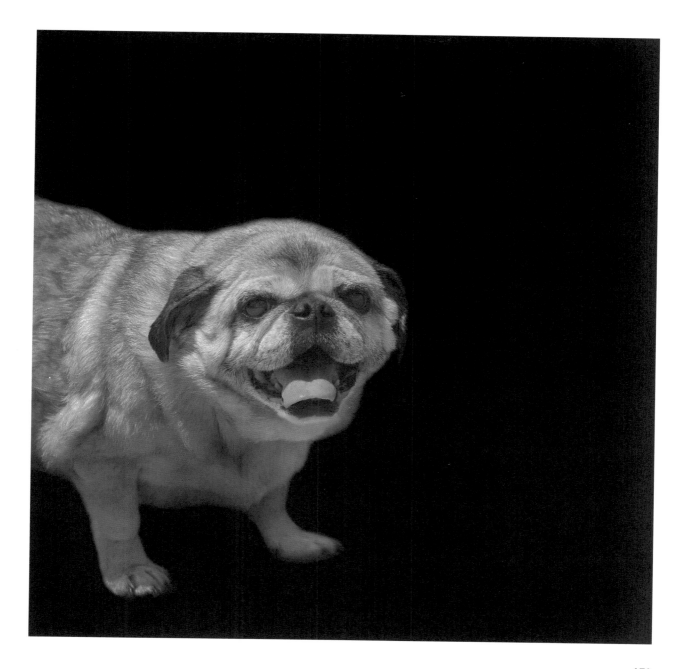

PRINCESS TULIP
I.D. # A16944964, TERRIER-PIT BULL MIX, FEMALE, 1 YEAR, 2013
ADOPTED—125 DAYS IN THE SHELTER

During Summer 2012, Princess Tulip's owner surrendered her to a shelter in Maryland for undisclosed personal reasons. Princess Tulip was first adopted from the shelter on August 19, 2012, but was then discovered as a stray dog about six months later and returned to the same shelter. In April 2013, Princess Tulip was transferred to a rescue organization. At the time, rescue personnel estimated Princess Tulip to be approximately one year old. Their veterinary team did not report any health or behavioral issues. According to the shelter, "Princess Tulip is good with other dogs and very affectionate with people."

During her initial photo shoot, Princess Tulip was full of energy—all she wanted to do was play and interact with humans!

After about four months at the shelter and rescue, Princess Tulip was adopted on August 9, 2013. Princess Tulip was renamed "Emmy" by her adopter.

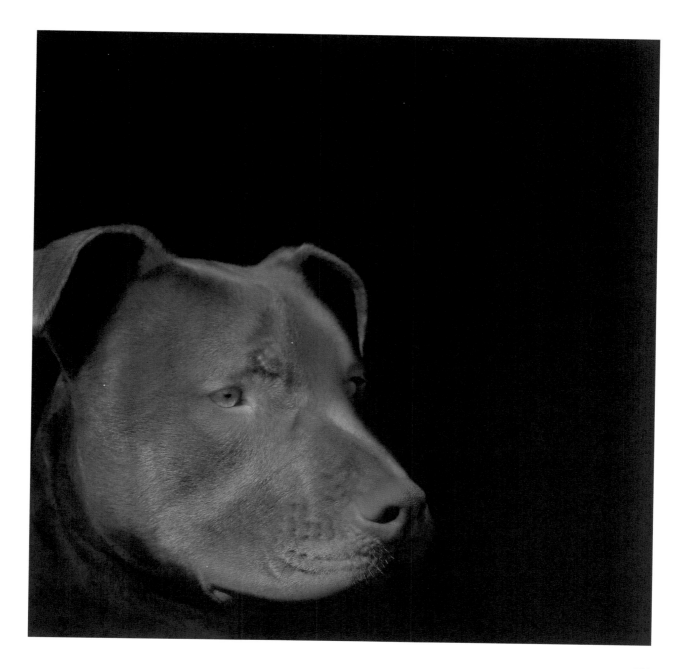

EMMY
TERRIER-PIT BULL MIX, FEMALE, 2 YEARS, 2014

Emmy's adopter was looking for a young female dog to adopt after losing a beloved Rottweiler. According to Emmy's adopter, "Emmy has eased our heartache, after our great loss."

"Emmy is such a joy, and she is so loveable. She is a ninety pound lap dog through and through!"

Emmy's adopter also indicated that she is very comforting. "She just knows when one of us is not feeling well or when we are emotionally upset, and during these times, she stays by our side and puts her head in our lap."

Most importantly, according to Emmy's adopter, "She is the joy of our lives."

Emmy has transitioned extremely well to her permanent home and helps make her adopter feel safe. Emmy's adopter indicated that Emmy loves children and loves to cuddle. "Emmy loves her new home, and she is a very happy and loving dog. She now weighs a healthy ninety pounds, much bigger than we anticipated!"

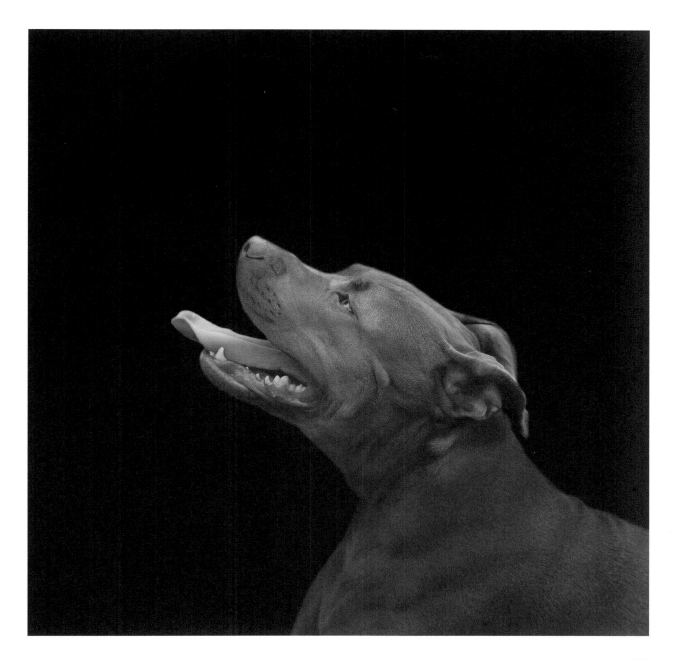

DORA
PHALENE MIX, FEMALE, 3 YEARS, 2014
ADOPTED—127 DAYS IN THE RESCUE

In Summer 2014, Dora was seized as part of a hoarding case in Maryland and transferred to a local Maryland rescue. At the time, rescue personnel estimated that she was approximately three years old. Their veterinary team did not report any health issues. The rescue indicated that "Dora is very sweet, but she is fearful, a flight risk, and she likes to go and hide."

During her initial photo shoot, Dora was very sweet; however, she was also quite frightened.

After four months in the rescue, Dora was adopted on December 19, 2014. Dora was renamed "Dorie" by her adopter.

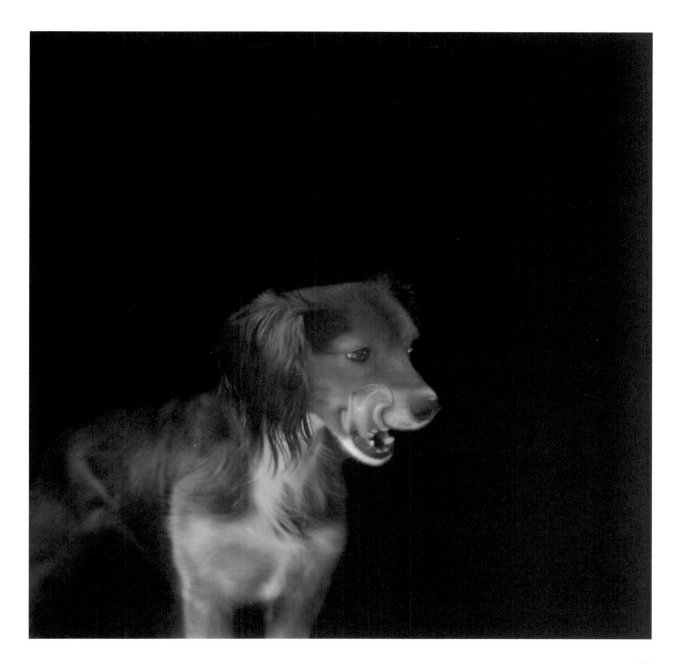

DORIE
PHALENE MIX, FEMALE, 3.5 YEARS, 2015

"When I first met Dorie, she behaved so crazily that I wasn't going to take her. But gradually, I realized she was just terrified, and when her foster mom told me that I was the only person who had shown any interest in her, the entire three months she had been in foster care, I decided to take her no matter what. I knew that she needed a loving home, and I was determined to help her adjust no matter how long it took. Little did I know, Dorie would transform into an entirely different dog within minutes of entering my house."

"She is a totally different little girl from the scared-out-of-her-wits dog I first met at the foster home." Most of all, according to Dorie's adopter, "Dorie has made our family happy and whole again after the loss of our former dog."

Dorie's adopter reports she is healthy and doing well in her permanent home. "Dorie's a very well-behaved girl. She is not destructive at all, rides quietly in the car, comes when she's called, and has learned to walk nicely on a leash."

Dorie's adopter indicated that she has a small cloudy spot on both of her eyes, which does not seem to impact her vision. Dorie's veterinarian suspects the small cloudy spots on her eyes were caused by corneal edema as a result of exposure to fumes from urine and feces accumulation in the hoarding house where Dorie lived. She is still leery of strangers and will not voluntarily approach them, but occasionally allows strangers to pet her.

MEDIA
I.D. # FRTKY-14-128-SF, GREAT DANE MIX, FEMALE, 8 YEARS, 2014
ADOPTED—142 DAYS IN THE RESCUE

In Winter 2014, Media was transferred from a shelter in Kentucky to a local Maryland rescue. The precise date and circumstances leading to her arrival in a shelter are unknown. At the time, rescue personnel estimated her to be approximately eight years old. Their veterinary team noted that Media had arthritis, which the rescue treated. The rescue did not report any behavioral issues. According to the rescue, "Media is high energy, loves to play, and is very sweet. Also, she would do best in a single-level home, as she has arthritis, with children older than six years of age."

During her initial photo shoot, Media was very calm and a bit shy. She clearly liked to remain very close to her foster mom. I also felt a bit of sadness from Media when I photographed her.

After nearly five months in the rescue, Media was adopted on August 5, 2014.

MEDIA
GREAT DANE MIX, FEMALE, 9 YEARS, 2015

"The big breakthrough came during the third week when we noticed that Media was wagging her tail. Up until that point, it was always straight down, and she never wagged it."

"We were looking for a large breed dog, particularly a Great Dane mix, and we wanted to adopt a rescue." Media's adopter said the first few Great Danes they considered turned out not to be the best fit for their home, which was shared by young children, another dog, and a cat. Media's adopter kept looking, and kept seeing Media's photograph on the rescue's website. The adopter was concerned that Media was a bit older, and hoped for a younger dog. "Finally, we decided to meet Media and we fell in love with her. She came out of the foster home, right up to me, and leaned against me to get attention. She is so sweet."

"We feel real good giving Media the home that she has always deserved. She appears to have had a rough life, but yet she still has the sweetest disposition. We see ourselves as her retirement home where she can live out her golden years in comfort."

Media's adopter reported that she did well in her new home. "She is super sweet, and she goes up to anybody and leans against them to get attention. All she wants is to be petted. She'll follow us from room to room while we are doing errands around the house, and Media turns sideways to block our path and get a head rub while we walk by. She just wants to be loved and touched."

Media lived the last year-and-a-half of her life with her adoptive family who cared for her and loved her dearly. Sadly, Media passed away peacefully on February 26, 2016.

"We miss her dearly. People looking to rescue dogs should give the older dogs a try. Rescuing an older dog is a great introduction to a large breed—they are past the destructive puppy phase and much of the 'wild running' phase. She had a lot of love to give, and she just wanted some attention and a warm house in return. It is tough when it is their time to go, but we will always remember the love Media gave us."

STRADLATER
I.D. # HUNWV-13-451-NM,
YELLOW LABRADOR-SHEPHERD MIX, MALE, 1 YEAR, 2014
ADOPTED—93 DAYS IN THE RESCUE

In Autumn 2013, Stradlater was transferred from a shelter in West Virginia to a local Maryland rescue. The exact date and circumstances leading his placement in the shelter are unknown. At the time, rescue personnel estimated Stradlater to be a year old. Their veterinary team did not report any health or behavioral issues. The rescue reported that "Stradlater needs basic training and barks a lot in his crate."

During his initial photo shoot, Stradlater posed well for the camera, and enjoyed barking at all the other dogs as well!

After three months in the rescue, Stradlater was adopted on February 9, 2014. He was renamed "Diesel" by his adopter.

DIESEL
YELLOW LABRADOR-SHEPHERD MIX, MALE, 2 YEARS, 2015

"I chose him because I liked his disposition and temperament. I have always preferred large dogs. My previous dog was a rescue that was older when I adopted her, so our time together was short. I searched for a younger dog this time and I found this puppy who was housebroken and just needed some consistency in his life."

According to Diesel's adopter, he is doing well in his new home. He is very energetic and loves to be around people and keeps himself occupied. "Diesel is a lot of work since he desires constant attention, but he's a great companion when you come home. He has helped me become healthier due to his necessary walks and play time!"

URSULA
I.D. # A21068234, TERRIER-PIT BULL MIX, FEMALE, 2 YEARS, 2013
EUTHANIZED—53 DAYS IN THE SHELTER

In Autumn 2013, Ursula was discovered as a stray dog in someone's yard and taken to a local Maryland shelter. At the time, shelter personnel estimated her to be about two years old. Their veterinary team reported no health or behavioral issues. According to the shelter, "Ursula is a huge favorite among the staff and volunteers; and she loves to cuddle with humans, a true 'love bug.'"

During her initial photo shoot, Ursula was very sweet and full of energy. She was especially excited to be outside of her cage! After burning off some energy, she was very happy to pose in front of the camera.

After nearly two months at the shelter, Ursula was adopted on November 15, 2013.

Ursula was euthanized on November 22, 2013.

URSULA
I.D. # A21068234, TERRIER-PIT BULL MIX, FEMALE, 2 YEARS
EUTHANIZED, NOVEMBER 22, 2013

Sadly, Ursula was euthanized at the shelter on November 22, 2013. After Ursula was adopted on November 15, 2013, she was returned to the shelter a week later and euthanized.

According to the shelter, "Ursula was set up to fail by her adopter, who was instructed by the shelter to ease her into interactions with the adopter's resident dog during the first two weeks, in order to give Ursula a chance to settle and acclimate into her new home."

Instead, the shelter reported, "The adopter placed the two dogs together immediately, and Ursula attacked the resident dog."

HOPE
I.D. # LHOMO-14-073-SF, ENGLISH MASTIFF, FEMALE, 8 YEARS, 2014
ADOPTED—48 DAYS IN THE RESCUE

In Winter 2014, Hope's owner surrendered her to a shelter in Missouri. She was bred extensively and was no longer of value to the owner. The Missouri shelter transferred her to a local Maryland rescue. The precise date of Hope's arrival in the Maryland rescue is unknown. At the time, rescue personnel estimated her to be eight years old. Their veterinary team treated Hope for allergies. No behavioral issues were reported.

During her initial photo shoot, Hope was shy and wary of the camera; however, she loved being close to her foster mom and had a very sweet temperament.

After spending a little over a month in the rescue, Hope was adopted on April 5, 2014.

HOPE
English Mastiff, Female, 9 years, 2015

"We rescued Hope because we fell in love with her, and we felt that we could offer her a good home. She was already quite old for her breed when we adopted her, and we wanted to give her a nice sofa to lie on for her remaining years, which, hopefully, will be many!"

"Hope has brought so much joy to each and every day. She's always happy to see me and just hang out together."

According to Hope's adopter, she has settled in well at her new home. Hope's adopter reported that she is easygoing, laid-back, and shy. "Hope is the funniest dog. We take many walks each day. Sometimes we get a short way from the house, and she will sit or lie down. Other times, she will lie on her back with her paws in the air in the middle of the sidewalk. Everyone in the neighborhood knows her and loves her."

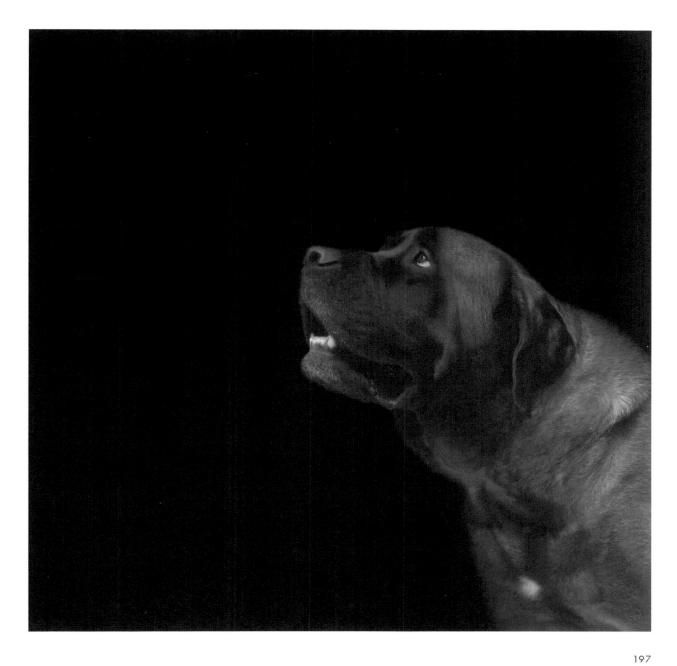

CLEM
I.D. # OSMO-12-507-SF, SHEPHERD MIX, FEMALE, 3 YEARS, 2014
ADOPTED—850 DAYS IN THE RESCUE

In Autumn 2012, Clem was transferred from a shelter in Missouri to a local Maryland rescue. The precise date and circumstances leading to Clem's placement in a shelter are unknown. At the time, rescue personnel estimated her to be three years old. Their veterinary team did not note any health or behavioral issues. However, the rescue indicated that Clem was previously adopted, but was returned after ten months for unknown reasons. While Clem waited for a permanent home, she lived with foster families and at the rescue's boarding facility. The rescue indicated that "Clem is high-energy and loves people."

During her initial photo shoot, Clem exhibited very high energy levels, was very excited, and posed well for the camera!

After over two years living in the rescue, Clem was adopted on March 3, 2015. Clem's adopter renamed her "Leela."

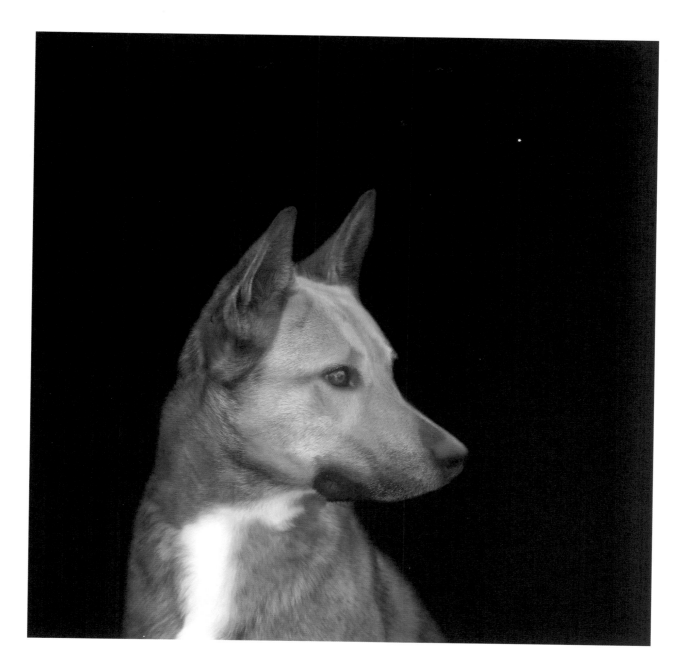

LEELA
SHEPHERD MIX, FEMALE, 4 YEARS, 2015

"While working at the boarding facility where Leela was being housed through the rescue in Maryland, I fell in love with her and decided to adopt her."

"Our family loves her. Leela is perfectly fine cuddling with each member of the household and hanging out on the sofa and in beds—at night and during the day, while we're home and away."

According to her adopter, Leela loves her new home and is thriving. "She's helped my family become more active. Members of the family that used to not really do too much are now getting up with Leela to take her outside throughout the day. Leela is settling in very nicely, and now my family has someone else to spoil and love!"

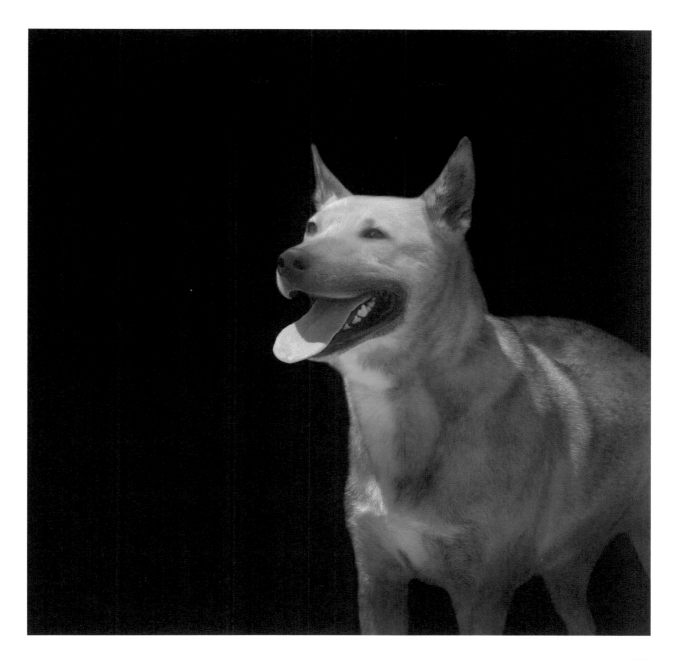

SADIE
HOUND-POINTER MIX, FEMALE, 3 YEARS, 2014
ADOPTED—250 DAYS IN THE RESCUE

In Summer 2014, Sadie was transferred to a local Maryland rescue after she was seized from a property in Virginia, where she was found chained outside along with her three puppies. The rescue team reported that Sadie dug a hole to help provide shelter for her puppies. Rescue personnel estimated Sadie to be three years old. Their veterinary team noted that Sadie was severely underweight and malnourished. No behavioral issues were reported. The rescue noted that "Sadie is very sweet, but extremely fearful of people."

During her initial photo shoot, Sadie was very sweet; however, she was quite scared of being photographed. Sadie often hid behind her foster mom during the initial photo shoot.

After approximately eight months in the rescue, Sadie was adopted on March 9, 2015.

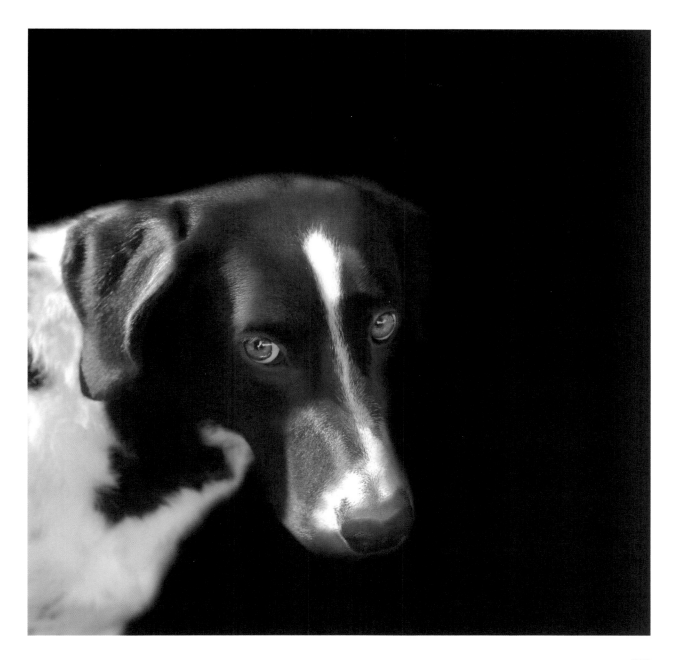

SADIE
HOUND-POINTER MIX, FEMALE, 3.5 YEARS, 2015

"Sadie's photo was posted online in the *McLean Patch*, an online newspaper. Sadie's face reminded us of our last dog, whom we lost to leukemia approximately three years ago. We also thought that it was a good omen that she had the same name as our Border Collie, and we wanted our next dog to be a rescue dog, so we inquired about Sadie. Fortunately, the rescue organization thought that we were a perfect match for a dog with Sadie's needs."

"Our daily routine now revolves around Sadie. Sadie has added energy to our house, and she has added another dimension to our relationship. We are constantly checking on her and making her feel welcome. Sadie is a good-natured dog that is very affectionate and sweet-natured. The challenges she presents provide an opportunity for us to work on something that is very positive, fun, and fulfilling."

Sadie's adopter reported she is doing well in her permanent home, and they are committed to providing Sadie with the best home possible. Due to past abuse, she is fearful of men, sudden noises, and strangers. However, "Sadie is a very happy dog—and that makes us happy. We see her prancing and sunning in the backyard, enjoying the house, and spending time with us. It is very satisfying to see the progress that Sadie has made in the short time she has been with us."

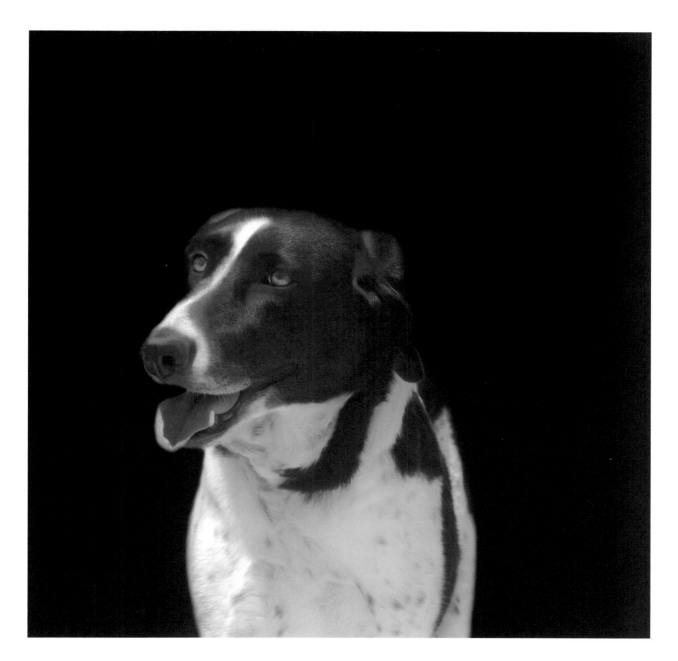

MINNIE
I.D. # PAGVA-11-252-SF, PIT BULL MIX, FEMALE, 3 YEARS, 2014
ADOPTED—APPROXIMATELY 3,460 DAYS IN THE RESCUE

In Autumn 2011, Minnie arrived at a local Maryland rescue after Minnie's owner left her on the porch of his house for multiple days. During her time outside, Minnie gave birth to three puppies that were also left unattended on the porch. Both Minnie and her pups received no care from the owner. A Good Samaritan convinced the owner to relinquish both Minnie and her pups to a rescue organization. At the time, rescue personnel estimated Minnie to be approximately three years old. Their veterinary team reported no health or behavioral issues. According to the rescue, "Minnie is not good with all dogs, and she is not good with cats."

During her initial photo shoot, Minnie was very calm and a little shy, as she avoided looking at the camera as often as possible.

Minnie's puppies were quickly adopted upon arriving at the rescue; however, Minnie was not as fortunate. She remained in the rescue's care via a foster home for nearly ten years, the longest waiting period for a dog to receive a permanent home recorded in this project. During the summer of 2021, Minnie's foster dad formally adopted her. The rescue organization was set to suspend its operations and Minnie's foster dad wanted to ensure she remained in his care. Minnie's extended stay in the rescue is the longest waiting period for a permanent home recorded in this project.

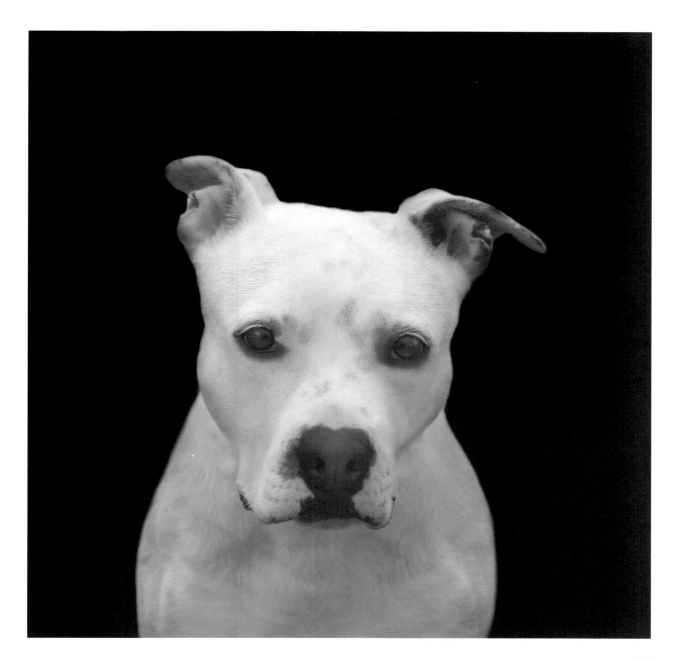

MINNIE
PIT BULL MIX, FEMALE, 4 YEARS, 2015

According to Minnie's adopter, "Minnie can get over stimulated in some situations where there is a lot of sensory stimulation; and she does not get along well with dogs who challenge her, although she does well with neutral, passive, or submissive dogs."

"Minnie entertains me and provides good companionship. She can be such a clown, she cheers me up when I am having a bad day, and she is very affectionate. Minnie likes to play with some of the other dogs in the house, and I often find her curled up, asleep with one or more of the dogs."

According to Minnie's adopter, she is a happy and healthy dog that is friendly, affectionate, confident, joyful, entertaining, and playful, making her an excellent companion especially for someone living alone.

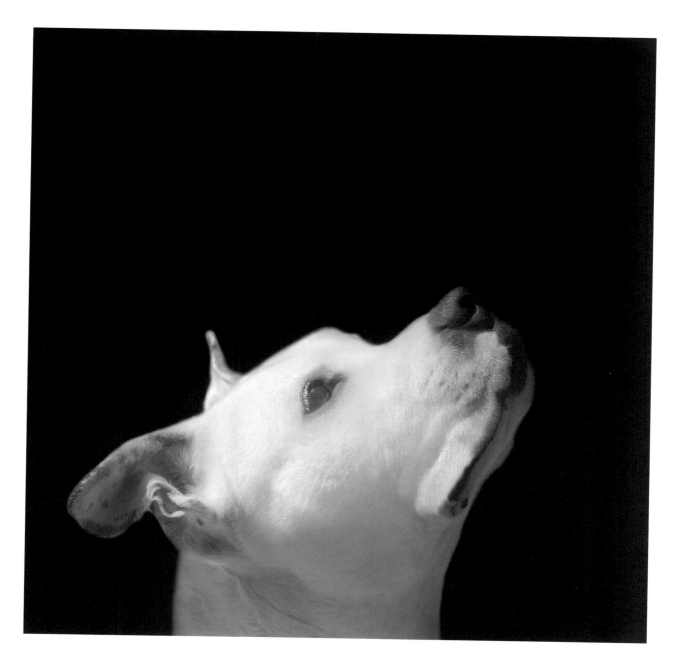

BLU
SHETLAND SHEEPDOG, FEMALE, 7 YEARS, 2014
ADOPTED—84 DAYS IN THE RESCUE

In Winter 2014, Blu's owner surrendered her to a local Maryland rescue. According to the rescue, "The former owner went through a divorce and had to sell her small farm to move to Texas for a new job." Blu's former owner had eleven Shetland Sheepdogs, all of which were surrendered to the same rescue. At the time, rescue personnel estimated Blu to be approximately seven years old. Their veterinary team noted that Blu tested positive for Lyme disease and suffered from a mouth infection as result of excessive tartar build up on her teeth. The rescue successfully treated both of these medical issues. No behavioral issues were noted. "Blu is a sweet dog, and she very much wants to please. She is a happy dog who enjoys being in the yard with the other dogs and people."

During Blu's initial photo shoot, she sat happily for the camera.

After approximately three months in the rescue, Blu was adopted on May 30, 2014.

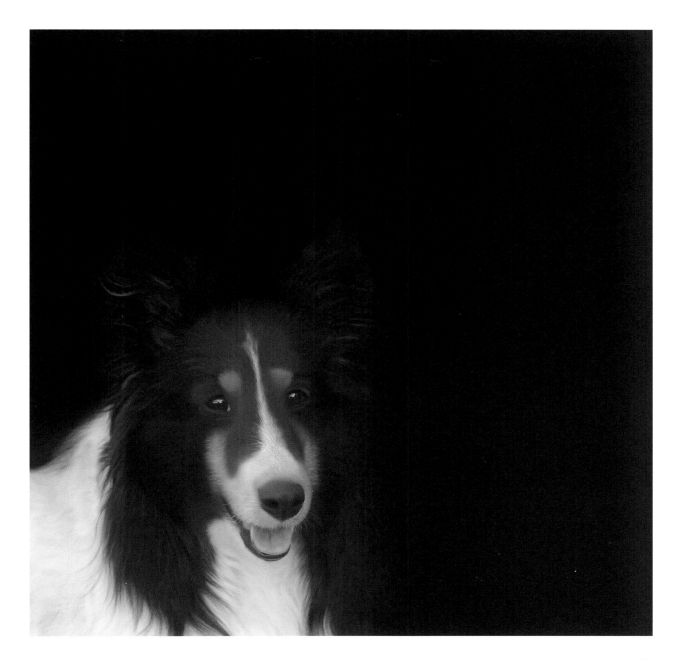

BLU
SHETLAND SHEEPDOG, FEMALE, 8 YEARS, 2015

"Blu seemed like she would be a good fit into our family setting. We found Blu on the rescue's website. We recently lost our fifteen-year-old Sheltie in April 2014. We also lost another Sheltie that we only had for four months in September 2014. Needless to say, we all were having a difficult time with such tough losses in such a short amount of time."

"Adopting Blu has put more spunk into our lonely six-year-old, Coco, and has repaired a hole in all of our hearts with a lot of love and affection. Blu is a welcome addition to our Sheltie-loving family and we couldn't imagine life without her."

According to Blu's adopter, she is doing well in her permanent home. Blu's adopter indicated Blu is very sweet, loveable, listens well, and likes to please. Her adopter also reported that she is a much more relaxed dog, but it still takes time for her to warm up to strangers. "She loves to chase the frisbee, and she could run all day. She seems to have endless energy. She has also learned a few tricks such as giving her paw and sitting pretty for a treat."

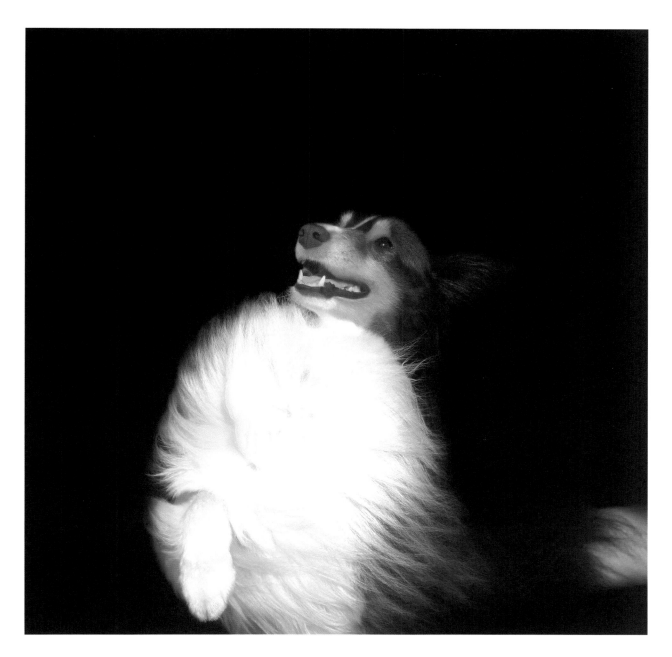

DELILAH
POODLE MIX, FEMALE, 11 YEARS, 2014
ADOPTED—235 DAYS IN THE RESCUE

During Summer 2014, Delilah was seized from a Missouri puppy mill and transferred to a local Maryland rescue. The rescue reported that Delilah lived her entire life in a travel crate and was solely used for breeding. The rescue estimated that she gave birth to over seventy puppies during her lifetime. At the time, rescue personnel estimated Delilah to be eleven years old. The rescue indicated that Delilah was successfully treated for heartworm, and noted she only had four teeth. No behavioral issues were reported. The rescue also indicated that "Delilah was very shut down, fearful, and almost feral when she arrived at the rescue."

During Delilah's initial photo shoot, she was very sweet and shy. She found comfort hiding behind her foster mom.

After approximately eight months in the rescue, Delilah was adopted on March 16, 2015.

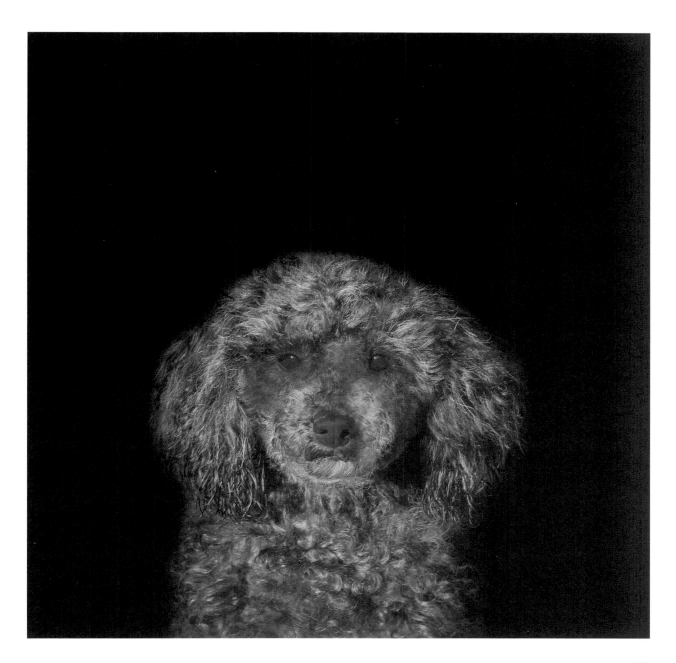

DELILAH
POODLE MIX, FEMALE, 12 YEARS, 2015

"Delilah is a 'foster failure.' She was with me for so long that I got attached to her more than any of my eight previous foster dogs. When she finally got an adoption application form a nice family, I decided that I couldn't live without her and adopted her myself."

According to Delilah's adopter, she had three of her four remaining teeth removed, leaving her with only one tooth in her entire mouth. "Her one remaining tooth kept her tongue in on one side, so it flopped to the other side, giving her a cartoonish look that always made me smile."

Most importantly, according to Delilah's adopter, "I could not part with her. My other foster dogs have been terrific dogs, but there is just something about this timid, terrified little survivor who is now an active, comfortable companion."

According to Delilah's adopter, she thrived in her permanent home and excelled at potty training. "Delilah is much more outgoing and willing to greet her human pack members. Now that Delilah is not so shy, she pushes her face into someone's hand for attention and she almost approaches when she is called. My family members remark on her progress. Every little step she takes toward being a 'normal dog' is a victory we all celebrate."

After her adoption, Delilah was diagnosed with Immune-Mediated Hemolytic Anemia (IMHA), a disorder where red blood cells are destroyed faster than they are produced. Delilah had two blood transfusions, and was prescribed medication to keep her immune system stable.

Delilah lived out the remaining year and a half of her life with a wonderful adopter who cared for her and loved her dearly. Sadly, on February 16, 2016, Delilah passed away peacefully in her adopter's arms. "I would not trade these last eighteen months with this gentle girl for anything. Run free, Monkey!"

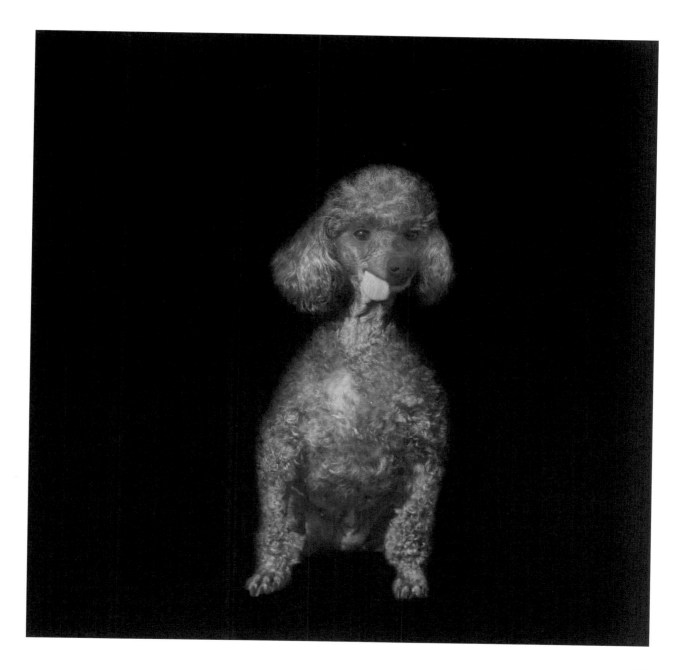

217

Coco
I.D. # A20345358, Terrier-Pit Bull Mix, Female, 4 years, 2013
Adopted—44 days in the Shelter

In Summer 2013, Coco was surrendered by her previous owner to a local Maryland shelter in conjunction with an Animal Control investigation. The exact date and circumstances leading to Coco's surrender are unknown, and for legal reasons, the shelter was unable to provide any details concerning the Animal Control investigation. At the time, shelter personnel estimated Coco to be approximately four years old. Their veterinary team reported that Coco came to the shelter pregnant; however, she lost her entire litter during surgery. The shelter indicated that Coco did not have any behavioral issues. According to the shelter, "Coco is gentle, quiet, and easy going."

During her initial photo shoot, Coco was very active and wanted to play. She was extremely happy to be out of her cage at the shelter!

After spending just over a month at the shelter, Coco was adopted on August 10, 2013.

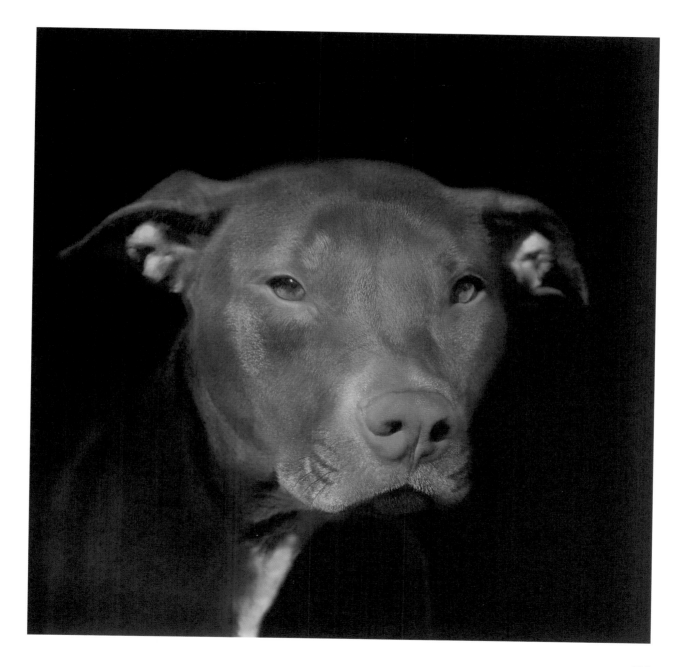

Coco
Terrier-Pit Bull Mix, Female, 5 years, 2014

"Our dog, Zoey, died from a tragic accident a few months prior to finding Coco. I began searching for a new dog that could be our companion. I saw Coco featured on the shelter's Facebook page listed as needing a new home. Later, I learned that Coco, unfortunately, lost her litter during surgery at the shelter. Being seven months pregnant myself, at the time, I felt compelled to save Coco's life."

The adopter indicated that Coco looked "really rough" at their first meeting. "It was clear she had been heavily bred. I knew that she wasn't likely to be adopted easily."

Coco's adopter reported that she is doing well in her permanent home and Coco's anxiety has also lessened over time. "She has turned out to be a calm, sweet, and playful dog that is very loyal. We weren't quite sure how things would turn out at first, but Coco has settled into her new role in our family and has made a new spot of her own in our hearts."

Importantly, according to the adopter, "Coco brought back a joy to our lives, which was missing when we lost our former dog, Zoey."

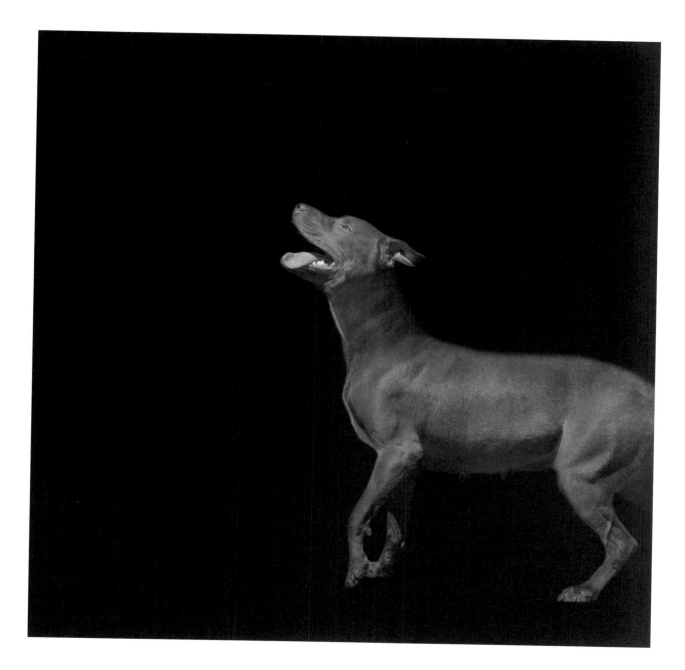

JENNY
SILVER LABRADOR MIX, FEMALE, 4.5 MONTHS, 2014
ADOPTED—66 DAYS IN THE RESCUE

In Spring 2014, Jenny was transferred from a shelter in Virginia to a local Maryland rescue after being seized as part of a hoarding case in an undisclosed Virginia location. At the time, rescue personnel estimated her to be four and a half months old. Their veterinary team did not report any health or behavioral issues. The rescue noted that "Jenny warmed up quickly and she was placed in foster care with another dog to help her gain confidence."

During her initial photo shoot, Jenny posed very well for the camera and seemed content.

After spending two months in rescue-sponsored foster care, Jenny was adopted on June 15, 2014. She was renamed "Violet" by her adopter.

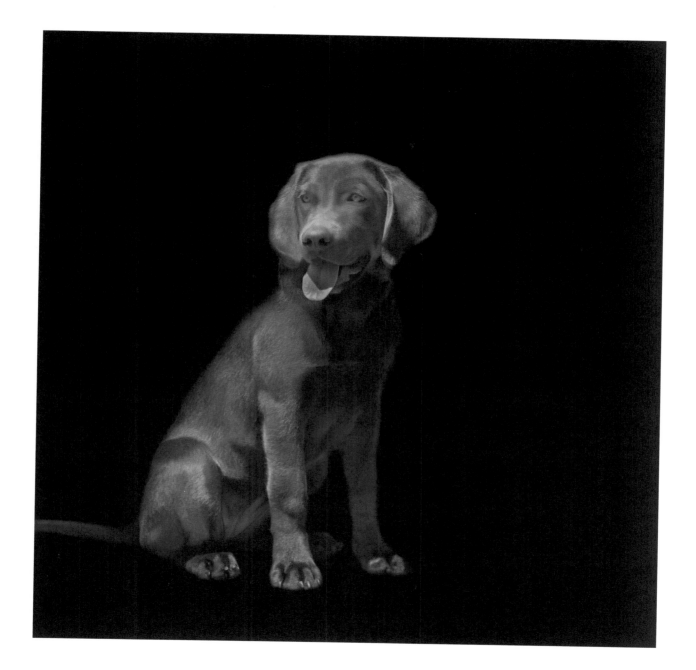

Violet
Silver Labrador Mix, Female, 1.5 years, 2015

"Violet had a very special disposition, and was a perfect fit for our family."

"Violet is sweet and incredibly mellow, except for when she is around the water, which she loves to play in—along with the mud!"

"I think it is important to remember when adopting a dog, potentially from a previously less-than-desirable situation, that they are acclimating to a new environment. Patience and continued love will inevitably pay off ten-fold."

According to Violet's adopter, she is doing well in her permanent home. Violet quickly warmed up to her new environment and now revels in cuddling with her adopter at the end of the day. Violet's adopter also indicated that Violet was a kind puppy from the very beginning, but she was simultaneously very independent.

Violet, with the help of her adopter, is well on her way to completing Canine Good Citizen Training, with the hope of one day becoming a therapy dog-human team. "After all, it just wouldn't be fair to keep this wonderful pup all to ourselves!"

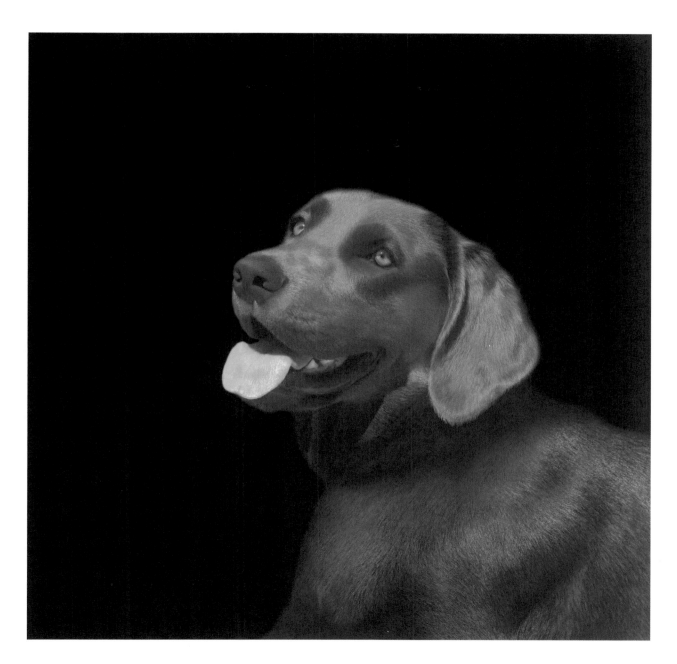

GABBY
I.D. # A19638345, RETRIEVER-SIBERIAN MIX, FEMALE, 1 YEAR, 2013
CANNOT LOCATE

In Spring 2013, Gabby's owner surrendered her to a local Maryland shelter. According to the shelter, the only reason given for her surrender was that "Gabby needed more training." At the time, shelter personnel estimated her to be approximately a year old. Their veterinary team reported no health or behavioral issues. According to the shelter, "Gabby is a super sweet and energetic puppy! However, the former owner was not willing to work with Gabby or consult with a trainer." The shelter representative reported that she tried to convince the owner to take Gabby to a trainer. To which the owner replied, "I don't want her at all."

During her initial photo shoot, Gabby was full of energy and loved being outside of her cage. She loved rolling around on the ground!

Gabby was transferred from the shelter to a local Maryland rescue on April 15, 2013.

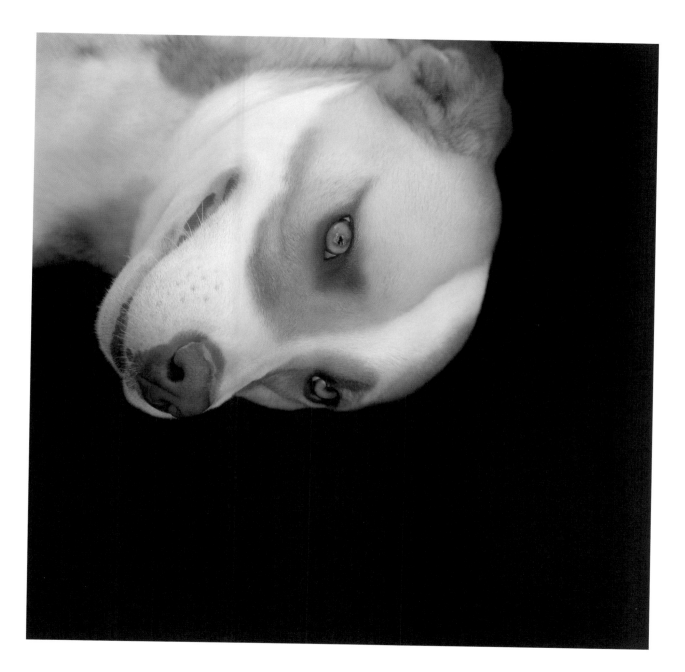

GABBY
RETRIEVER-SIBERIAN MIX, FEMALE
UNABLE TO LOCATE TO PHOTOGRAPH A SECOND TIME

Although Gabby was transferred from the shelter to a local Maryland rescue during the spring of 2013, the shelter was unable to provide the name and contact information of the rescue organization due to confidentiality reasons. Therefore, Gabby was unable to be photographed a second time.

CAIRO
I.D. # A19341570, TERRIER-PIT BULL MIX, MALE, 5 YEARS, 2013
ADOPTED—110 DAYS IN THE SHELTER

In Winter 2013, a Maryland Animal Control department seized Cairo and brought him to a local Maryland shelter. The circumstances leading to Cairo's arrival in the shelter are unknown. At the time, rescue personnel estimated Cairo to be approximately five years old. Their veterinary team reported that Cairo came to the shelter with abrasions on his leg and a few broken teeth, which needed to be extracted. Cairo was also suffering from an upper respiratory infection. Fortunately, the shelter successfully treated Cairo's aforementioned medical issues. The shelter did not report any behavioral issues and noted that Cairo was an "old soul."

During his initial photo shoot, Cairo was very calm, subdued, and greatly enjoyed being outside of his cage at the shelter.

On April 20, 2013, Cairo went to live with a foster family and was then adopted on June 22, 2013.

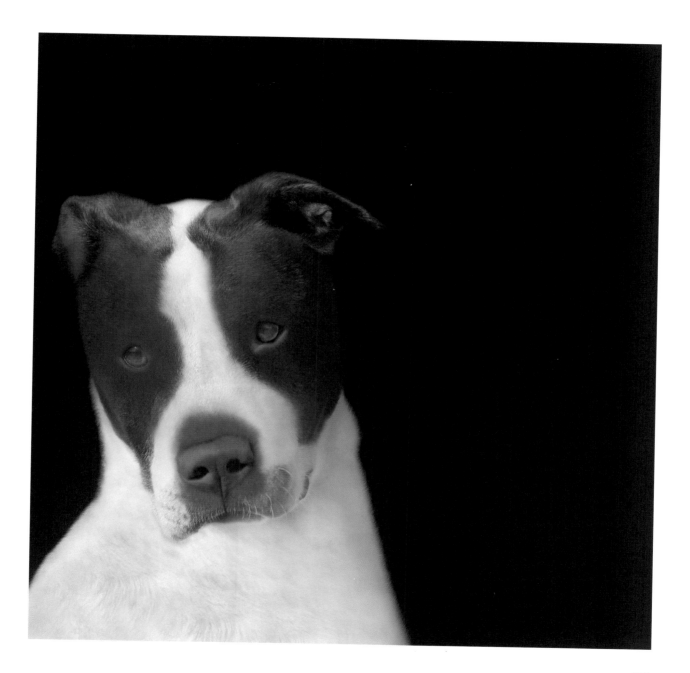

CAIRO
TERRIER-PIT BULL MIX, MALE, 6 YEARS, 2014

"We were looking for a pit bull mix dog because the media has done such a smear campaign on the breed. Pit bulls were originally 'nursery dogs' during the Victorian era." When Cairo's adopters met him, they instantly fell in love with him.

According to Cairo's adopter, he is doing well and is happy in his permanent home. He has gained weight since arriving at the shelter. "Cairo is a source of entertainment and loving devotion. He is a wonderful companion, keeping me active and interested in life."

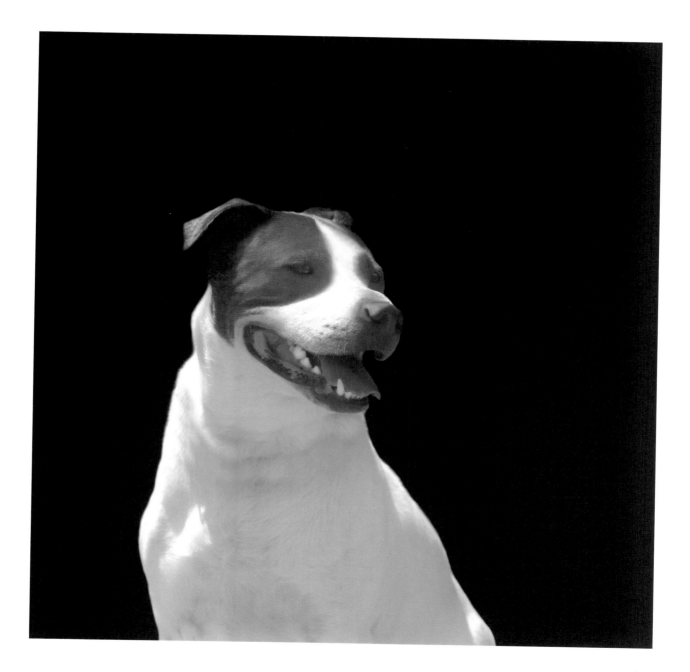

233

MURDOCK
I.D. # HSFVA-14-089-NM, YELLOW LABRADOR MIX, MALE, 4.5 YEARS, 2014
ADOPTED—173 DAYS IN THE RESCUE

In Winter 2014, Murdock was found as a stray dog in Virginia and taken to a local shelter. He was subsequently transferred to a Maryland rescue organization. The precise date and circumstances leading to Murdock's arrival in a shelter are unknown. At the time, rescue personnel estimated him to be four and a half years old. Their veterinary team did not report any health or behavioral issues. The rescue noted, "Murdock is nervous, shy, and he needs a patient adopter."

During his initial photo shoot, Murdock was indeed nervous and shy, and stayed very close to his foster dad.

After approximately six months in the rescue, Murdock was adopted on July 13, 2014.

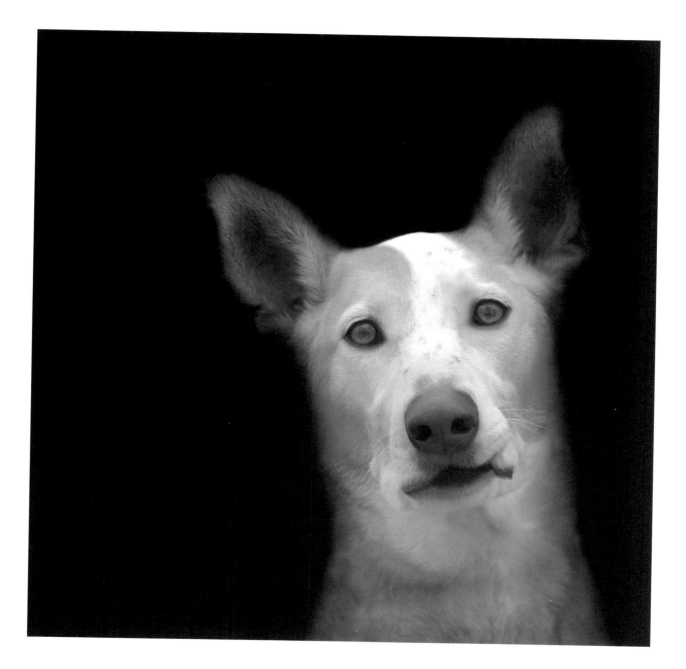

MURDOCK
YELLOW LABRADOR MIX, MALE, 6 YEARS, 2015

"We love dogs and I, myself, have had dogs my entire life, until a year and a half ago. We put our Mac, our former dog, down due to old age and it was very hard on all of us. We decided we had been without a dog for long enough."

"We saw Murdock's photograph, read what the rescue wrote about him on its website, and we knew that he was the dog we wanted to adopt. We knew he would be perfect for our family, and we hoped that we would be perfect for him."

According to Murdock's adopter, he was shy at first, but has really come into his own and has a wonderful temperament. He is very happy and sweet and has gained weight since his adoption. Murdock's adopter also reported being more active, as they go on multiple walks each day with him. "Murdock is such a loving dog that just craves attention, and he brings such warmth into our home. He is a true member of our family."

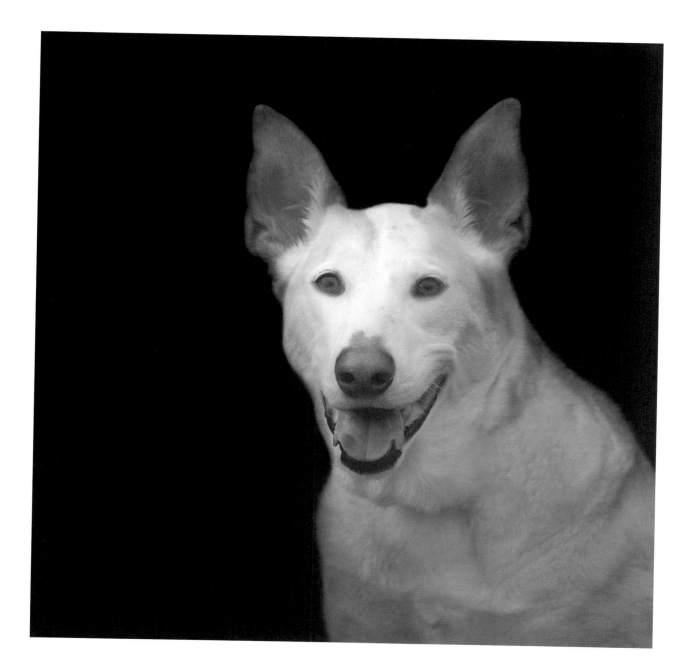

AFTERWORD

Deborah Samuel

As the stories of canine heroes unfold within *Abandoned: Chronicling the Journeys of Once-Forsaken Dogs*, they reveal their incredible journey from abandonment to belonging. This book is filled with hope, transformation, and the immeasurable rewards of dog rescue.

The process of rescuing dogs is undeniably challenging. The dedicated individuals working tirelessly in shelters and rescue organizations confront heartbreaking situations daily. They witness neglected and abused animals living in deplorable conditions, often bearing the physical and emotional scars of their past. Caring for these dogs takes immeasurable perseverance and compassion, as does returning them to health and rebuilding their broken trust in humanity.

But within these difficulties lies the extraordinary beauty of dog rescue—the opportunity to witness the miracle of transformation. In the "before and after" photographs and stories documenting each dog's journey, we see dogs on the brink of hopelessness form a magical bond with their new families. These dogs found a place they could call home and found their purpose again: to become the light that brightened their new family's lives. Each dog's unique story is a testament to the indomitable spirit of our canine companions. Rehoming a rescued dog is a profound act of compassion. It is a chance for ordinary people to become heroes, stepping forward to provide a second chance in life.

I met Katherine Carver at the beginning of this project, *Abandoned*. She interviewed me for her blog regarding two photography books I had published on my work with dogs, and she shared an idea with me for a project she was working on. She spoke about her first rescue, a Sheltie named Biscuit, who she had at the time. She shared how Biscuit had changed her life in immensely heartwarming ways, as many of my rescues had done the same for me. Carver wanted to raise awareness for abandoned dogs that needed rehoming. Carver's compassion, understanding, and desire to help educate were the same qualities every individual in shelters and rescue organizations strives for daily. Her steadfast effort and perseverance in completing this complex project have been miraculous: creating a document

that spoke to the transformation people experience who have given abandoned dogs their forever home, and how each dog bonded with their new family as evidenced in Carver's photographs, which brilliantly impart each dog's journey from abandonment to belonging.

Let us remember that the journey of animal rescue never truly ends. The stories shared in *Abandoned* are but a fraction of the countless lives transformed by the selfless dedication of individuals who believe in the power of compassion. Each dog's journey is a reminder that no matter how difficult the path may be, the rewards of dog rescue are immeasurable. Opening our hearts and homes comprises part of a greater narrative—a story of hope, resilience, and the unbreakable bond between humans and their canine companions.

—Deborah Samuel, Fine Art Photographer

DOG RESCUE RESOURCES

There are many dog rescue organizations and associations across the United States and internationally. In the United States alone, there are approximately fourteen thousand shelters and rescue organizations.[1] Statistics reveal that approximately three point one million dogs enter shelters in the United States each year and, more importantly, two million of these dogs are adopted annually.[2] Clearly, dog rescue organizations and associations play a vital role in the successful placement and adoption of abandoned dogs.

Contained immediately below are the following: (1) brief descriptions of selected major dog rescue organizations and associations both in the United States and abroad, (2) resources about dog rescue and dog adoption which provide information about this important cause, particularly for prospective adopters, and (3) a listing of the organizations that made this book possible.

Below is information about selected major national and international dog rescue organizations.

UNITED STATES

The American Society for the Prevention of Cruelty to Animals (ASPCA) was the first humane society to be established in North America and is, today, one of the largest in the world. The ASPCA is a privately-funded, 501(c)(3) not-for-profit corporation headquartered in New York City and combines a strong local presence with programs that extend the ASPCA's anti-cruelty mission across the United States. The ASPCA has three areas of expertise: animal rescue, animal placement, and animal protection. For further information, visit: www.aspca.org.

Best Friends Animal Society: No-Kill Animal Rescue and Advocacy (BFAS) is a 501(c)(3) not-for-profit organization and leader in the no-kill animal movement. BFAS is a pet rescue and advocacy organization with the largest no-kill sanctuary in the United States for companion animals. BFAS also strives to build effective programs that reduce the number of animals entering shelters. BFAS operates in the following locations: Kanab, Utah; Atlanta, Georgia; Houston, Texas; Los Angeles,

1 "Petpedia: Shocking Animal Shelter Statistics (2023 update)," accessed May 1, 2023, https://petpedia.co/animal-shelter-statistics/. In addition to kill shelters, no-kill shelters, and not-for-profit rescue organizations also operate in the U.S. These shelters rely on donations and staff to keep going, unlike the government-funded municipal shelters.

2 "American Society for the Prevention of Cruelty to Animals: Pet Statistics," accessed May 1, 2023, https://www.aspca.org/helping-people-pets/shelter-intake-and-surrender/pet-statistics.

California; New York, New York; Bentonville, Arkansas; and Salt Lake City, Utah. In addition, through BFAS' national network of partners, lifesaving tactics are being implemented in shelters and rescue groups across the country. For further information, please visit: www.bestfriends.org.

The Humane Society of the United States (HSUS) is a 501(c)(3) not-for-profit organization headquartered in Washington, DC, and it fights to end the suffering for all animals. The HSUS takes on puppy mills, factory farms, the fur trade, trophy hunting, animal cosmetics testing, and other cruel industries. The HSUS rescues and cares for thousands of animals every year through its work and other hands-on animal care services. Specifically, the HSUS works to: end the cruelest practices toward all animals, care for animals in crisis, build a stronger animal protection movement, and increase its capacity to drive global change. For further information, please visit: www.humanesociety.org.

Petfinder.com and the Petfinder Foundation (Petfinder) is an organization consisting of an online, searchable database of animals who need homes, including a directory of nearly eleven thousand animal shelters and adoption organizations across the United States, Canada, and Mexico. Organizations maintain their own home pages and available-pet databases. Petfinder's mission is to: increase public awareness of the availability of high-quality adoptable pets, increase the effectiveness of pet adoption programs across North America to end the euthanasia of adoptable pets, and elevate the status of pets to that of family members. Petfinder is updated daily, and anyone can search for a pet that best suits one's needs. Petfinder also includes discussion forums, a pet-care resource directory, and a library of free pet-care articles. Additionally, the Petfinder Foundation, a not-for-profit organization, provides grants to other charities and organizations that help prevent the euthanasia of pets. For further information, please visit: www.petfinder.com and www.petfinderfoundation.com.

CANADA

Humane Canada is a non-profit animal welfare organization headquartered in Ottawa, Canada, representing humane societies, Society for the Prevention of Cruelty to Animals (SPCAs), and animal rescue organizations. Humane Canada's mission is to promote positive, progressive change to end animal cruelty, improve animal protection, and promote the humane treatment of all animals. For further information, please visit: humanecanada.ca.

MEXICO

Compassion Without Borders (CWB) is a 501(c)(3) not-for-profit organization, which brings a brighter future to animals in need on both sides of the border in the United States and Mexico. CWB programs include a dog rescue program from Mexico and the California Central Valley. Dogs with backgrounds of homelessness, cruelty, and neglect are rescued directly off the streets or taken in from

animal control centers where they face euthanasia. Dogs are rescued and cared for, given veterinary treatment and care, and rehabilitated both emotionally and physically. For further information, please visit: www.cwob.org.

UNITED KINGDOM

Dogs Trust is a British animal welfare charity and humane society headquartered in London, England, which specializes in the well-being of dogs. It is the largest dog welfare charity in the United Kingdom. Dogs Trust's primary objective is to protect all dogs in the United Kingdom and elsewhere from maltreatment, cruelty, and suffering. This organization focuses on the rehabilitation and the placement of dogs which have been either abandoned or given up by their owners through rehoming services. Dogs Trust has twenty-two rehoming centers across the United Kingdom and Ireland. For further information, please visit: www.dogstrust.org.uk.

The Royal Society for the Prevention of Cruelty to Animals (RSPCA) is a charity that operates in England and Wales to prevent cruelty and promote kindness to (as well as alleviate the suffering of) all animals, which includes the rescue and adoption of dogs across Great Britain. RSPCA works in Europe, Africa, and Asia. RSPCA's mission states that animals can rely on the RSPCA to rescue them when they need it most, to rehabilitate animals whenever possible, provide the animals with the very best veterinary care, and to find the animals new homes, either through adoption or release. For further information, please visit: www.rspca.org.uk.

INTERNATIONAL

Humane Society International (HSI) is a non-profit organization headquartered in Washington, DC. HSI works around the globe to promote the human-animal bond, rescue and protect dogs and cats, improve farm animal welfare, protect wildlife, promote animal-free testing and research, respond to natural disasters, and confront cruelty to animals. For further information, please visit: www.hsi.org.

Sochi Dogs (SD) is an international not-for-profit organization based in the United States that rescues, rehabilitates, and finds homes for stray and abandoned dogs from Eastern Europe and South Korea. Importantly, SD works tirelessly to prevent dogs from ending up on the street by educating communities and offering low-cost spay and neuter initiatives. For further information, please visit: www.sochidogs.org.

To learn more about dog rescue and adoption and the importance of this cause, please review the following topics and links:

Dog statistics for the United States:

bestfriends.org/no-kill-2025/animal-shelter-statistics

www.aspca.org/helping-people-pets/shelter-intake-and-surrender/pet-statistics

Shelter statistics:

bestfriends.org/no-kill-2025/animal-shelter-statistics

Puppy mills:

www.humanesociety.org/all-our-fights/stopping-puppy-mills

Animal cruelty:

www.petfinder.com/helping-pets/animal-cruelty

The no-kill movement:

bestfriends.org/no-kill-2025/what-does-no-kill-mean

bestfriends.org/no-kill-faqs

Finding a rescue dog to adopt via a dog shelter or rescue organization:

www.petfinder.com/animal-shelters-and-rescues/search

Checklist for adopting a rescue dog:

www.petfinder.com/pet-adoption/dog-adoption/pet-adoption-checklist

Tips for preparing to bring home a new rescue dog:

www.petfinder.com/dogs/bringing-a-dog-home/tips-for-first-30-days-dog

www.petfinder.com/dogs/bringing-a-dog-home/changing-dog-name

Cost considerations when contemplating adopting a rescue dog:

www.petfinder.com/pet-adoption/dog-adoption/how-much-does-a-dog-cost

Dog fostering:

www.petfinder.com/animal-shelters-and-rescues/fostering-dogs/what-is-dog-fostering
www.petfinder.com/animal-shelters-and-rescues/fostering-dogs/20-questions-before-you-foster-dogs

Volunteering at a dog shelter or rescue:

www.petfinder.com/homeforeverhome/dog/volunteering
www.petfinder.com/animal-shelters-and-rescues/volunteering-with-dogs

Ten ways to help your local shelter or dog rescue:

www.humanesociety.org/resources/ten-ways-help-your-local-shelter-or-rescue

Starting an animal shelter:

www.petfinder.com/animal-shelters-and-rescues/starting-a-pet-adoption-organization

Additional dog rescue resources:

www.petfinder.com/pet-adoption/dog-adoption/finding-your-best-bud
bestfriends.org/no-kill-faqs
www.humanesociety.org/resources/pet-owners
www.humanerescuealliance.org/rehoming-resources

The following organizations helped make this body of work possible. I am deeply grateful for their participation in this project. Please visit their websites and support their work.

Baltimore Animal Rescue and Care Shelter, Inc.

www.barcs.org

Dogs XL Rescue, Inc.

www.dogsxlrescue.org

(Please note this rescue organization temporarily suspended its operations in September 2021.)

Fallston Animal Rescue Movement, Inc.

fallstonanimalrescue.org

Mutts Matter Rescue, Inc.
www.facebook.com/MuttsMatterRescue
(Please note this rescue organization permanently suspended operations in the spring of 2020.)

Sheltie Haven Sheltie Rescue, Inc.
www.facebook.com/sheltiehaven
(Please note this rescue organization permanently suspended operations in December 2019.)

ACKNOWLEDGEMENTS

I have worked for over a decade to create and publish this body of work. With the exception of parenting, I have never been so thoroughly committed to a project. I worked diligently for over ten years and maintained faith that this effort would end with a published book. An idea which came to me very clearly on a summer day in 2012 is now a reality, a dream realized. It is an achievement of which I am enormously proud and fortunate to share with a wider audience. A book is created in solitude, and yet contains within its pages the fingerprints, dedication, and love of others.

It is an understatement that the publication of this body of work required contributions from a large number of people whom I owe such a great debt. I appreciate the efforts of everyone who helped bring this project to fruition. I am grateful to each shelter, rescue organization, and adopter for their commitment to scheduling photography sessions and willingness to answer questionnaires and interview questions in support of documenting each dog's journey. I am also appreciative of the experienced professionals who shared their time and provided advice pertaining to the editing and revising of the images, the contracts and releases, the book production process, the website design, and the public relations campaign for this book. I am truly grateful to the numerous people who helped make this book a reality.

My enormous gratitude goes to the shelter and rescue organizations who helped make this project possible. These include the following: Baltimore Animal Rescue and Care Shelter, Inc.; Dogs XL Rescue, Inc.; Fallston Animal Rescue Movement, Inc.; Mutts Matter Rescue, Inc.; and Sheltie Haven Sheltie Rescue, Inc. I am immensely grateful to the staff and volunteer members of these organizations who shared their time and resources with me. I would like to acknowledge the contributions of: Barbara Bertling, Jennifer Brause, Carol Guth, Melanie Samet, Jessica Skopac, and Anne Wuhrer. Thank You. This book would not exist without your assistance.

I would also like to express my sincere gratitude to all of the adopters who generously shared their dogs and time with me. Without you, this project would not be possible. The adopters include: Lisa Barry, Vera Batey, Isaac Bell, Wendi Bon, Michael Buberl, Lisa Challberg, Judith Cluster, Holly Deroba, Lauren DeWitt, David Dudek, Lucy Ertter, David and Lynn Fanaroff, Erica Fox, Melissa Gallagher, Edward Gallick and Linda Zemke, Dee Gochnauer, Robert Hartmann, Christina Hawk of Sunrise of Montgomery Village, Kelli Hires, Kelly Hogan and Connie Hansen, Dick and Pat Huebschman, Carolyn Cody Jones, Jennifer Kali, Doron Kutnick, Travis and Haley Laganosky, Kristin Lamoureux, Mary Laurents, Robert and Julie Maloney, Margaret Marshall, Scott McArthur, E. Van McBryan, Sarah Ellen Miller, Amanda Moore,

Acknowledgements

Michael Moss, Kimberly Nelson, Easton Penland, Theresa Runk, Christina Ryan, Maria Sanchez, Jo-Ann Schaudies, Stefanie Schmidt, Charleen Slobodinsky, Barbara Sullivan, Henrietta Taylor, Angela Tennis, Holli Tucker and Steve James, Gina VanCamp, Gloria Volpe, Michael and Jena Wagner, Georgia Walker, Kaitlin Watson, and Gary Whitten. It was a great honor to meet you and photograph your dog to include in this project. It was also inspiring and heartwarming to learn how each dog enriched your lives.

I am enormously fortunate to have such wonderful, talented, and well-known and well-respected authors, artists, and presidents and executive directors from large dog rescue and animal welfare organizations provide written statements endorsing this book. I am very grateful for your kind, generous, and thoughtful words in support of this book. These generous contributors include: Erika Abrams, Jennifer Arnold, Marc Bekoff, Gregory Berns, Jane Goodall, Temple Grandin, John Grogan, Brian Hare and Vanessa Woods, Alexandra Horowitz, Steven Kotler, Emma Kronish, Lisa LaFontaine, Sally Mann, Jeffery Moussaieff Masson, Alison Maurhoff, Jo-Anne McArthur, Patricia McConnell, Debbie Millman, Sy Montgomery, Sally Muir, Susan Orlean, Leila Philip, Jessica Pierce, Carl Safina, Robin Schwartz, Theresa Strader, Elizabeth Marshall Thomas, Zazie Todd, Anna Umansky, Martin Usborne, and Diana Walker.

Gina Harasti and Bill McComas. Thank you for your time and guidance with respect to contracts, releases, and all things legal. I am very grateful for your time and assistance. Thank you.

Bob Jewett. Thank you for your assistance and expertise regarding the printing and presentation of this project. I am enormously grateful for your insights.

Graham Letorney. Thank you for your assistance and patience while we worked together to update my website and make this book its focal point. It has been a pleasure working with you.

Elina Vaysbeyn. Thank you for your design assistance. It has been a great pleasure working with you.

Scott Manning and Abigail Welhouse. Thank you so very much for your dedication and kindness, with respect to the public relations campaign to usher this book into the world, and your ability to generate publicity for this book, which I have dedicated so much time and effort into creating. Working with you both has been a dream. My sincere thanks.

I would like to extend enormous thanks to the Lantern Publishing & Media team, specifically, Brian Normoyle for taking a chance on me and publishing this body of work. It has been a wonderful experience working with the Lantern team. I would also like to give an enormous thank you to Pauline Lafosse for your copyediting magic and for your brilliant design of this book. Finally, I would like to give a tremendous thank you to Emily Lavieri-Scull—thank you so very much for getting this book to the finish line. It has been a great pleasure. My heartfelt thanks.

Francis Battista. Thank you for your gracious and lovely foreword introducing this work and for sharing your insights on dog rescue. You are an expert and thought leader on animal and dog rescue and I am greatly honored that you are a part of this book.

To my mentor, Deborah Samuel. This body of work would not exist without your guidance, insights, kindness, and support. I am grateful for the years of mentorship, friendship, and creative collaboration. Words cannot accurately encapsulate my gratitude for you being on this journey with me. Thank you for believing in me and in this book. I am exceedingly grateful for your feedback on my photographs and always pushing me to improve, your uplifting words, your encouragement to fully embrace and trust the creative process and path, and for lending a hand to talk things through whenever something new arose. I have grown in so many ways throughout this process and I have learned so much from you, which I will always cherish. Thank you for the beautiful, thought-provoking words contained in the afterword. This book would not be what it is without you. With abundant, boundless, and wholehearted thanks.

To my girlfriends: Amelia Chan, Marsha Hall, Gina Harasti, Charlyn Kwiatkowski, Hilma Munson, Patricia Pope, and Marie Salvino. Thank you for your enduring friendship, love, support, and enthusiasm. In particular, I wish to thank Marsha Hall for encouraging me to trust beyond what is visible. I am grateful for your encouragement and friendship.

To my parents, Richard and Rebecca Carver. Thank you for your love and generosity over the years and for your unwavering and enduring support of this project. I am enormously grateful. And to Nick, my parents' rescue Papillon dog, who ascended the rainbow bridge before this book was published: thank you for being a part of my life. We miss you dearly. In your honor, we welcomed Finn, a rescue Papillon dog, who recently joined our family.

And finally, to my family. My husband, Douglas Fenneman, is my first and most trusted reviewer and reader. Your steadfast love, support, presence, and belief in this project has made it possible to bring this book to publication. Thank you for always believing in me. I could never have achieved this dream without you. I am exceedingly grateful for you and our marriage. My daughter, Alexandra Fenneman, inspires me each day to do my best and to follow creative inspiration. You are the greatest miracle in our lives, and I am so fortunate to have the honor and privilege of being your Mom. My beloved Victory, our rescue Shetland Sheepdog, you kept me company every step of the way, sitting at my feet under my desk. I am forever grateful for your companionship, love, and spirit. Your presence kept me motivated with the knowledge that this work could help other dogs like you. My dear Biscuit, our first rescue Shetland Sheepdog, who provided the inspiration for this project. Although you were with us only at the beginning of this project, your legacy will always live on within these pages. This book would not exist without them.

All my love and thanks.

INDEX OF ABANDONED DOGS

FRANCIS BATTISTA—BIOGRAPHY

Francis Battista is the co-founder of the Best Friends Animal Society (BFAS), and is today one of the foremost thought leaders in animal welfare. Born in 1945 and raised in the New York City metropolitan area, Francis has always been in the company of pets.

Over the years, he has worn many hats at BFAS, including co-director of animal care at the Best Friends Animal Sanctuary. In 1991, he started the Best Friends Los Angeles program along with his wife, Silva. Following Hurricane Katrina in 2005, Battista managed the Best Friends rescue shelters in Tylertown, Mississippi, and Metairie, Louisiana. In 2008, he was involved in the BFAS' negotiations with federal agencies and courts that brought twenty-two of Michael Vick's dogs to the Best Friends Animal Sanctuary for care and rehabilitation. Most of the "Vicktory Dogs" as they came to be known, went on to enjoy life as loving pets, therapy dogs, agility champions, and breed ambassadors. In 2012, Francis was instrumental in launching No-Kill Los Angeles, a BFAS initiative and coalition comprising of 152 Los Angeles area organizations. In 2014, he presented a TED Talk at TEDxReno, entitled *Four Legged Citizens*.

Today, Francis Battista serves as Chair of the BFAS Board of Directors, works as an internal consultant to various BFAS programs, and writes for the organization. The mission of BFAS is to end the killing of healthy pets in America's shelters by 2025. To learn more about Battista and his work, **visit:** www.bestfriends.org.

DEBORAH SAMUEL—BIOGRAPHY

Deborah Samuel was born in Vancouver, Canada. Her family moved to Toronto, Canada and by the age of fourteen, they had moved to Ireland, where she studied art at the Limerick College of Art and Design. Samuel returned to Canada and studied photography at Sheridan College in Oakville, Ontario, Canada.

Samuel was quickly recognized for the distinct style of her fashion photographs and her intuitive and intense portraits of celebrities, writers, artists, dignitaries, sports heroes, and musicians including Leonard Cohen, Margaret Atwood, Rush, and Queen Noor. Professional opportunities required time spent in New York, London, and Los Angeles, where Samuel became an in-demand editorial portrait photographer. She worked for magazines such as *GQ*, *Rolling Stone*, *Esquire*, *Spin*, *Entertainment Weekly*, the *Los Angeles Times*, *Saturday Night*, and *Macleans*.

In 2000, Samuel turned away from the commercial world of photography to pursue her own personal work. This work evolved into formal portrait studies of animals and nature. In 2012, the Royal Ontario Museum in Toronto exhibited *Elegy*, a solo exhibition of subtle photographs of animal bones. In 2017, the Gardiner Museum in Toronto exhibited her work, *Artifact*.

Samuel's work is exhibited in Canada, the United States, and internationally. It is included in the collections of the Royal Ontario Museum, the Winnipeg Art Museum, the Santa Barbara Museum of Art, the Museum of Fine Arts in Houston, and numerous private and corporate collections. Samuel has lectured and led photography workshops throughout North America and has published four books: *Dog*; *Pup* (a collection of canine portraits); *The Extraordinary Beauty of Birds: Designs, Patterns, and Details*; and *Elementals*, an ode to the enduring beauty of nature's phenomena. To learn more about Samuel and her work, visit: www.deborahsamuel.com.

ABOUT THE AUTHOR

Katherine Carver was born in Ann Arbor, Michigan in 1978. She was introduced to photography during high school. In 2011, she found herself behind a camera lens creating photographs of her first dog, a rescue Shetland Sheepdog named Biscuit, who inspired Carver's great passion, interest, curiosity, and the study of dogs in her work.

Abandoned: Chronicling the Journeys of Once-Forsaken Dogs is Carver's debut book, though her photographs have been published in international publications such as, *L'Oeil de la Photographie, Four&Sons,* and *My Modern Met.* Carver holds a Juris Doctor, with Honor, from the University of Maryland Francis King Carey School of Law. She currently lives in the Washington, DC area with her husband, daughter, and rescue Shetland Sheepdog, Victory. To learn more, visit: www.katherinecarver.com **and** www.biscuitsspace.com.

Katherine and Victory
Photograph by Douglas Fenneman

ABOUT THE PUBLISHER

Lantern Publishing & Media was founded in 2020 to follow and expand on the legacy of Lantern Books, a publishing company started in 1999 on the principles of living with a greater depth and commitment to the preservation of the natural world. Like its predecessor, Lantern Publishing & Media produces books on animal advocacy, veganism, religion, social justice, humane education, psychology, family therapy, and recovery. Lantern Publishing & Media is dedicated to printing in the United States on recycled paper and saving resources in its day-to-day operations. Lantern Publishing & Media titles are also available as e-books and audiobooks.

To learn more about Lantern Publishing & Media, please visit www.lanternpm.org.

 facebook.com/lanternpm
twitter.com/lanternpm
instagram.com/lanternpm